Today most historians
view the Renaissance

argely an intellectual and ideological change, rather than a substantive one. Moreover, many
orians now point out that most of the negative social factors popularly associated with the
dieval" period – poverty, warfare, religious and political persecution, and so forth – seem to have
ally worsened during this age of MACHIAVELLI, the Wars of Religion, the corrupt Borgia Popes,
the intensified witch-hunts of the 16th century. Eine Voraussetzung für die neue Geisteshaltung
Renaissance waren die Gedanken selbstbewusster italienischer Dichter des 14. Jahrhunderts wie

FRANCESCO PETRARCA,
durch seine ausgiebige Beschäftigung mit den antiken Schriftstellern und durch seinen Indivi-
lismus den Glauben an den Wert der humanistischen Bildung förderte und das Studium der
eben, der *Literatur*, der *Geschichte* und der *Philosophie* außerhalb eines religiösen Zusammenhangs
s Selbstzweck – befürwortete. Los supuestos históricos que permitieron desarrollar el nuevo estilo

e remontan al siglo XIV cuando,
on el Humanismo, progresa un
deal individualista de la cultura
un profundo interés por la lite-
atura clásica, que acabaría dirigiendo, forzosamente, la atención sobre los
os monumentales clásicos. Italia en ese momento está integrada por una serie de estados entre los que
tacan Venecia, Florencia, Milán, el Estado Pontificio y Nápoles. Alors qu'au Moyen Âge, la création
tique était essentiellement tournée vers la religion chrétienne, la Renaissance artistique utilise les
nes humanistes et mythologiques. Le renouvellement

*réflexion
hilosophique*

fournir aux artistes de nouvelles
es : avec le néoplatonisme, l'Homme est au centre de l'univers. L'étude des textes antiques,
enouveau de la philologie, permettent aux architectes d'abandonner les formes gothiques. Ils
ssent les enseignements de PYTHAGORE et de VITRUVE pour élaborer leurs plans. *Den italienska
sansen växte fram på 1300-talet, och utvecklingen nådde Sverige på 1500-talet. För konsten innebar renässansen
konstnärerna steg fram ur anonymiteten, och att porträtt och landskap fick som främsta uppgift att exakt avbilda
ven.* Typiska för epoken är universalgeniema MICHELANGELO BUONARROTI och LEONARDO
VINCI som båda perfekt behärskade en mängd konstarter. Ofte leder man også renæssancens
rtvidenskab omfatte KOPERNIKUS, KEPLER og GALILEI. De hævdede, at de samme mekaniske
gjaldt for himmellegemernes bevægelser, som for bevægelserne på jorden. På den måde opløste
den middelalderlige etageverden og fratog den kristne himmel- og helvedesforestillinger deres
dgribelighed.

detrás del p

CAI

Borneo

Pa amb tor

BARC

El veloz mu

comía feliz

Carmela, Remedios, Loli
dómino y toman choco
del chalet que se ha con

Montaña

PASIO-N

Maiola Regular

Buchgewerbe

Maiola Bold

Inspirován prací českých typografů

Maiola Italic

DISCLOSURE

Maiola SmallCaps

книгопечатание

Maiola Cyrillic Italic

δημιουργός

Maiola Greek Bold

N16LE *LOUGHBOROUGH JUNCTION*

Maiola Regular/Italic SmallCaps

Dynamically

Maiola Bold Italic

New Fonts to Make You Think

Typosphere

New Fonts to Make You Think

Typosphere

COLLINS|DESIGN

An Imprint of HarperCollins*Publishers*

TYPOSPHERE: NEW FONTS TO MAKE YOU THINK
Copyright © 2007 by COLLINS DESIGN and maomao publications

HarperCollins books may be purchased for educational, business, or sales promotional use.
For information, please write: Special Markets Department, HarperCollins Publishers,
10 East 53rd Street, New York, NY 10022.

First Edition:
Published by maomao publications in 2007
Tallers, 22 bis, 3º 1ª
08001 Barcelona, Spain
Tel.: +34 93 481 57 22
Fax: +34 93 317 42 08
mao@maomaopublications.com
www.maomaopublications.com

English language edition first published in 2007 by:
Collins Design
An Imprint of HarperCollinsPublishers
10 East 53rd Street
New York, NY 10022
Tel.: (212) 207-7000
Fax: (212) 207-7654
collinsdesign@harpercollins.com
www.harpercollins.com

Distributed throughout the world by:
HarperCollinsPublishers
10 East 53rd Street
New York, NY 10022
Fax: (212) 207-7654

Publisher:
Paco Asensio

Editorial Coordination:
Anja Llorella Oriol

Editors:
Pilar Cano
Marta Serrats

Editorial assistant:
Claire Dalquié

Translation:
Jay Noden
Verónica Fajardo

Art Direction:
Emma Termes Parera

Layout:
Zahira Rodríguez Mediavilla

Library of Congress Cataloging-in-Publication Data

Serrats, Marta.
Typosphere : new fonts to make you think / Marta Serrats, Pilar Cano.
— 1st ed.
p. cm.
ISBN-13: 978-0-06-114421-9 (pbk.)
ISBN-10: 0-06-114421-5 (pbk.)
1. Type and type-founding. I. Cano, Pilar, 1978- II. Title.

Z250.S48 2007
686.2'21—dc22

2007007139

Printed in Spain
First Printing, 2007

Contents

Introduction

In the early 1990s, a huge number of graphic designers launched themselves into creating typefaces. Both the technological revolution that preceded the appearance of the first Macintosh computer, in 1984, and the development of relatively user-friendly typeface-production software encouraged many designers to enter a field that was previously limited to highly experienced professionals.

The appearance of the computer brought with it a greater sense of freedom, and it allowed the graphic design world in general to explore the apparently nonexistent limits of this new technology. Large numbers of creators generated masses of bizarre pieces, mostly of an experimental nature, and the frenetic rhythm of production inevitably affected their quality, both in graphic and typeface design. However, from this technological revolution, like all revolutions, arose a relatively short period of energetic, large-scale production, which came to an end as quickly as it had started. By the end of the 1990s the world of graphic design had settled down. Those experimenting with type design returned to graphics; some went on to Web design, the next revolution, and typeface designers ruled the roost once again.

This return to specialization is due in part to the appearance of more complex typeface-production software, which required technical sophistication. Unicode, for example, is an encoding system which can identify the glyphs that each typeface contains. It locates a specific glyph in a typeface's database, when that typeface is used. OpenType, a project started in 1995 and developed by both Microsoft and Adobe, actually produced a new typeface format, which, in reality, is a hybrid of existing formats and new extensions. OpenType is a versatile format, compatible with both platforms—Mac and PC—which also allows the development of large character sets. A single font may contain up to 65,000 glyphs compared to a previous 256.

This feature favors the development of typefaces that contain various writing systems within a single font. It also allows the production of complex writing systems, such as Japanese, which uses two syllabic alphabets, *hiragana* and *katakana*; one ideographic, *kanji*; and, in recent years, the so-called *romaji*, or Latin alphabet. OpenType also allows users to add other features, such as small capitals, alternative characters, ligatures, Old Style figures and others—attributes that previously had to be separated into different "expert" fonts, which were aimed at professional graphic designers.

In short, these new technologies have once again limited typeface design to professionals with an in-depth knowledge of both the new tools and the traditional techniques. So anyone creating new fonts these days is doing much more than merely creating attractive shapes. In the words of Paul Renner: "Heed this professionals: Typeface design is technology, and it is art."

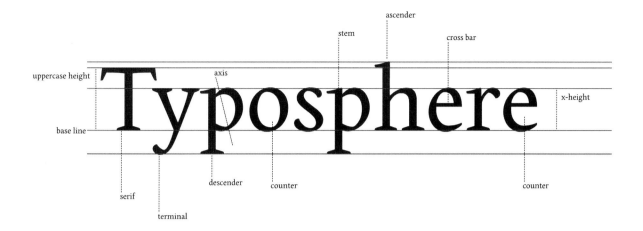

Arm
The upper diagonal stem in the letter *k*.

Ascender
The stem of the lowercase letter that ascends above the x-height.

Axis
The angle of inflexion is where the thinner strokes of a typeface meet. Depending on the design, it could be oblique, vertical or nonexistent.

Base line
The line that supports the x-height.

Beak
A stroke that joins a stem with its serif.

Body
The height of the typeface, which is measured from the ascenders to the descenders.

Character
The graphical representation of a sound. For example, *a* and *A* are a single character.

Counter
The interior, empty space that some glyphs present, such as in the letters *o*, *d*, and *p*. *Counter* also refers to the exterior spaces of some glyphs, such as *C*, *c*, *S*, *s*, and *n*.

Descender
The stem of the lowercase, which descends beneath the base line.

Ear
Terminal of the letter *g*.

Glyph
Graphical representations of a character. For example: *a* and *A* are the same character, but *a* is a glyph and *A* is a different glyph.

Old Style figures
The figure set designed to be used in long text. The figures have ascenders and descenders.

Serif
The stroke at the end of the stems in roman typefaces.

Spur
The circular ending of some letters such as the *a*, the *j* and the *f*.

Tabular figures
The figure set designed to be used in tables or in any other kind of layout that requires vertical alignment of figures. Each of the figures occupies exactly the same space horizontally, which means they can be aligned vertically.

Tail
The oblique stem of some glyphs, among them the *R*, the *K* and the *Q*.

Terminal
The final stroke of a stem.

Inspirován prací českých typografů

KING PA

Auf

{magical}

He won't t

MILLIMETER

| 2 | 3 | 4 | 5 | 6 | 7 | 8 | 9 | 10 | 11 | 12 |

0.001MM	0.0020PT
0.02MM	0.05PT
0.04MM	0.1PT
0.06MM	0.15PT
0.08MM	0.2PT
0.1MM	0.25PT
0.12MM	0.3PT
0.14MM	0.35PT
0.16MM	0.4PT
0.18MM	0.45PT

240 239 238 237 236
235 234 233 232 231
230 229 228 227 226
225 224 223 222 221
220 219 218 217 216
215 214 213 212 211
210 209 208 207 206
205 204 203 202 201
200 199 198 197 196
195 194 193 192 191
190 189 188 187 186
185

io-n

erksamkeit

be the girl I never loved. Never loved, never loved.

l you this

Aggressive

Jeremy Tankard

www.typography.net

Alchemy is an unusual typeface family—inspired by manuscripts from the Middle Ages—which contains an extraordinary diversity of capitals whose forms display almost infinite variations. In this font, the uppercase first letters have a larger body than that of the text, and they are used at the beginning of a chapter or section.

Jeremy Tankard was inspired largely by the calligraphic art in the manuscript *Lindisfarne Gospels*, one of the world's most important religious art treasures, which dates to the end of the seventh century and the beginning of the eighth century. The *Gospel of Saint Matthew*, which forms part of this manuscript, was a great source of inspiration for some of the letters in the Alchemy family.

By way of its sharp-pointed terminals and punctuation marks, together with its general structure, Alchemy transmits a certain aggressiveness. This single-variant typeface has a limited use; however, its technical characteristics make it an interesting project for designers, giving them the freedom to experiment and create at will. Based on medieval capitals, there is only one case, which Jeremy Tankard has endowed with endless alternative characters that can be combined and altered, thereby producing an almost infinite range of possibilities.

Apart from its ligatures, Alchemy has a series of decorative elements that can be added to the rest of the glyphs to generate new forms. It also has a set of glyphs that act as a superindex and another that acts as a subindex. Because these glyphs are smaller, they can be superimposed onto normal-size letters, allowing the designer to create his own ligatures. Obviously all these elements can be combined with each other by mutual overlapping.

In the hands of different designers, Alchemy has the potential to become a new design. Thanks to its appearance, it is the ideal typeface to give works a Gothic touch.

ALCHEMY

Family: Alchemy
Variants: Alchemy
Designer: Jeremy Tankard
Year: 2004
Distributor: www.typography.net
Use: Display
Other uses: Not recommended
Advice or considerations: Explore the wide range of possibilities that the alternative characters and ligatures offer.

{magical}
the highlands of scotland
marches
white moonstone
mediæval

MAIN FORMS

ΑΑΑΑΑΒΒΒCDEⅭEEFFFFGGGHHHₕħijjjKKKKLLMMMMMMM
ᴍᴍNNOOPPPPQQRRRRSΣŦŦŦtUUVWWXXYYYYZ

ÀÁÂÃÄÅÀÁÂÃÄÅÀÁÂÃÄÅàáâãäåÆÆÆÆÇÈÉÊ
ÈÉÊËÈÉÊËÈÉÊËÌÍÎÏÌÍÎÏÌÍÎÏłŁŃÑÑÒÓÔÕÖÒÓÔÕÖŒÆ
ŒŒØØŠŠUÙÚÛÜÙÚÛÜÝŸÝŸÝŸÝŸŽĐÞÞÞÞßß

LIGATURES

Fi Fj FL FL Ħ Ħ LL Ll' Ŧ Ŧ Ŧ Ŧ Ŧ Ŧ Ŧ

JOINING FORMS

ʃ ʃ ʃ C ← - → ← - → ← - - → ← - - →

SUPERIORS

ᴀᴀʙʙᴄᴅᴇᴇꜰꜰɢɢʜʜꞮꞮᴊᴊᴋᴋʟʟᴍᴍᴍɴᴏᴏᴘᴘǫǫʀ
ʀꜱꜱꔸŦŦᴜᴜᴠᴡᴡxxʏʏᴢàáâãäåçèéêëèéêë
ìíîïɪɩíîïłŁñɴòóôõöòóôõöšžùúûüýÿýÿžđþþ

INFERIORS

ᴀᴀʙʙᴄᴅᴇᴇꜰꜰɢɢʜʜꞮꞮᴊᴊᴋᴋʟʟᴍᴍᴍɴᴏᴏᴘᴘǫǫʀ
ʀꜱꜱꔸŦŦᴜᴜᴠᴡᴡxxʏʏᴢàáâãäåçèéêëèéêë
ìíîïɪɩíîïłŁñɴòóôõöòóôõöšžùúûüýÿýÿžđþþ

FIGURES, CURRENCY & RELATED FORMS

[DEFAULT] 00I2345567889

[TABULAR] 00I2345567889

€$$¢¢£ſ ƒ¥¥¤

+−±×÷=~∧⟨⟩|¦∪ / ¼½¾%‰123°ᴬᴼ

PUNCTUATION & MARKS

_ - – — ‴ ‘ ’ ‚ ‛ “ ” „ ‟ , „ ⟨ ⟩ ⟪ ⟫ « » . , : ; … · · ¡ ! ¿ ? ¿

& ⅋ ◊ () { } [] { } \ / * † ‡ § ¶ • @ © ® ™ #

ACCENTS

` ´ ˘ ˆ ˇ ˜ ¯ ¨ ˙ ˚ ˝ ¸ ˛ �¸ · · ·

Cape Arcona Type Foundry

Cape Arcona's legendary obsession to create a DIN-like font substitution brought them to CA BND™, named after the German Intelligence Agency. The font was created for the new CI of the Intelligence Agency, but the presentation was not successful because there was no contact person available—everything and everyone is just TOP SECRET.

CA BND appears to be simply functional. In general, it *is* unemotional, but if you look at the details you may find something emotional that you will learn to love. It comes in two styles with an alternate letterset. It also comes in two weights, Regular and Bold, each of which offers an Alternate style.

The Cape Arcona Type Foundry was founded in Essen, Germany, in 2002 by designers Thomas Schostok and Stefan Claudius. It is an independent type foundry that produces and distributes digital typefaces; it also offers a wide range of typographic services, from original typeface design to individual font production and graphic design.

The typefaces of the Cape Arcona Type Foundry cover all styles. Their most popular typefaces are: CA Blitzkrieg Pop, CA Aires Pro, CA BND, CA Zaracusa. As the designers say, "We are always searching for the strange and the unexpected in a font," but they never gave more detailed information about what they really meant.

For the sake of political correctness, the founders always say that the Foundry was not named after the destroyed luxury liner SS Cap Arcona (the ship was named after Cape Arkona on the island of Rügen in Mecklenburg, Western Pomerania, Germany). The destruction of the ship is a tragedy, and the founders of the Cape Arcona Type Foundry always assure people that they did not have destruction in mind when naming their design house.

BND

Family: CA BND™
Weights: Regular and Alternate styles in Regular and Bold weight
Designer: Thomas Schostok
Year: 2004
Distributor: Cape Arcona Type Foundry
Use: Text and Display
Advice or considerations: The Alternate style offers a lot of funny and useful variations to the regular characters.

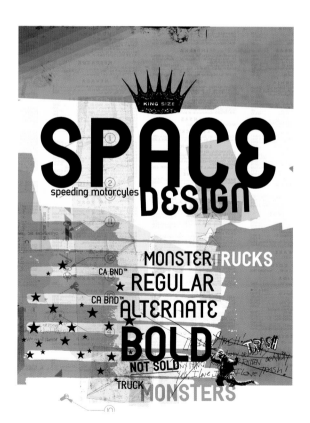

CA BND™ Regular

abcdefghijklmnopqrstuvwxyz

ABCDEFGHIJKLMNOPQRSTUVWXYZ

1234567890 €£¥$¢

?!¿i"№%&'(*)+,-./:;<=>@[\]^_'{|} ~

ÄÅÇÉÑÖÜáâàãäåçéèêëiîìñóòöõúùûü

ÂÊÁËÈÍÎÏÓÔÒÚÛÙiÀÃÕŒœÿŸ

°§•β®©™'''ÆØ±°æøf≈«... −—""""÷/> •„^~ ‿‿'°″�‚˛˘

TEXTSAMPLE

Yes, there were times, I'm sure you knew. When I bit off more than I could chew. But through it all when there was doubt. I ate it up and spit it out. I faced it all and I stood tall. And did it my way. The kiss I never got. Somebody else will take. The plans I never made. Somebody else will make. Oh I'm lonely, I'm so lonely. 'Cause it's her I'm thinking of. But she'll always be the girl I never loved. Never loved, never loved. Überfållãrtigér Schnëllsçhûss Yes, there were times, I'm sure you knew. When I bit off more than I could chew. But through it all when there was doubt. I ate it up and spit it out. I faced it all and I stood tall. And did it my way. The kiss I never got. Somebody else will take. The plans I never made. Somebody else will make. Oh I'm lonely, I'm so lonely. 'Cause it's her I'm thinking of. But she'll always be the girl I never loved. Never loved, never loved.

CA BND™ Alternate

abcdefghijklmnopqrstuvwxyz

ABCDEFGHIJKLMNOPQRSTUVWXYZ

1234567890 €£¥$¢

?!¿i"№%&'(*)+,-./:;<=>@[\]^_'{|} ~

ÄÅÇÉÑÖÜáâàãäåçéèêëiîìñóòöõúùûü

ÂÊÁËÈÍÎÏÓÔÒÚÛÙiÀÃÕŒœÿŸ

°§•β®©™'''ÆØ±°æøf≈«... −—""""÷/> •„^~ ‿‿'°″˂˛˘

TEXTSAMPLE

Yes, there were times, I'm sure you knew. When I bit off more than I could chew. But through it all when there was doubt. I ate it up and spit it out. I faced it all and I stood tall. And did it my way. The kiss I never got. Somebody else will take. The plans I never made. Somebody else will make. Oh I'm lonely, I'm so lonely. 'Cause it's her I'm thinking of. But she'll always be the girl I never loved. Never loved, never loved. Überfållãrtigér Schnëllsçhûss Yes, there were times, I'm sure you knew. When I bit off more than I could chew. But through it all when there was doubt. I ate it up and spit it out. I faced it all and I stood tall. And did it my way. The kiss I never got. Somebody else will take. The plans I never made. Somebody else will make. Oh I'm lonely, I'm so lonely. 'Cause it's her I'm thinking of. But she'll always be the girl I never loved. Never loved, never loved.

Tarocco was originally designed to appear in a book about orange plantations in Sicily. Since this activity includes some Swedish connections, Waldemar Zachrisson based this typeface on Nordisk Antikva, which was very popular in the 1930s; it was also designed with the Swedish language in mind. This, along with certain art nouveau traits, constitutes its most important characteristics.

Tarocco is a typeface family designed for books, and it has this specialty's typical structure. It has a generous x-height, which as well as giving it a certain elegance greatly facilitates its legibility. It is also a broad typeface that could almost fall into the expanded category instead of the regular category.

Among its most distinguished characteristics is the subtle irregularity of its design, which gives it its unique personality. The *g* for example, has the typical shape of a normal letter, but its terminal is completely different from the rest of the typeface.

Tarocco's art nouveau heritage can be openly seen in the design of its numerals, especially in the numbers three and five, the curved sections of which acquire a disproportionate importance, as well as in the differentiated breadth of some of the letters. For example the *e* is wider than normal, and the *t* is narrower, a style that is typical of art nouveau.

On the whole, the design of this typeface is a little rough. The shapes that result from the combination of curves and straight lines as well as some of the terminals are quite crude. This gives Tarocco its aggressive trait, which is especially noticeable in its italics, thanks to the highly pronounced angle of its serifs and the heavily sloping angle that this version presents in general. The Tarocco italics are also considerably wider than normal and seem to maintain the same proportions as the regular version, which is quite uncommon and contributes to this typeface family's unusual character.

Tarocco

AaBbCc€&! ROMAN	*AaBbCc€&!* ITALIC
AaBbCc€&! MEDIUM	*AaBbCc€&!* MEDIUM ITALIC
AaBbCc€&! BOLD	*AaBbCc€&!* BOLD ITALIC
AABBCC€&! SMALL CAPS	❈ ❖ ⚿ ❉ ◉ ▦ ORNAMENTS

Family: Tarocco
Variants: Tarocco Roman, Tarocco SCOSF, Tarocco Medium, Tarocco Medium Italic, Tarocco Bold, Tarocco Bold Italic.
Designer: Stefan Hattenbach
Year: 2000
Distributor: Psy/Ops Type Foundry
Use: Long text
Other uses: Not recommended
Advice or considerations: Excellent both for books and magazines

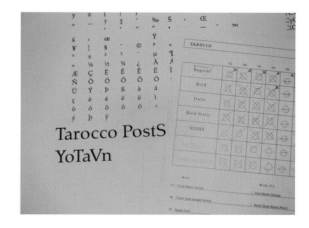

ORANGE

orchards kept in the family for generations

Every tree is his child

each piece of the dimpled fruit is his pride

He won't tell you this

See it in the stains on his hands and his

confident smile

– AND SKIN WORN BY 65 YEARS OF CARE

as keeper of the land

Application

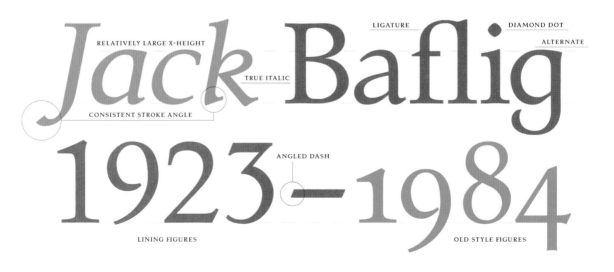

Sketches

Tarocco is a typography designed for books. The typographical family follows the same structure of this specialty. Curves and straight lines are combined to give fluidity to the text; however, its serifs have a slightly pronounced angle, which gives it a somewhat aggressive personality.

KAPITEL 16

Paradis bakom glas

Det står ett litet apelsinträd i skyltfönstret till blomsteraffären i Stockholm. På gatan rusar en blå buss förbi och det stänker snömos över trottoaren.

DE SMÅ FRUKTERNA LYSER STARKARE än alla andra blommor. De går inte att äta, men de väcker paradisiska drömmar i en isande vintervind.

Han säger ingenting när han klämmer apelsinens saft över hennes nakna rygg, sedan slickar han henne omsorgsfullt. Hon vänder sig om och ler. Mannen har rest sig upp ur sängen, öppnat dörren och gått. Det drar en kall vind genom rummet och hon sluter sina ögon.

Någon timme senare vaknar hon och inser att allt bara var en dröm. Ryggen kladdar mot lakanet när hon rullar upp ur sängen. Hon går ut till kylskåpet, tar ut juicepaketet och dricker direkt ur pipen. Munnen fylls av hopp. Utanför fönstret hänger månen som en jättelik, blek boll från den iskalla vinterhimlen. Den lovar henne att någonstans finns det ändå ett paradis. Redan under romartiden ryktades det om de märkliga träden i Kina och bortre Indien. Det var särskilt doften av blommorna som fångade äventyrarna från Europa. I flera sekler försökte handelsresande förgäves frakta hem apelsinträd, men plantorna dog under transporten. Eller så tvinade de bort i det nya klimatet. Men så småningom fann man att träden trivdes i Medelhavs-

området. Man odlade två sorter, den bittra och den söta. Den bittra användes mest till parfymer och matlagning. Columbus tog med sig båda typerna till Haiti 1493. Det karibiska klimatet passade frukten. Vid samma tid började portugiserna att odla en söt apelsin, som de ansåg vara överlägsen de italienska sorterna. Den portugisiska apelsinen blev snabbt eftertraktad, inte minst i 1500-talets England.

Ju fler nordeuropéer som fick smak på apelsinen, desto fler försökte sig på att odla. Under barocken byggdes orangerier i

I sekler har nordeuropéer försökt att odla apelsiner i växthus. Orangeriet Ulriksdal strax norr om Stockholm började uppföras 1693. Det har senare byggts om, och i dag används det också som utställningsrum för Nation museums samlingar av en del svensk skulptur.

81

Michael Ives

Xplor is an extensive typeface family, designed for the corporate identity of Xplor International. As in any other project of this kind, Xplor had to reflect the concepts that give the brand identity as well as being an all-purpose family, since it would be used in different circumstances and with diverse technology: in text, displays or on-and screen, both for homemade and high-quality prints.

To develop a project of this range, Michael Ives began by considering all these questions before creating a family based on these characteristics he knew the typeface needed to cover all the areas with the consistency that a corporate image project requires.

The designer rose to this challenge by creating an extensive family, both roman and normal, that presents two variants, Office and Book. All are of different weights and, of course, include the corresponding italic version, each weight and version complementing the family. All these subtle variations of the design are due to the typeface's application with a wide and diverse range of technologies.

Generally speaking, all typefaces when printed with a low-resolution—which therefore shows the consequences of lower-quality technology compared to that of professional printing—seem thicker due to the expansion of the ink; also, the forms of the letters are not reproduced precisely. The Office version of this family was created specifically to tackle the disadvantages of low-resolution printing. Ives solves the problem of thicker typeface resulting from low-quality printing by making the Office version less black. This gives the sensation that it has the same thickness as the Book version, which is designed for high-resolution printing.

Another technical limitation that the designer had to consider was the screen-based use of Xplor. With the aim of obtaining the best possible result in terms of screen reproduction, the design of this family is relatively simple: its stems are straight; it counters opens, and its serifs clean. Xplor is a typeface without too much complexity in its structure and with a high degree of consistency throughout its several applications.

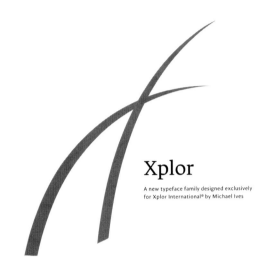

Xplor

A new typeface family designed exclusively for Xplor International® by Michael Ives

Family: Xplor
Variants: Xplor Office Serif, Xplor Office Serif Bold, Xplor Book Serif, Xplor Book Italic, Xplor Book Serif Bold, Xplor Office Sans, Xplor Office Sans Bold, Xplor Book Sans, Xplor Book Sans Bold.
Designer: Michael Ives
Year: 2005
Distributor: Mitchthemod
Use: Display, headings, long text, screen, etc.
Other uses: Any
Advice or considerations: Use the version appropriate to each application

hamburgefons

afgpobqdikyhlu

bdpqocezryniku

ABCDEFGHIJ
KLMNOPQR
STUVWXYZ
abcdefghij
klmnopqr
stuvwxyz
[0123456789]
«{(– —-)}»

ABCDEFGHIJ
KLMNOPQR
STUVWXYZ
abcdefghij
klmnopqr
stuvwxyz
[0123456789]
«{(– —-)}»

Xplor is also a typeface with a strong personality. It has rather aggressive, rectangular counters that play down the softness of the stems, based on broad nib pen strokes and upright writing. It is a variation of the Gothic scripture developed in Italy and in the South of France during the eighth century and used until the fifteenth century in southern Europe, especially on the Iberian Peninsula. This Gothic writing was strongly influenced by Carolingian writing. As the name itself indicates, upright writing is more upright than other Gothic writing; with humanist strokes and terminals without tips, it provides a less black and more legible texture.

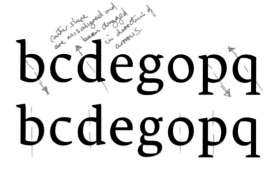

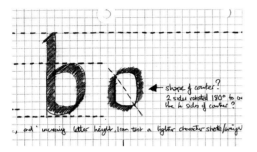

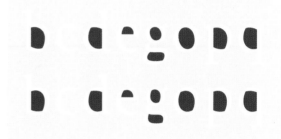

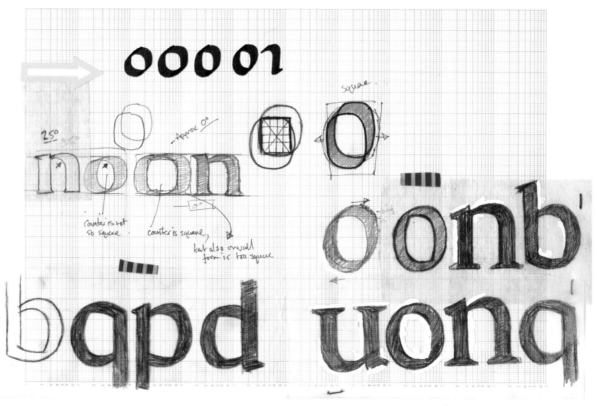

Sketches

Xplor was designed for its applications in the different corporate formats of Xplor International website, the worldwide electronic document systems association. Ives gets a typography with internal eyes in rectangular shape, straight lines, and clean serifs.

Membership application

To complete this form please use
BLACK INK AND CAPITAL LETTERS

Xplor
UK & Ireland

If more than one member of your company wishes to apply for membership or you are applying for corporate membership then simply use copies of this form to provide us with the names and addresses of all the applicants.

your details

title Mr, Mrs etc name .

company .

job title .

address .

. .

. postcode

country . tel fax

e-mail .

Xplor 2006 annual memberships fees

Individual		£150 + VAT =	£176.25 ☐
Corporate	*up to 5 members*	£565 + VAT =	£663.88 ☐
Corporate Extra	*up to 10 members*	£1 000 + VAT =	£1 175.00 ☐
Corporate Plus	*up to 25 members*	£2 835 + VAT =	£3 331.13 ☐

Individual memberships are not transferable but remain with the individual even when they change
Individuals listed in any Corporate memberships may be changed at any time with written instructi...
Corporate members must all belong to the same organisation but not necessarily at the same address
Membership begins on the first of the month in which the dues are received and expires on the same d...

payment

card American Express / Visa / MasterCard ☐ card no .

name on card . signature .

cheque *made payable to 'Xplor UK & Ireland Ltd'* ☐ cheque number

direct bank transfer ☐ *to* NatWest Bank account 903 645 38 sort code 60 - 08 - 15

electronic ☐ *you can also make your payments through* www.xplor.org/join

data protection compliance

Please tick this box if you **do not** *wish to receive industry or product information from us* ☐

when you have completed this form

please date *and sign it* . *and send it with your payment to:*

Roberta McKee-Jackson EDP · 2 Sherfield Ave · Rickmansworth · London · WD3 1NH
Any queries, please contact the Xplor office *tel & fax* 01923 896 037 *e* xploruk@aol.com

EDP evaluation form (RH)

(candidate's name or reference code)

A Depth & Breadth of Knowledge

Where there is evidence of the candidate's role and competency at any of the steps in the document journey, tick the relevant boxes for all three Work Examples

Steps in the Document Journey
(with suggested examples)

Candidate's
skills & roles →

content creation & input (scan; OCR; data input; forms; filters; write)
system design & implement (databases; tagging; SGML; life cycle; continuance)
connectivity & systems (platform; operating systems; networks; cabling)
storage/file mgmt (fiche; COLD; version control; security; archive; recovery)
document design (substrate; fonts; 1/ 2/4 color; graphics; forms; text)
document composition (doc comp software; datastream conversion; data extract)
legal control (compliance; intellectual property; corp affairs; mergers & aquisition)
electronic imaging (creating XML; HTML; PDF; web pages; CRM; EOI)
paper imaging (laser imaging; monochrome; color; PDL; POD)
electronic distribution (EBPP; browsers; search engines; firewalls)
paper distribution (finishing; mailing; barcodes; internal distribution)

B EDP Professionalism

1 = abysmal; 5 = average; 10 = outstanding

case studies
1 2 3

work example well laid out & easy to comprehend
candidate provides sufficient documentation to illustrate the project
candidate provides clear project objectives and rationale for chosen approach
clear indication of candidate's role
evidence that objectives were achieved or not
demonstrates thoroughness throughout the project
ability to evaluate the project and monitor the results
innovative approach
ability to deal with the unexpected
ability to consult with, motivate and manage people
demonstrates awareness of budget considerations
demonstrates good project management skills

mandatory criteria score each
optional criteria score 5 or more must relevant

Please note any comments regarding concerns or less than good performance on the reverse

total for each case study
number of entries in each column
average for each case study

overall average

date

evaluator's name

548-2006

Veronika Burian

Maiola is a large typeface family, which, apart from its sixteen variations, takes full advantage of the possibilities that OpenType technology offers to create an extensive character set that includes the Greek and Cyrillic alphabets. The complexity of this project is even more impressive. Maiola has a series of additional characters, also based on OpenType technology, such as small capitals, four figure sets for text and uppercase that are either proportional or tabular, the ligatures, characters that are case sensitive, and fractions.

Even though Maiola is a contemporary typeface, designer Verónika Burian has in-depth knowledge of its historical typographical heritage. The oblique axis, the modest contrast, the soft modulation, the diagonal bar on the *e*, among other things, show Maiola's historical links.

This typeface implies the idea of the imperfection of old printing technology. Although it does not attempt to copy old methods, it does contain certain details that refer to this idea. For example, the lines and the serifs vary slightly in thickness; the serifs are asymmetrical, in terms of their length and their diagonal cut, where angle subtly changes. A large part of the ideas expressed through Maiola were inspired by the way in which Czech typeface designers Vojtech Preissig (1873-1944) and Oldrich Menhart (1897-1960) solved design problems.

In the initial phases of its design process, Maiola was much more angular; however, this characteristic was softened in following stages in order not to distract the reader. In cases such as typeface for long text, it is not uncommon to give priority to legibility over aspects that are more closely related to design. Sometimes aesthetics have to be sacrificed for functionality. Verónika Burian manages to soften the typeface to the point of rendering it highly legible, without taking anything away from the design's strong personality.

The final result is an aggressive family, but with the necessary moderation not to excessively seek the reader's attention. It is a highly comprehensive and elegant font, the extreme and consistent quality of which is sustained throughout its many variants.

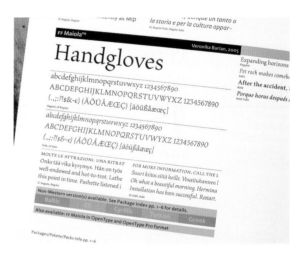

Variants: Maiola Bold, Maiola Bold Italic, Maiola Italic, Maiola LF Bold, Maiola LF Bold Italic, Maiola LF Italic, Maiola LF Regular, Maiola Regular, Maiola SC Bold, Maiola SC Bold Italic, Maiola SC Italic, Maiola SC Regular, Maiola TF Bold, Maiola TF Bold Italic, Maiola TG Italic, Maiola TF Regular
Designer: Verónika Burian
Year: 2003
Distributor: Fontshop International
Use: Long text
Other uses: Display
Advice or considerations: Designed for high-resolution printing

Aufmerksamkeit
Maiola Regular

Trzecia Sesja Ogólnego Zgromadzenia
Maiola Regular

Buchgewerbe
Maiola Bold

Inspirován prací českých typografů
Maiola Italic

DISCLOSURE
Maiola SmallCaps

книгопечатание
Maiola Cyrillic Italic

δημιουργός
Maiola Greek Bold

N16LE *LOUGHBOROUGH* JUNCTION
Maiola Regular/Italic SmallCaps

Dynamically
Maiola Bold Italic

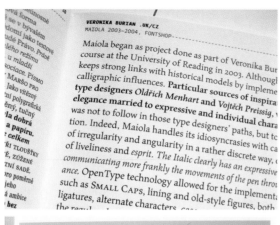

Samples

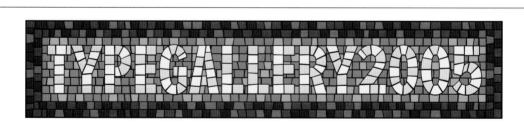

Applications

At the beginning of its creation, Maiola was much more angular. However, as the process advanced, it became softer, managing the traces and the serifs to vary slightly in thickness in order not to distract the reader.

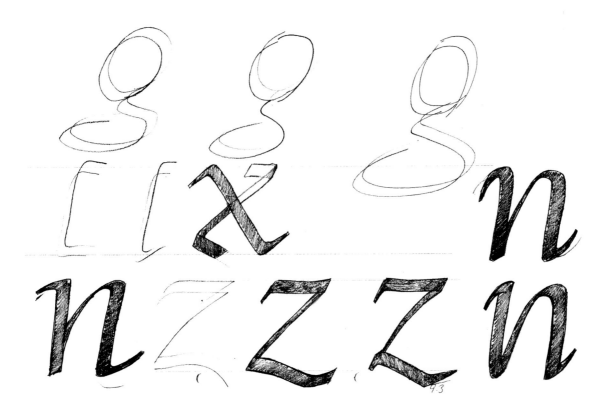

Sketches

Maiola 25

Often some designers base their typefaces on anonymous work that for some reason or another captures their attention—so much so that it offers them the beginnings of an idea for the creation of a new typeface.

Template Gothic, designed by Barry Deck in 1990 and distributed by Emigre Inc., is one of the best-known cases. Stephen Banham had a similar experience with a typeface designed for signage students, an anonymous face from the text "Learning to Letter," which became the inspiration behind the development of Berber.

Letterbox, developed since 1991, works with the dynamic components of research, teaching, publication, and exhibition, which explains why Berber has developed such a strong following since it was created in 2002.

Berber developed extensively and became a strong normal typeface, with exaggeratedly long, rectangular, and reasonably condensed ascenders and descenders. It has been designed for use in large-scale sign work and is outstandingly suited to applications such as signage and headlines. Its aesthetic characteristics are reminiscent of the typefaces that appear on car registration plates.

The family incorporates two full versions of different weights, Regular and King Caps, the uppercase of which is noticeably darker. King Caps includes lining numerals. Regular has non-lining numerals, but it features ligatures for some of its characters, giving the designer the ability to alter and customize particular words.

Berber is recommended for large-scale signage and will adapt perfectly to all kinds of display work, giving it a strong graphic identity.

BERBER

Family: Berber
Variants: Berber Regular, Berber King Caps
Designer: Stephen Banham
Year: 2003
Distributor: Emigre Inc.
Use: Display
Other uses: Not recommended
Advice or considerations: Designed for signage

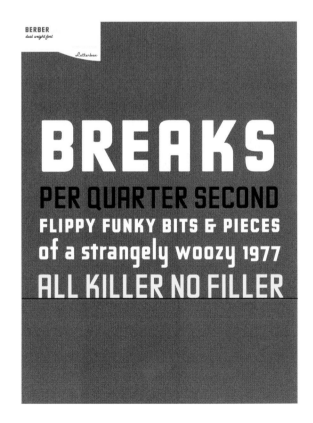

ABCDEFGHIJKLMNOPQRSTUVWXYZ

ABCDEFGHIJKLMNOPQRSTUVWXYZI234567890

abcdefghijklmnopqrstuvwxyzi234567890

KING
RULES
FOUNDRY

ARCHITEKTURAL
WHILST JOURNAL BANK
installations examples
ZINK TOUCHED ROOF CAPEL
dolphin communicating thanks
numeral brilkation schopfer
numeral publications messenger chunky kindred

Ourtype

Sansa, a sans serif family by Fred Smeijers, benefits from the relative liberties taken in recent sans serif design. Yet Sansa is full of character. The family comes in four weights: Light, Normal, Bold, and Black, with matching italics. The same weights are available in Sansa Condensed. For down-to-earth display type, there is Sansa Condensed Ultra Black with matching italics. Also part of the Sansa family are Sansa Soft, Sansa Soft Condensed, and Sansa Slab.

As a non-bookish typeface—there are no small caps or non-lining figures—Sansa is still very effective for a wide range of daily uses. It is suitable for uncomplicated jobs of all kinds. Its image is open and straightforward, blending a mix of smooth and friendly features, yet without any sacrifice in character. Although in many respects Sansa is a typeface of its time, care has been taken to make sure that this up-to-date characteristic is not overdone.

The lack of Old Style figures, as well as of small capitals, makes Sansa definitely a non-bookish typeface. It will serve very well in any text with a shorter life, for commercial, business, and corporate purposes. It is happy to be a non-literary typeface, the area from which the sans serif typefaces in fact originate.

Although Fred Smeijers is a first-generation digital type designer, his interests and practice are rooted in the years before the digital technologies became crucially important. Now he has twenty years of involvement behind him with letterforms in general, and with the design and use of type and its history. Smeijers is internationally known for his writing and lectures, but, above all, for his type designs. These encompass custom-made types as well as those that are commercially available.

For Fred Smeijers, flexibility is very important, as the versatility of his oeuvre testifies. The wish to operate in a more open and flexible way encouraged him and Rudy Geeraerts of FontShop Benelux to launch their own label: OurType.

Sansa is available in TrueType and PostScript formats, for both PC and Mac platforms, as well as in OpenType Standard and OpenType Pro.

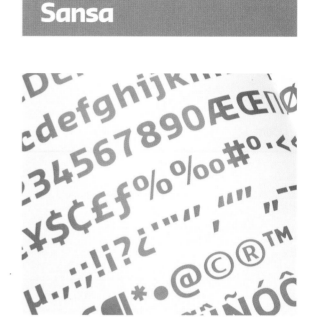

Family: Sansa
Weights: Sansa Light, Sansa Light Italic, Sansa Normal, Sansa Normal Italic, Sansa Semi-Bold, Sansa Semi-Bold Italic, Sansa Bold, Sansa Bold Italic, Sansa Black, Sansa Black Italic
Designer: Fred Smeijers
Year: 2002
Distributor: OurType
Use: For a wide range of daily uses

CHARACTER SET FOR SANSA ROMAN FONTS

ABCDEFGHIJKLMNOPQRSTUVWXYZ abcdefghijkmnopq
rstuvwxyz &1234567890 ÆŒ∏Øœⁿfiflßðøıªº$¢£¥ƒ€
%‰#°·<≤≥±>÷¬≈=≠+∞∑∆Ω√ʃ/µ.,:;!¡?¿'"'''‚""„–-—‹›«»()
[]{}/|\..._†‡§¶*•@©®™´^¨`~¯¸˚ ÁÂÄÀÅÃÇÉÊËÈÍÎÏÌÑÓ
ÔÖÒÕÚÛÜÙŸ áâäàåãçéêëèíîïìñóôöòõúûüùÿ

CHARACTER SET FOR SANSA ITALIC FONTS

*ABCDEFGHIJKLMNOPQRSTUVWXYZ abcdefghijkmnopq
rstuvwxyz &1234567890 ÆŒ∏Øœⁿfiflßðøıªº$¢£¥ƒ€
%‰#°· <≤≥±>÷¬≈=≠+∞∑∆Ω√ʃ/µ.,:;!¡?¿'"'''‚""„–-—‹›«»
()[]{}/|\..._†‡§ ¶*•@©®™´^¨`~¯¸˚ ÁÂÄÀÅÃÇÉÊËÈÍÎÏÌ
ÑÓÔÖÒÕÚÛÜÙŸ áâäàåãçéêëèíîïìñóôöòõúûüùÿ*

SANSA LIGHT, NORMAL, BOLD & BLACK

ABDEHKRVXZadefgnkoprstvxyz
ABDEHKRVXZadefgnkoprstvxyz
ABDEHKRVXZadefgnkoprstvx
ABDEHKRVXZadefgnkoprstv

SANSA LIGHT ITALIC, NORMAL ITALIC, BOLD ITALIC & BLACK ITALIC

ABDEHKRVXZadefgnkoprstvxyz
ABDEHKRVXZadefgnkoprstvxyz
ABDEHKRVXZadefgnkoprstvx
ABDEHKRVXZadefgnkoprstv

SANSA CONDENSED LIGHT, NORMAL, BOLD, BLACK & ULTRABLACK

ABDEHKRVXZadefgnkoprstvxyz
ABDEHKRVXZadefgnkoprstvxyz
ABDEHKRVXZadefgnkoprstvxyz
ABDEHKRVXZadefgnkoprstvxyz
ABDEHKRVXZadefgnkoprstvxyz

SANSA CONDENSED LIGHT ITALIC, NORMAL ITALIC, BOLD ITALIC, BLACK ITALIC & ULTRABLACK ITALIC

ABDEHKRVXZadefgnkoprstvxyz
ABDEHKRVXZadefgnkoprstvxyz
ABDEHKRVXZadefgnkoprstvxyz
ABDEHKRVXZadefgnkoprstvxyz
ABDEHKRVXZadefgnkoprstvxyz

SANSA OFFERS LINING FIGURES ONLY. ALL FIGURES, CURRENCY SIGNS & MATH SYMBOLS OF SANSA FONTS ARE TABULAR

1234567890£$€ 1234567890£$€
1234567890£$€ 1234567890£$€
1234567890£$€ 1234567890£$€
1234567890£$€ 1234567890£$€
1234567890£$€

1234567890£$€ 1234567890£$€
1234567890£$€ 1234567890£$€
1234567890£$€ 1234567890£$€
1234567890£$€ 1234567890£$€
1234567890£$€

www.midoristudio.net

This project began with a commission carried out by the design studio Obsolet Disseny. The commission was to create a family typeface of three fonts, to be used in the demo of the third album from the Barcelona-based group Ojos de Brujo. The album was entitled "Techarí," gypsy terminology for "free."

These three fonts had to comply with certain requisites: one had to be for text, another was designed for the band's logo, and the guidelines for the third font were yet to be determined. The key to starting the sketches was found in three words: ethnic, baroque, and graffiti. Listening to the band's previous work was a source of inspiration throughout the design process. The final product is the fruit of the close collaboration between the typeface designer, Pilar Cano, and the art director and graphic designer from Obsolet Disseny, Miguel Ángel Ramos. This collaboration paved the way for the final development of the Stencil version, widely used in the world of hip-hop, as well as for Techarí Extra, which complements the design with a sumptuous touch and gives an ethnic feel with its arabesque-like dingbats.

Techarí is a mix of many references, which all helped to form its innovative character. This idea of mixing is reaffirmed by the fact that Techarí is not roman or normal.

On a technical level, Techarí presented a challenge. On the one hand its aesthetic appearance was crucial; on the other, it had to be legible, since it would be used in the small text of a CD's lyrics booklet. Pilar Cano resolved this dilemma, retaining the design's strong personality while using different techniques to ensure legibility. Among other things, she made the x-height considerably larger, designed a typeface of open forms, and used ink-traps in the joins between the curves and straight lines of some letters.

Ornaments, a classic typeface tool that is still in use today, continue to be a traditional element used to "decorate" pages of long text as well as separate information. This is why ornaments are often found in typefaces designed for long text, used as independent fonts or as part of regular versions. Techarí Extra takes this element and gives it a contemporary shape. It also offers two series of dingbats: one based on Arabic motifs and another offering a series of floral elements that, through repetition, can be used as patterns.

techarí

ABCDEFGHIJKLMNOPQR
STUVWXYZ abcdefghijklmn
ñopqrstuvwxyz № 0123456789

ÁÀÂÃÄÅÆ ÉÈÊËÍÌÎÏÓÒÔÖÕØÙÛÛÜÇÐŁŁ
ŠÝŸŽÞ áàâãäæéèêëíìîïóòôöõøœúùûü
çð l·ł š ý ÿ ž ß þ + - ± × ÷ = ° ◊ ℯ @ § ¶ † ‡ * _ ¡ ! ¿ ? -
% ‰ – — • ‹ ›({[« »]})/ | \ . , ; : „ ' " ' ' " " … fi fl º ª | :
€ £ $ ¢ ? ¤ ℮ © ™ ®

◊ odb-text ◊

Family: Techarí
Variants: Regular, Stencil and Extra
Designer: Pilar Cano
Year: 2005
Distributor: Midoristudio
Use: Display
Other uses: It can be used in short texts and with small bodies
Advice or considerations: Do not use bodies smaller than 9 point

techarí

abcdefghijklmnñopqrstuvwxyz
ABCDEFGHIJKLMNÑOPQRSTUVWXYZ

áäãâåæéëêèíìîıóòôõøœúüûßçŧł·šýÿžþðÁÄÃÂÅÆÉËÊÈÍÌÎÓÒÔÕØŒ
ÚÜÛÇŁŁ·ŠÝŽÞÐ.,:;„''"" •-*‹›«»¡!¿?°+-±÷×=∕%‰(){}/|¦_-—@…ªº&
№1234567890¤€£¥$¢fifl†‡§¶©®™e ❖

stencil

abcdefghijklmnñopqrstuvwxyz
ABCDEFGHIJKLMNÑOPQRSTUVWXYZ

áäãâåæéëêèíìîıóòôõøœúüûßçŧł·šýÿžþðÁÄÃÂÅÆÉËÊÈÍÌÎÓÒÔÕØŒ
ÚÜÛÇŁŁ·ŠÝŽÞÐ.,:;„''"" •-*‹›«»¡!¿?°+-±÷×=∕%‰(){}/|¦_-—@…ªº&
№1234567890¤€£¥$¢fifl†‡§¶©®™e ❖

extra

01	sultanas de merkaillo	3:30
02	color	3:51
03	todo tiende	4:26
04	runalí	4:20
05	el confort no reconforta	3:44
06	tanguillos marineros	3:17
07	silencio	4:11
08	no somos máquinas	3:33
09	bailaores	3:04
10	corre lola corre	3:59
11	feedback	3:03
12	piedras vs. tanques	3:17
13	respira	3:15
14	nana	3:57

Sketches

BAILAORES
("Porque tú lo vales")

Héctor Rivera - Adaptación ODB (Marina Abad, Ramón Giménez).

INTÉRPRETES:
Ramón Giménez ∿ Guitarra flamenca, palmas.
Paco Lomeña ∿ Guitarra flamenca.
Marina "la Canillas" ∿ Voz y coros.
Sergio Ramos ∿ Batería.
Xavi Turull ∿ Congas, cajón, palmas.
Maxwell Wright ∿ Bongó, cajón cubano, shaker.
Javi Martín ∿ Bajo.
Panko ∿ Scratches.
El Huevo ∿ Trompeta, fiscorno.
Toni Moñiz ∿ Baile.

CORRE LOLA CORRE
Marina Abad, Ramón Giménez, Francisco Gabas, Juan Luis Leprevost, Eldys Vega, Xavi Turull.

INTÉRPRETES:
Ramón Giménez ∿ Guitarra flamenca, palmas.
Paco Lomeña ∿ Guitarra flamenca.
Marina "la Canillas" ∿ Voz.
Sergio Ramos ∿ Batería.
Xavi Turull ∿ Cajón, congas.
Maxwell Wright ∿ Palmas.
Javi Martín ∿ Bajo.
Panko ∿ Guitarra eléctrica, scratches, teclaos.

FEEDBACK
Nitin Sawhney, Marina Abad, Ramón Giménez, Maxwell Wright, Francisco Lomeña, Xavi Turull, Sergio Ramos, Francisco Gabas, Javi Martín.

INTÉRPRETES:
Ramón Giménez ∿ Guitarra flamenca y palmas.
Paco Lomeña ∿ Guitarra flamenca.
Marina "la Canillas" ∿ Voz y mantras.
Sergio Ramos ∿ Cajón y palmas.
Xavi Turull ∿ Cajón, tar, percusiones.
Javi Martín ∿ Bajo.
Panko ∿ Scratch.
Maxwell Wright ∿ B. box, voz y talking drum.
Nitin Sawhney ∿ Teclados, programación y guitarra.
Satyajit Talwalkar ∿ Tabla y voz.
Rajinder Singh ∿ Violin.

PIEDRAS vs. TANQUES
Ramón Giménez, Marina Abad, Xavi Turull, Francisco Gabas, Sergio Ramos, Paco Lomeña, Maxwell Wright y Javi Martín.

INTÉRPRETES:
Ramón Giménez ∿ Guitarra flamenca, palmas.
Paco Lomeña ∿ Guitarra flamenca.
Marina "la Canillas" ∿ Voz y coros.
Sergio Ramos ∿ Batería.
Xavi Turull ∿ Congas, bongó, cajón, palmas.
Javi Martín ∿ Bajo.
Panko ∿ Scratches, teclaos.
Loli ∿ Jaleos.
Maxwell Wright ∿ Shekeré, berimbau, shakers,

RESPIRA
Ramón Giménez, Marina Abad, Xavi Turull, Francisco Gabas, Sergio Ramos, Paco Lomeña, Maxwell Wright y Javi Martín.

INTÉRPRETES:
Ramón Giménez ∿ Guitarra flamenca y palmas.
Paco Lomeña ∿ Guitarra flamenca.
Marina "la Canillas" ∿ Voz y coros.
Xavi Turull ∿ Cajón y palmas.
Maxwell Wright ∿ B. box.
Francisco Gabas ∿ Scratch y teclados.
Javi Martín ∿ Bajo.

NANA
Pepe Habichuela, Marina Abad, Javi Martín, Ramón Giménez.

INTÉRPRETES:
Pepe Habichuela ∿ Guitarra flamenca.
Marina "la Canillas" ∿ Voz, crótalos y cuenco tibetano.
Xavi Turull ∿ Tabla, udu.
Maxwell Wright ∿ Loop.
Javi Martín ∿ Bajo 12 cuerdas.

ILUSTRADOR★S
Nina Bays | Los Ángeles
www.tightsweaterpress.com/nina
David Foldvari | Brighton
www.davidfoldvari.co.uk
Montse Beltrán | Barcelona
www.ramonasplace.blogspot.com
Natalie Shau | Vilnius
www.photo.net/photos/NatalieShau
Dran | Toulouse
www.dranshow.com
Santos de Veracruz | Barcelona
gitanito@santosdeveracruz.com
Matthew Curry | Washington
www.ninjacruise.com
El Niño de las Pinturas | Granada
www.elninodelaspinturas.com
Riki Blanco | Barcelona
rikiblanco@hotmail.com
August Tharrats (Thá) | Barcelona
augusttharrats@hotmail.com
Miguel Ángel Ramos | Barcelona
www.obsolet.com.es
7 Potencias | Planeta Tierra (de momento...)
www.tiunaelfuerte.org/7potencias
Gislene Mayumi Matsui | Tokyo
www.geocities.jp/laichro
Ilaria Consolo | Milán
www.ilariaconsolo.com

Applications

Techarí was created for the demo of the third album of the Barcelona band Ojos de Brujo. It provides a rich touch and adds an ethnical and baroque style with its dingbats based on arabesque. Techarí was also designed to be used in short x-heights to write the songs lyrics; this is why it had parallel missions—to be legible and to maintain its strong personality.

Applications

Ribei

INTERLOCK

IT IS A STRANGE

GURI

The smell of fresh baked bread and roaste

QUE QUE

Pa amb

2	3	4	5	6	7	8	9	10	11	12	

ILLIMETER

0.001MM	0.0028PT
0.02MM	0.05PT
0.04MM	0.1PT
0.06MM	0.15PT
0.08MM	0.2PT
0.1MM	0.25PT
0.12MM	0.3PT
0.14MM	0.35PT
0.16MM	0.4PT
0.18MM	0.45PT

240 239 238 237 236
235 234 233 232 231
230 229 228 227 226
225 224 223 222 221
220 219 218 217 216
215 214 213 212 211
210 209 208 207 206
205 204 203 202 201
200 199 198 197 196
195 194 193 192 191
190 189 188 187 186
185 186

O *free*

SQUE

e was in the air

EIS

nquet i fuet

Fun

Here we have a package containing a series of five independent fonts that House Industries developed as a tribute to the legendary designer Ed Benguiat, creator of endless typefaces both for Photo-Lettering Inc and International Typeface Corporation (ITC). Ed Benguiat is probably one of the most prolific typeface designers in the world to date.

House Industries decided to bring together a varied collection of fonts that showed the great diversity of styles that this typeface designer was capable of. Fascinated by this subject, Ken Barber, letterer as well as typeface designer and member of the House Industries team, generated a set of digital fonts and added a few new elements, such as the ligatures and the diacritical marks, which were not included in the original designs.

The five fonts that this collection is composed of are presented in OpenType format and include characteristics that give some of them the very convincing appearance of handwriting. This is especially noticeable in the ligatures of Ed Script, which gives the font a natural and flowing appearance. Ed Interlock contains a series of 1,000 combinations of different letters based on contextual, alternative characters. This means that certain characters can only be made to appear when a certain combination of letters is typed. Ed Gothic, in itself, carries two versions of different styles. The collection package also includes a set of more than 50 illustrative icons, known as Bengbats, and even features an exclusive interview with Ed Benguiat.

This collection is a fun and friendly one with an overt sense of humor, which is typical of the staff at House Industries. It successfully offers the designer a wide range of possibilities without losing its touch of playfulness.

BENGUIAT

THE ED BENGUIAT FONT COLLECTION

Family: Ed Benguiat Collection
Variants: Ed Interlock, Ed Gothic, Ed Brush, Ed Script, Ed Roman
Designer: House Industries
Year: 2004
Distributor: House Industries
Use: Display
Other uses: Not recommended
Advice or considerations:

Script
Gothic
Roman
Brush
INTERLOCK

ANIMATION
ANIMATION
ANIMATION

BOUNCE

ar → ar

ar cr dr er hr ir kr
or tr ur ax ex ix ux
arr err irr rr urr ss

Details

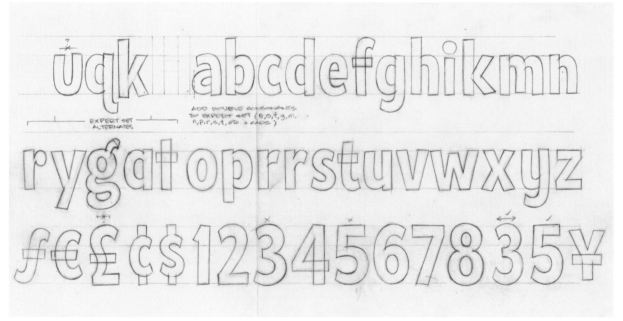

Sketches

House Industries compiled some of the fonts of Ed Benguiat and created a collection of digital fonts to which some elements, unconsidered in the original typography, were added; these included ligatures and diacritical marks. The result was obtained from a careful and delicate study on paper.

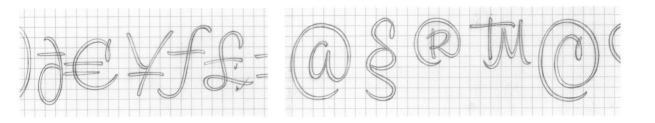

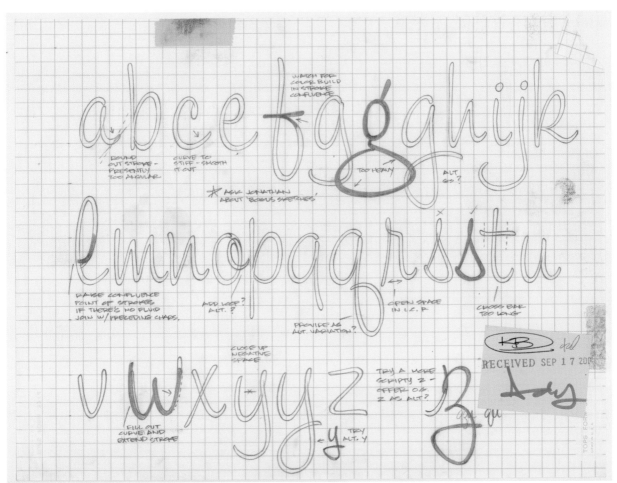

Sketches

Curtida is an amusing typeface, taking its inspiration from a handmade sign in a leather goods shop, situated in the Raval neighborhood of Barcelona. The freshness and movement of the original typeface, hand-drawn using traditional techniques by a sign painter, captivated this young designer. On this sign, the direction and nature of the brush strokes could be appreciated as well as the fact that the sign displayed a singular personality, since all the letters had small differences, an inherent trait in any work developed by hand.

When drawing and designing the typeface, the designer had to take into account these different aspects in order to successfully pull off the spirit of the original hand-painted version. This can be seen as another example of the influence that handmade works continue to have on contemporary digital typeface. The typical traits of the wide brush strokes used for centuries for signage are not only clearly visible in Curtida, they have become the typeface's most important characteristic, providing it with its distinguished personality.

Curtida presents the challenge of being able to find a balanced mix between signage and typography, two very different disciplines. Iván Castro, both an excellent calligraphist and typeface designer, fuses them with great skill, annexing Curtida to the signage tradition. This typeface family consists of alternative characters that help it appear slightly random. It also includes Curtida Ombra, a shadowed variant, which, when superimposed on Curtida Regular, produces a three-dimensional effect, as well as Curtida Puntets, a series of decorative elements that can be superimposed to reinforce the decorative effect. New ornaments continue to emerge from time to time, keeping this typeface as alive as the original sign it was based on.

Curtida is obviously a typeface with a limited use, but when applied to the right project it can give the best of results. The graphic project that is presented here is the image and promotion that was used for the ligatures season, a series of conferences and workshops that the group Catalana de Tipos, to which Iván Castro belongs, runs every spring-summer in Barcelona. In 2004, the main theme throughout the workshops was local character, beautifully presented by Curtida.

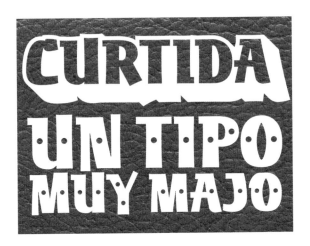

Family: Curtida
Variants: Curtida Regular, Curtida Ombra, Curtida Puntets
Designer: Iván Castro
Year: 2004
Distributor: www.catalanadetipos.com
Use: Display
Other uses: Not recommended
Advice or considerations: Decorative effects can be achieved by superimposing the layers.

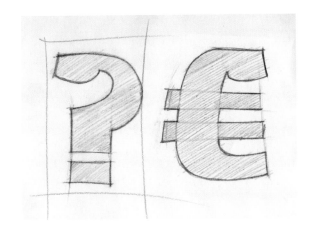

BOLSOS
CINTOS
CARTERAS
PARA LOS MARIDOS
QUE QUEREIS
HOY NENAS
CUEROS

Bello is a typeface that, finding itself halfway between brush stroke and pencil stroke, was designed for use on large bodies. The main idea that Underware explores through this typeface family consists in the creation of a Script typeface with as much diversity, movement, and freshness as possible while conveying the freedom and spontaneity of handwritten lettering. Bello has two main styles in its family, which are quite different from each other. Bello Script, of arbitrary quality, has a style that re-creates a feel very close to the fluidity of handwriting, while Bello Small Caps, which is more rigid than the latter, is much closer to traditional typography, giving the family an interesting contrast between the movement of one style and the stillness of the other.

One of the more notable characteristics lies in the use that Underware makes of the possibilities offered by the Open-Type format to re-create the naturalness of handwriting. Bello is a typeface family that is rich in variety. Its wide range of ligatures, sixty-four in total, include some typographical and some originating from brush work, as well as alternative characters, that can differ, depending on whether they are placed at the beginning of the word or at the end. All this gives this family great fluidity and versatility, affording the designer countless possibilities to work with a wide range of elements.

Other relative elements to this typeface, especially noticeable in the Bello Script design, are its letter spacing and kerning, carefully carried out to give Bello the appropriate rhythm and to give it a legated effect; almost all the possible combinations of letters are touching each other, bringing this typeface even closer to handwriting.

Aesthetically, Bello is a friendly and fun typeface, with a relaxed modulation and without a lot of contrast between the thin and thick strokes. Some of the shapes suggest an enormous complexity regarding their structure. Although Underware makes everything seem simple at first glance, Bello is actually extremely complicated technically.

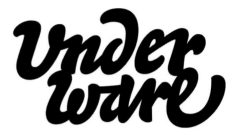

Family: Bello
Variants: Bello and Bello Pro contain Bello Script, Bello Small Caps, Bello Ligatures, Bello Words Body, Bello Words Solo
Designer: Underware
Year: 2004
Distributor: Underware
Use: Display
Other uses: Not recommended
Advice or considerations: Bello is perfect to accompany the Sauna typeface.

It was a warm day in spring, when I arrived at the main bus station of Bello. After I walked a bit through the city, I recognised what a beautiful village it was. The smell of fresh baked bread and roasted coffee was in the air. I felt welcomed by the village from the beginning. They told me about the criminality of Bello, but to me it seemed to be an inseparable part of this village. Like a temperamental person who can hate, but love too. MARTIN LORENZ, GERMANY

NORMAL BELLO SCRIPT

It was a warm day in spring, when I arrived at the main bus station of Bello. After I walked a bit through the city, I recognised what a beautiful village it was. The smell of fresh baked bread and roasted coffee was in the air. I felt welcomed by the village from the beginning. They told me about the criminality of Bello, but to me it seemed to be an inseparable part of this village. Like a temperamental person who can hate, but love too. MARTIN LORENZ, GERMANY

BELLO PRO WITH AUTOMATIC OPENTYPE LIGATURES

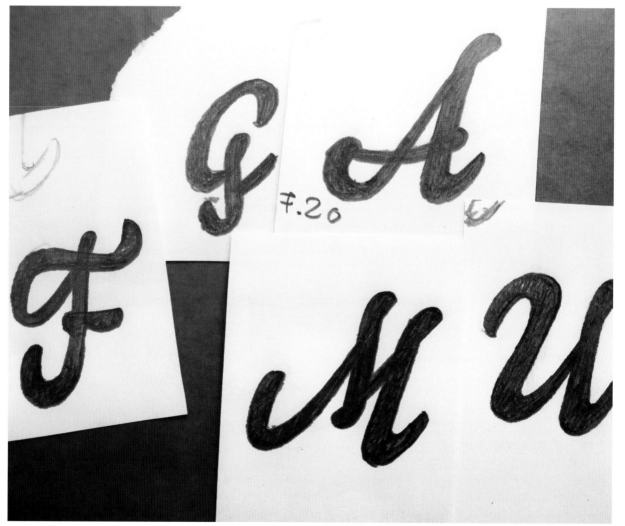

Sketches

This is a typeface meant to be used in large x-heights, and it is the result of an extremely complicated technical process. This script typography of great versatility makes the text flow at a good pace and makes it ideal for marking.

Applications

Rumba is a small typeface family, which is composed of three fonts: Rumba Small, for use in texts, Rumba Large, for use in headings, and Rumba Extra, for use in words that require a singular lettering touch. It was initially created and developed as a graduation project in the postgrad Type and Media course at the Royal Academy of Art, of The Hague (KABK). The design of this lettering typeface clearly presents a marked influence from the characteristics of the pen and the brush; its terminals and even its general structure come from observing the behavior of these tools.

One of the many strong points of this family is the consistency that it diligently maintains throughout its character set. The solution found by Laura Meseguer is noteworthy, especially in the design of some of the punctuation marks, usually an area where many designers tend to abandon personal touches in favor of more standardized forms. In fact, this attraction towards the punctuation marks and the diacritical marks led the designer to actually expand the character set for each of the fonts, in this way allowing their usage in all other European languages.

This consistency can also be seen in the different variants, which, although based on the same model, differ between themselves in contrast, in construction, and in their degree of expression. For example, Rumba Small has less contrast than its sibling fonts, to be expected from a typeface designed for text. Rumba Large gains in contrast and refines the design in some of the letter's details, such as its terminals. Finally, Rumba Extra presents a generous contrast, has an italic construction, though without the classical inclination, and shows a cruder modulation. Its structure also shows greater fluency, and its terminals are more defined.

Rumba is a fun and individual typeface, which honors its name through its attributes of movement and great fluidity. For those who believe in the existence of a Latin style in the world of graphic design, Rumba is a clear example of a typeface that would happily fit into this category.

Rumba

Una nueva familia de tipos
para texto y titulares
PARA USARLA A CUALQUIER TAMAÑO
La familia se compone de:
Rumba Small, Rumba Large y Rumba Extra

✳ ✳ ✳ ✳ ✳ ✳ ✳ ✳ ✳ ✳ ✳ ✳ ✳ ✳ ✳ ✳ ✳

Designer: Laura Meseguer
Year: 2004–2006
Distributor: Laurameseguer
Use: Text and display
Other uses: Not recommended
Advice or considerations: Do not use Rumba Small in bodies smaller than 14 point; use Rumba Large in headings of one or two lines, and Rumba Extra for loose words. Explore the ligatures and the alternative characters.

Made in Holland!

ABCDEFGHIJKLMNOPQRSTUVWXYZ

abcdefghijklmnopqrstuvwxyz

0123456789€1234567890€

ÁÀÄÂÃÅĂĀĄÇČĆĈĐĎÉÈÊËĚĘĖĒĞĜĜĤ

ÎÏÍÌĮİĪĴĶŁĹĻĽĿÑŇŅŃÓÒÔÖÕŐŌØŘŖ

ŔŠŞŚŜŤŢŲÚÙÛÜŬŰŪŮŸÝŽŹŻÆŒ

áàäâãåăāąçčćĉðďđéèêëěęėēğĝġĥ

ıïíìįîījĵłĺļñňņńóòôöõőōøřŗŕšşśŝşß

ťţųúùûüůŭűūÿýžźżæœ¡!¿?&....,·:;"'""'

''"[]{}()/\« » ‹ › + = - – — _*** ® © ¶ @ º ª ⁰ ¥ $ ƒ £ ¢

† ‡ # < > ≤ ≥ ± ≠ ÷ = + × ∞ ~ ≈ % ‰ § | ¦ / ½ ¼ ⅓ ¹²³⁰ªᵀᴹ

fi fi fì fî ff ffi fb ffb fj ffj fk ffk fh ffh tx l· k r

ÁÀÉÈÎÌÓÒÚÙÝ ℓₘ

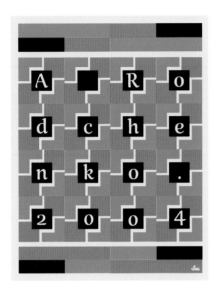

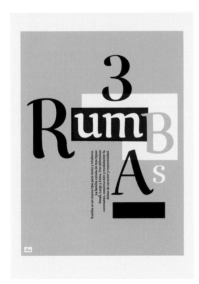

Postgraduate
Course 03/04
Royal Academy of Art,
The Hague

Susana Carvalho
Alessandro Colizzi
Vera Evstafieva
Maarten Idema
Krassen Krestev
Laura Meseguer
Diego Mier-y-Teran
Trine Rask Olsen
Circe Penningdevries
Bas van Vuurde

The internationally acclaimed Type and Media
masters course at the Royal Academy is a one
year program in advanced type design and
typography.

Faculty:
Erik van Blokland, Peter Verheul,
Anno Fekkes (head of the Visual Communication department),
Jan Willem Stas (course supervisor)

Guest teachers:
Françoise Berserik, Peter Bil'ak, Frank Blokland,
Petr van Blokland, Paul van der Laan,
Frans van Mourik, Just van Rossum,
Fred Smeijers

Guests:
Wigger Bierma, Jelle Bosma, Evert Bloemsma,
Robin Kinross, NLXL (Bob van Dijk,
Joost Roozekrans), Underware (Akiem Helmling,
Bas Jacobs), Huda Smitshuijzen AbiFarès,
František Štorm, Gerard Unger, Rick Vermeulen

Type and Media

www.kabk.nl

Applications

Ribeiro

84 Kg. de Rovellons a la planxa

Gernikako piperrak

XXVI Degustación del Vino de

Jerez

Unha tortilla de patacas e pementos de Padrón

Txipiroiak tintan!

Una copita de Rioja

Cafè amb llet

Sample

On many occasions the inappropriate use of a particular tool may cause small accidents, which contribute to the creation of a typeface. In this case, Malou Verlomme started the design process using a broad nib pen for some calligraphic sketches. Due to his inexperience with this tool, the designer created certain unexpected effects in the shapes of the letters, which would later become part of this typeface's personality.

After this first stage, Oops went from being roman to being a normal typeface; its weight was increased and it was condensed, which gave a considerably dark texture in the composition of a text. Another characteristic, which would later give Oops its personality, is its deliberately closed spacing, which helps to create an even darker texture.

In the second stage of the design process, Oops complied with a strict typeface regime. The calligraphic experiment took the shape of a typeface and began to define the typeface's personality. In the words of its designer, "Oops was created almost without me realizing."

Since it was a typeface for display and had to be used large, Oops sharpened the angles, making them one of the most important features of the design. This, combined with the rounded shapes, creates an apparent contradiction that, surprisingly, also works in small characters without removing too much from their legibility.

The result is a family with certain calligraphic features; it is supported by a strong, dynamic, and flexible typeface structure. Although the family has been designed for large type, it can also be used for relatively small type. Malou Verlomme offers us a wide-ranging typeface family, fun and versatile, that has six variants. Generally in typefaces like this, both upper- and lowercase letters are mixed, avoiding the ascenders and descenders; in this way, it is possible to set a zero or negative leading, without the stems from the different glyphs overlapping.

Despite being a very recent typeface, Oops has already been used in various graphic projects. One of those projects is the collection of contemporary German literature *Petite Bibliothèque Allemande*, designed by Stéphane Darricau for Otrante Editions. Oops also serves as a tool to promote Shangaï Paris, an annual event that is a meeting point for Chinese and French musicians and artists.

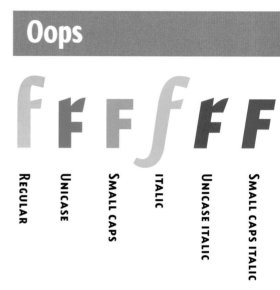

Oops

REGULAR · UNICASE · SMALL CAPS · ITALIC · UNICASE ITALIC · SMALL CAPS ITALIC

Family: Oops
Variants: Oops Regular, Oops Italic, Oops Small Caps, Oops Small Caps Italic, Oops Unicase, Oops Unicase Italic
Designer: Malou Verlomme
Year: 2006
Distributor: Malouverlomme
Use: Display, headings, small extracts of text
Other uses: Posters, logos, etc.
Advice or considerations: Do not use for long texts.

IT IS a strange Fact

Oops Regular

Oops Regular
It is a strange fact for which I do not expect ever satisfactorily to account, and which will receive little credence even among those who know that I am not given to romancing—it is a strange fact, I say, that the substance of the following pages has evolved itself during a period of six months, more or less, between the hours of midnight and four o'clock in the morning, proceeding directly from a type-writing machine standing in the corner of my

OOPS UNICASE
IT IS A STRAnGE FACT FOR WHICH I DO nOT EXPECT EVER SATISFACTORILY TO account, and WHICH WILL RECEIVE LITTLE CREDENCE EVEN AMOnG THOSE WHO KnOW THAT I AM nOT GIVEn TO ROMAnCInG—IT IS A STRAnGE FACT, I SAY, THAT THE SUBSTAnCE OF THE FOLLOWInG PAGES HAS EVOLVED ITSELF DURInG A PERIOD OF SIX MOnTHS, MORE OR LESS, BETWEEn THE HOURS OF MIDnIGHT AnD FOUR O'CLOCK In THE MORnInG, PROCEEDInG DIRECTLY FROM A TYPE-WRITInG MACHINE STAnD- InG In THE CORnER OF MY

OOPS
SMALL CAPS
IT IS A STRANGE FACT FOR WHICH I DO NOT EXPECT EVER SATISFACTORILY TO ACCOUNT, AND WHICH WILL RECEIVE LITTLE CREDENCE EVEN AMONG THOSE WHO KNOW THAT I AM NOT GIVEN TO ROMANCING—IT IS A STRANGE FACT, I SAY, THAT THE SUBSTANCE OF THE FOLLOWING PAGES HAS EVOLVED ITSELF DURING A PERIOD OF SIX MONTHS, MORE OR LESS, BETWEEN THE HOURS OF MIDNIGHT AND FOUR O'CLOCK IN THE MORN- ING, PROCEEDING DIRECT- LY FROM A TYPE-WRIT- ING MACHINE STANDING

Oops Italic
It is a strange fact for which I do not expect ever satisfactorily to account, and which will receive little credence even among those who know that I am not given to romancing—it is a strange fact, I say, that the substance of the following pages has evolved itself during a period of six months, more or less, between the hours of midnight and four o'clock in the morning, proceeding directly from a type-writing machine standing in the corner

OOPS UNICASE ITALIC
IT IS A STRAnGE FACT FOR WHICH I DO nOT EXPECT EVER SATISFACTORILY TO account, and WHICH WILL RECEIVE LITTLE CREDENCE EVEN AMOnG THOSE WHO KnOW THAT I am nOT GIVEn TO romancing—IT IS a STRAnGE FACT, I SAY, THAT THE SUBSTAnCE OF THE FOLLOWInG PAGES HAS evolved ITSELF DURInG a PERIOD OF SIX MOnTHS, more or LESS, BETWEEn THE HOURS OF MIDnIGHT anD FOUR O'CLOCK In THE mornInG, PROCEED- InG DIRECTLY FROM a TYPE-WRITInG MACHINE STAnDInG In THE CORnER

OOPS
SMALL CAPS ITALIC
IT IS A STRANGE FACT FOR WHICH I DO NOT EXPECT EVER SATISFACTORILY TO ACCOUNT, AND WHICH WILL RECEIVE LITTLE CREDENCE EVEN AMONG THOSE WHO KNOW THAT I AM NOT GIVEN TO ROMANCING—IT IS A STRANGE FACT, I SAY, THAT THE SUBSTANCE OF THE FOLLOWING PAGES HAS EVOLVED ITSELF DURING A PERIOD OF SIX MONTHS, MORE OR LESS, BETWEEN THE HOURS OF MIDNIGHT AND FOUR O'CLOCK IN THE MORN- ING, PROCEEDING DIRECT- LY FROM A TYPE-WRIT- ING MACHINE STANDING

adhesion

adhesion

adhesion

adhesion

adhesion

adhesion

Evolution

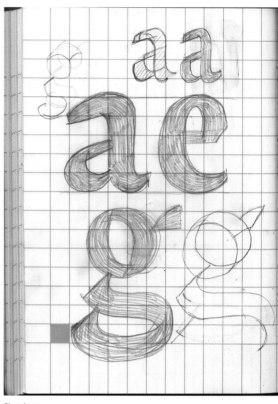

Sketches

adhesion

he ai his oae is oide a hooh ondin in he inies and ehods eae desin he oae inooaes he sd hisoia and heoeia isses ih a onsideae aia eeen in adaes an ndesandin he onsains he onsains and oenia en ehnoo and eiin he ih he sis desin and ode hei on eaes shod aea alied o eaield oahes and ahi desines o hose o eaed leds ho an deonsae a een sensi he deais eae desinhe ai his oae is oide a hooh ondin in he inies and ehods eae desin he oae inooaes he oae inooaes he en ehnoo and eiin he ih he sis desin and ode hei on eaes shod aea alied

he ai his oae is oide a hooh ondin in he inies and ehods eae desin he oae inooaes he sd hisoia and heoeia isses ih a onsideae aia eeen in adaes an ndesandin he onsains and oenia en ehnoo and eiin he ih he sis desin and ode hei on eaes shod aea alied o eeiened oahes and ahi desines o hose o eaed ieds ho an deonsae

he ai his oae is oide a hooh ondin in he inies and ehods eae desin he oae inooaes he sd hisoia and heoeia isses ih a onsideae aia eeen in adaes an ndesandin he onsains and

adhesion

he ai his oae is oide a hooh ondin in he inies and ehods eae desin he oae inooaes he sd hisoia and heoeia isses ih a onsideae aia eeen in adaes an ndesandin he onsains and oenia en ehnoo and eiin he ih he sis desin and ode hei on eaes shod aea alied o eeiened oahes and ahi desines o hose o eaed ieds ho an deonsae a een sensi he deais eae desinhe ai his oae is oide a hooh ondin in he inies and ehods eae desin he oae inooaes he en ehnoo and eiin he ih

he ai his oae is oide a hooh ondin in he inies and ehods eae desin he oae inooaes he sd hisoia and heoeia isses ih a onsideae aia eeen in adaes an ndesandin he onsains and oenia en ehnoo and eiin he ih he sis desin and ode hei on eaes shod aea alied o eeiened oahes and ahi desines o hose

he ai his oae is oide a hooh ondin in he inies and ehods eae desin he oae inooaes he sd hisoia and heoeia isses ih a onsideae aia eeen in adaes an ndesandin he onsains

Earlier versions

Oops was used in posters for the promotion of Shangaï Paris, an annual event that brings together different Chinese and French contemporary artists and musicians.

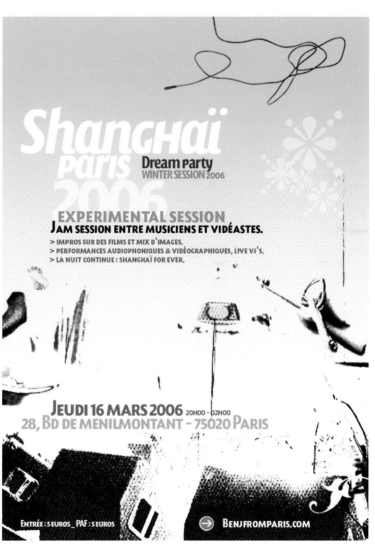

Letterbox

Although it may seem relatively simple in its linear structure, Morice is actually the result of a more complex design process. The fruit of collaboration between HeadFirst and Letterbox, it was originally designed by Morice Kastoun and produced by Letterbox Studio. The final product is a typeface that exudes a quiet elegance.

There are four variations within the Morice family. Take your pick between rounded terminals or straight terminals, each of which comes in two weights, Bold and Light.

Morice was listed as one of the notable font releases in 2005 in the international type community surveys, and HeadFirst was actually commissioned to produce a series of cushions, or typo-toys, each emblazoned with a different Morice font letter so as to spell the word *character*. It was to be used at the Character Conference organized by the RMIT University in Melbourne.

Letterbox is a Melbourne-based typography studio that opened in 1991 under the diligent hand of typeface addict Stephen Banham. An ever-evolving creative nest, Letterbox undertakes typographic assignments for commercial clients in print as well as for TV and the Web. But it also initiates its own projects of a more personal and socially conscious nature. With a wide range of parallel projects covering practice, research, and education (both Morice Kastoun and Stephen Banham are lecturers in communication studies at RMIT), Letterbox also offers lectures, forums, exhibitions, and it independently publishes its own books and studies on typographical topics.

The Letterbox Web site supplies illustrative information about the company's varied commercial projects; a *research* section shows usage examples of their typefaces accompanied by informative texts. There is also a frequently updated agenda of news and events organized by the studio and the popular Letterbox store, where one can purchase the now-infamous "Death to Helvetica" T-shirts as well as stickers, books, and fonts.

MORICE

Family: Morice
Weights: Morice Rounded Bold, Morice Rounded Light, Morice Square Bold, Morice Square Light
Designer: Morice Kastoun and Stephen Banham
Year: 2005
Distributor: Letterbox
Use: Titles

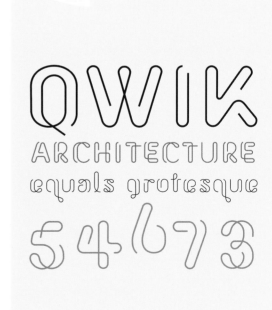

MORICE
six weight font

ABCDEFGHIJKLMNOPQRSTUVWXXYZ

abcdefghijklmnopqrstuvwxxyz

Rounded & Straight

QWIK

Zooming

ARCHITECTURE

Requiem

54673

Judgement Day 28

Miles & Song

CURLESQUE

Lettering artist Michael Clark brought this long-awaited design to the International House of Fonts in 2005. Sweepy, which is based on his popular typeface Pooper Black, presents what could be described as a lighter version with connecting letters. This brush script presents a lush design that is casual and fluid.

Michael Clark is a calligraphic lettering artist who resides in Richmond, Virginia. Among other things, his work encompasses creating logo designs, titles for CDs, books, magazines, and other printed material, as well as developing commercial fonts for corporations and independent foundries.

The P22 type foundry started in 1994, offering digital fonts inspired by both history and artist. After winning over the public, thanks to the success of the company's packaged font sets sold in museum gift shops and specialty stores, P22 expanded into mail-order catalogues and direct marketing as well as fonts. But it always remained focused on art history and on design.

To diversify its catalogue, P22 branched out and created the International House of Fonts, a Web page dedicated to showcasing international designers. It was devised as an online-only type boutique, later adding further divisions such as Sherwood Type and Rimmer Type Foundry. Although it appears to be a sprawling company, the P22 collective is actually a small group of individuals dedicated to designing artistic and creative fonts, packaging, and books.

There is an expanded Open Type version of Sweepy that comes loaded with alternate characters and ligatures, offering a vast array of options and flexibility for the designer. Sweepy is an elegant script face that is great for product, titling, tags, small amounts of copy, and identity.

Sweepy

Family: P22 Sweepy
Weights: Sweepy, Sweepy OT
Designer: Michael Clark, 2005. First released by International House of Fonts (a division of P22 type foundry)
Year: 2005
Distributor: P22 Type Foundry
Uses: Display, small bodies of text

The word, and each of its constituent parts, is, after all both container and content.

The word, and each of its constituent parts, is, after all both container and content

Sweepy Sweepy Sweepy

quire

sassafrass

The smitten quarreling

There was no possibility of taking a walk that day. We had been wandering, indeed, in the leafless shrubbery an hour in the morning; but since dinner (Mrs. Reed, when there was no company, dined early) the cold winter wind had brought with it clouds so sombre, and a rain so penetrating, that further out-door exercise was now out of the question.

won · too · free

the fifth estate

ABCDEFGHIJKLMNOPQRSTUVWXYZabcdefghijklmnopqrstuvwyz
!"*§%₵()*+,-.0123456789:;<>?@(\)_`(\)'¿£ſ°«©®®°¬⁰±µ¶·¼
½¾¿ÀÂÃÄÅÆÇÈÉÊÌÍÎÏÐÑÒÓÔÕÖ×ØÙÚÛÜÝÞßàáâãäåæ
çèéêëìíîïðñòóôõö÷øùúûüýþ÷ìłŒœŠŸŽƒˆˇˉˊˋ˘˙˚˛'',."„†‡·…‰ˆˇ
0123456789 0123456789 ˇ0123456789 0123456789€™⅓⅔⅛⅜⅝⅞∂–—≠
ﬀﬁﬂﬃﬄﬅﬆhﬁﬃﬀﬂﬄﬅﬆllqurrshthtitltacddeefﬀg
hijkllmmnnoopsrrsssttttuvvwyyzꝗ

Cape Arcona Type Foundry

The Italic version of CA Emeralda™ was originally inspired by headlines from an early 1950s magazine advertisement. From there onwards, it evolved and grew to develop a catchy personality of its own with a modern script style that gives a fun and retro touch to display work and headlines.

It was created at Cape Arcona by Stefan Claudius. Born in Essen, Germany, Claudius studied Industrial Design at the Universities of Wuppertal and Essen. In 2000, he started a small graphic design studio from which he worked as a free-lance graphic designer. After spending some time in the Chank Army, he moved to Cape Arcona, a small fictitious country in the Atlantic. Together with fellow designer Thomas Schostok, he bought this little country and in 2002 transformed it into the type foundry Cape Arcona.

"It is really a small place, and it's no wonder you never heard about it before. It was really quiet for hundreds of years, but then arrived two multimillionaires, called Thomas Schostok and Stefan Claudius, who took over the state and declared themselves King and President of this dreamy little spot. The new regents made a few minor changes to Cape Arcona. Within the borders of the country, they abolished money and introduced the production of fonts," say Claudius and Schostok.

"For hundreds of years, Cape Arcona was a melting pot for the most different cultures, but the main influences came from England, America, Spain, Germany, and France. Wherever people felt dissatisfied with their countries, they immigrated to Cape Arcona and found a friendly climate, nice folks, and a peaceful place to live."

Besides organizing type workshops and designing new fonts, Stefan Claudius likes to play guitar in his instrumental band Volvo Penta. If he is not on a beach at Cape Arcona with cofounder Thomas Schostok, he is most likely working on a new font.

Emeralda

Family: CA Emeralda™
Weights: Italic and Script
Designer: Stefan Claudius
Year: 2005
Distributor: Cape Arcona Type Foundry
Use: Display
Advice and considerations: Do not use the script capitals unless they are followed by a lowercase character. Some people forget that, among other things, that is what the italic font is good for.

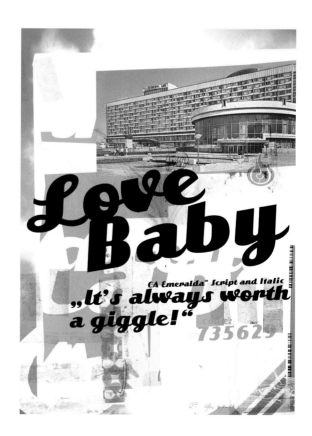

Love Baby

CA Emeralda™ Script and Italic
„It's always worth a giggle!"

CA Emeralda™ Script

abcdefghijklmnopqrstuvwxyz
ABCDEFGHIJKLMNOPQRSTUVWXYZ
1234567890 €£¥ʃ¢
?!¿¡"#%&'(*)•,-./:;‹›@[\]ˆ`_{|}˜
ÄÅÇÉÑÖÜáâàäãåçéèêëíûïñóòôõúùûü
ÂÊÁËÈÍÎÌÓÔÒÚÛÙıÀÃÕŒæÿŸ
°§·ß®©™´¨ÆØ± æøf≈«… –—""''‹›÷/› ·,„ ˆ˜¯˘˙˚˝ˇ

Textsample

Yes, there were times, I'm sure you knew. When I bit off more than I could chew. But through it all when there was doubt. I ate it up and spit it out. I faced it all and I stood tall. And did it my way. The kiss I never got. Somebody else will take. The plans I never made. Somebody else will make. Oh I'm lonely, I'm so lonely. 'Cause it's her I'm thinking of. But she'll always be the girl I never loved. Never loved, never loved. Überfällärtigér Schnëllschüss Yes, there were times, I'm sure you knew. When I bit off more than I could chew. But through it all when there was doubt. I ate it up and spit it out. I faced it all and I stood tall. And did it my way. The kiss I never got. Somebody else will take. The plans I never made. Somebody else will make. Oh I'm lonely, I'm so lonely. 'Cause it's her I'm thinking of. But she'll always be the girl I never loved. Never loved, never loved.

CA Emeralda™ Italic

abcdefghijklmnopqrstuvwxyz
ABCDEFGHIJKLMNOPQRSTUVWXYZ
1234567890 €£¥ʃ¢
?!¿¡"#%&'(*)•,-./:;‹›@[\]ˆ`_{|}˜
ÄÅÇÉÑÖÜáâàäãåçéèêëíûïñóòôõúùûü
ÂÊÁËÈÍÎÌÓÔÒÚÛÙıÀÃÕŒ æÿŸ
°§·ß®©™´¨ÆØ± æøf≈«… –—""''‹›÷/› ·,„ ˆ˜¯˘˙˚˝ˇ

Textsample

Yes, there were times, I'm sure you knew. When I bit off more than I could chew. But through it all when there was doubt. I ate it up and spit it out. I faced it all and I stood tall. And did it my way. The kiss I never got. Somebody else will take. The plans I never made. Somebody else will make. Oh I'm lonely, I'm so lonely. 'Cause it's her I'm thinking of. But she'll always be the girl I never loved. Never loved, never loved. Überfällärtigér Schnëllschüss Yes, there were times, I'm sure you knew. When I bit off more than I could chew. But through it all when there was doubt. I ate it up and spit it out. I faced it all and I stood tall. And did it my way. The kiss I never got. Somebody else will take. The plans I never made. Somebody else will make. Oh I'm lonely, I'm so lonely. 'Cause it's her I'm thinking of. But she'll always be the girl I never loved. Never loved, never loved.

Andreu Balius

Typerware developed Czéska's first stages basing themselves on some old types carved in wood by Czech artist Vojtech Preissig at the beginning of the 20th century. Later on, Andreu Balius completed the design and created the italics version, as well as including a complete collection of ligatures for both the regular and italic versions.

Balius's insatiable quest for creating functional forms, influenced, as a former sociology student, by the first vanguards and language theories, is highly evident in Czéska. The result is a typography that experiments with the shapes and forms of types from the beginning of the century while exploring their modification and adaptation to new technologies.

Other work assignments and projects have made Balius search deep into the past and research eighteenth century typographies to find design solutions, without ever leaving aside the present. The result is Skai, a superficial type for a hedonistic world, or the typography developed for La Vanguardia, a Barcelona-based newspaper. Another example is the Durruti type, named after the famous Spanish anarchist, which is inspired by the typefaces used in propaganda posters during the Spanish Civil War.

Czéska seems to be coarse and rough, even a bit staggering, but it doesn't allow its eclectic character in shapes and style to be evident to the eye. It has humanistic traits that give it approachability, and the curves are softly and smoothly drawn in general. Its trace is finished by a subtle cut, which gives it a light aspect when in text, less mechanical than that of other typographies. Its appearance is not so versatile, although it grants a unique character to the composition as a whole by giving it great vital strength.

Céska may be used in long or short texts, as well as in promotions and magazines. It is especially appropriate and effective for use in posters and headlines.

Czeska

Family: Czéska
Weights: Regular, Italics, and ligatures
Designer: Typerware / Andreu Balius
Year: 2002
Distributor: TypeRepublic
Uses: Display, Titles

Đð ŁłŠšÞþÝýŽž!"$%&'()*
+,~./0123456789:;<≈>?@
ABCDEFGHIJKLMNOPQRS
TUVWXYZ[\]^_`abcdefghi
jklmnopqrstuvwxyz{|}~Ä
ÅÇÉÑÖÜáàâäãåçéèêëíìîï
ñóòôöõúùûü†°¢£§•¶ß®©
™´¨≠ÆØ¥sHªº æø¿ıf≈
«»…ÀÃÕŒœ--—""''÷ÿŸ/€‹›
fifl‡·‚„‰ÂÊÁËÈÍÎÏÌÓÔ Tr
ÒÚÛÙı^~‾˘˙˚˛˝ˇ

After decades of revolutionary

TOUR DE F

Renaiss

Lybrary of Babel

DiStinĒti

Hva

gress

ance

ce

NG & EVERYTHING

BE THE ANSWER.

n

takoder!

Nostalgic

Artscript was Sol Hess's attempt to turn the graceful penmanship of the ancient scribe into rigid metal. This type of script is more common in digital form, but, when originally released in 1948, it required special handling to avoid breakage. Extensive alternates were added based on original Hess drawings and additional sources. Both versions are combined into the OpenType version along with an expanded Central European character set, as well as ligatures, swash/alternates, fractions, superior and inferior numerals, and ornaments.

Artscript is a classic and elegant scriptface that comes in three more or less flourished variants, and proves ideal for display and titling.

The P22 type foundry creates computer typefaces inspired by art, history, and sometimes science. P22, and especially its Lanston Type Co. division, is renowned for its collaboration with museums and foundations to ensure the development of accurate historical typefaces that are fully relevant and adaptable to today's computer user. In addition to its in-house font design, P22 also licenses several new type designs from around the world.

The history of P22, like all history, is filled with a mix of myth, fact, conjecture, and legend. At first conceived as an art collective during the mid-1980s, the original four founders created paintings, mail art, and poetry under the guise of P22. It flourished as a thriving, viable business by the late 1990s. Over the first ten years of P22, the type foundry experienced its share of highs and lows and a legacy filled with many digital fonts and other fine examples of printed matter. The company has recently published a book called "P22: Thoughts on Ideas for Inspiration towards...," which gives the reader insight into selected projects from their extensive catalogue. The book is a practical source of inspiration for any designer and is divided into three distinct sections that require the reader's interaction.

Family: LTC Artscript
Weights: LTC Artscript, LTC Artscript Alt, LTC Artscript Pro
Designer: Redesigned by Paul Hunt in 2005. Original by Sol Hess. First released by Lanston Type Co. (a division of P22 type foundry) in 2005
Year: 2005
Distributor: P22 Type Foundry
Uses: Display, titles

Sretan put! Hvala, također!

Lucky Duck

Respondez S'il Vous Plaît

One More Kiss

Los Gauchos de la Montaña Negra

New Year

Başınız sag olsun!

LTC Artscript Pro Full Character Showing:~

ABCDEFGHIJKLMNOPQRSTUVWXYZabcdefghijklmnopqrstuvwxyz ÆŒHANXQ ß æ œ c ç g h i kk k kff l m n r f-js-t u v w x y ž ž
ÁÁÁÁÁÁÆ ÁÇ ÉÉÉÉÉÍ ÍÍÍÍÐ ÑÓÓÓÓÓÓ Ú Ú Ú Ú Ý ẞ ßß á á á á á á ã ç é é é é é í í í í í ð ñ ó ó ó ó ó ó ú ú ú ü ý þ ÿ Áa Áa Áa Áæ Áe Íé Íí Íé íé Ð Ð Ðé Éé Êe Ée Ëe Gg
Ğğ Ĝĝ Ĥĥ Ḣḣ Îî Îî Ĵĵ Îĵ Ïj fj fj Ĵ Ḱḱ Ĺĺ Ĺĺ Ĺĺ Ĺĺ Ńn Ñn Ñḣ Ŋŋ Óŏ Óŏ Óŏ Óœ Ŕŕ Ŕṝ Ŝṡ Ŝṡ Ŝĵ Ṫṫ Îṫ Ḟṫ Ŭŭ Ŭŭ Ŭŭ Ŭŭ Ŭŭ Ŷŷ Ŵŵ Ŷŷ Ŷŷ Źż Żż Żż Żż
&ÁÁÁÁÁÁÁÁÁÁÁÁÁÁÁÁÁ Æ Ĺĺĺĺĺ ĆÐ Ð ÉÉÉÉÉÉÉÉÉÉ ÉÉĠĠĠḢḢ ÍÍÍÍÍÍÍÍÍÍ ÍĴĴ ĴL ĹĹĹĹĹ Ñ Ṝ Ṝ
Ñ Óóóóóóóóó Ð ÉṘṘṘ ŚŚŚŚŚŚ ŚĴ ĴĴ Ú Ú Ú Ú Ú Ú Ú Ú Ú Ú Ú Ú Ú Ŵ Ŷ Ŷ Ŷ Ŷ Ŷ Ż Ż Ż Ð Ð ß ä á á ä ä ä æ ö ó ô õ ö þ þ þ þ b þ þ ß ı í û ü û ý ý ŷ
0123456789 01234567890 § $ € £ ¥ ƒ ⁰¹²³⁴⁵⁶⁷⁸⁹₀₁₂₃₄₅₆₇₈₉ ⅓⅔⅛⅜⅝⅞ ½¼¾ · • % ‰ + − × ÷ = ≠ < > ≤ ≥ ± ~ ^ – # √ ≈ ∂ ° º μπ ∂ Ð Ω Π E | |
¶ · ¨ ´ `... : ; ! ¡ ' " ' ' ' " " „ — - - — & ⁊ * @ © ® ™ † ‡ () \ | [] { } fb ff fi fl ffi ffl ft fj fff ffj fk fff ff aa as es cs is is as us us
b d b k l d h-L s b ˘ ĕ ĭ ŏ k k k Ŀ p ß ā ē ĩ ō k k k k k d f ff lb ĥ ĩ g ĭ w fb fb ĥ k ř ŝ þ ıl þ ý ŷ ǰ ~ ~ ⁓ ≈ ∞ ✻ ❀

Andreu Balius developed Trochut based on the Bisonte type, designed by the Catalan typographer Joan Trochut Blanchart during the difficult post-civil war years in Spain.

Towards the end of the nineteenth century, manipulating characters was common practice in print workshops. In order to give the characters a certain originality, the shapes of fonts were altered with the help of a knife and a file. It is quite probable that these homemade practices during the 1920s, together with the influence of the European vanguard movement on small local industries, contributed to the commercialization of a series of lead types with combinable geometric shapes—circles, squares and triangles. These could be used in composition design, which printers employed for designing logos, headlines, and decorative graphics.

With the development of advertising during the 1930s and the increasing demand for printed material, small printers soon found themselves running out of ways to design original and innovative work. Amidst these printers preoccupied with the quality and dignity of their everyday work was Esteban Trochut Bachmann, father of Joan Trochut and a renowned Barcelona printer. Determined to make his contribution in the improvement of paper quality for small print, Esteban Trochut edited a series of albums named ADAM (Documentary Archives of Modern Art) in which he put in practice his personal way of understanding and using typography. In these albums, Esteban and Joan Trochut wrote texts about the practice of their profession, all the while putting an accent on the letterform being used as the principal decorative element, with the objective of promoting the creative use of typography amongst professionals.

Andreu Balius recovers the Bisonte type created by Trochut to digitalize and develop it further for its adaptation to the new digital era. The result is a typographic system that can be used for the composition of texts, although it is an ideal font for use in advertising due to the modular nature of the alphabet and the visual strength of the graphics captured on paper.

TROCHUT

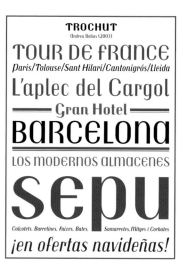

Family: Trochut
Variants: Regular, Italic, and Bold
Designer: Joan Trochut and Andreu Balius
Year: 2003
Distributor: TypeRepublic
Use: Advertising brochures

TROCHUT

Trochut (regular)
ABCDEFGHIJKLM
NOPQRSTUVWXYZ
abcdefghijklmnopqrstuvwxyz

Trochut (italic)
ABCDEFGHIJKLM
NOPQRSTUVWXYZ
abcdefghijklmnopqrstuvwxyz

Trochut (bold)
ABCDEFGHIJKLM
NOPQRSTUVWXYZ
abcdefghijklmnopqrstuvwxyz

0123456789 #%‰ $¢ƒ£€¥ Ww
çñâáâàäå@ëéêèïîìíöôòóøœüûùú?†‡§¶ fifl fl @ ß@
¡¿?!(G)[\]{}«»/·„-/-_—""'''·'^.~"'<=>•-°""®©™{}˘¯ι

0123456789 #%‰ $¢ƒ£€¥ Ww
çñâáâàäå@ëéêèïîìíöôòóøœüûùú?†‡§¶ fifl fl @ ß@
¡¿?!(G)[\]{}«»/·„-/-_—""'''·'^.~"'<=>•-°""®©™{}˘¯ι

0123456789 #%‰ $¢ƒ£€¥ Ww çñ
àáâãäåëéêèïîìíöôòóøœüûùú?†‡§¶ fifl fl @ ß@
¡¿?!(G)[\]{}«»/·„-/-_—""'''·'^.~"'<=>•-°""®©
™{}˘¯ι çñâáâàäåëéêèïîìíöôòóøœüûùú ,;;

That quick brown dog jumped over the lazy fox
Mix Zapf with Veljovic and get quirky Beziers
Portez ce vieux whisky au juge blond qui fume

Lorem ipsum dolor sit amet, consectetuer adipiscing elit. Etiam mi dolor, interdum ac, ornare in, interdum et, velit. Nulla eget nunc a odio vestibulum iaculis. **Phasellus ullamcorper**. In dictum, odio in vestibulum pellentesque, diam ante imperdiet velit, eu dapibus leo dui eu dolor. *Aenean pretium, dui eu ultricies mattis, nisl ipsum venenatis nulla, non egestas diam tellus quis ante. Nunc porta semper elit.* Maecenas sed elit. Morbi auctor, quam eget elementum consectetuer, nibh purus vestibulum turpis, non interdum nunc dolor in ligula. Aenean sit amet augue. Viva-

mus elementum luctus tellus. In urna turpis, semper eget, consequat et, eleifend in, mauris. **Nulla fringilla wisi ut lectus.** *Duis sed velit. Curabitur pharetra sollicitudin ipsum. Donec orci justo, facilisis non, tristique tincidunt, blandit ut, urna. Nam ullamcorper bibendum metus. Sed imperdiet. Suspendisse potenti. Duis aliquet commodo sapien.* Phasellus semper, ipsum et pharetra consectetuer, nunc libero pretium mauris, sit amet posuere nisl libero ac quam. **Vestibulum pulvinar.** Aenean et nisl. Quisque sem. Nam laoreet tincidunt nibh. Pellentesque

SANREMO CAPRI ROMA COPACABANA
CON FALDAS Y A LO LOCO
MONACO GRAND PRIX
FREERIDING
BERLIN

TROCHUT *está inspirada en el tipo «Bisonte» del impresor y tipógrafo catalán* **Joan Trochut Blanchard**
Cliente: TypeRepublic (2003)

Alejandro Lo Celso is a romantic typeface designer whose creations go beyond the faculty, inherent in typography, of acting as a conductive element for a statement: Through their shapes, they stand as representatives of the words themselves.

This typeface is the result of the creator's admiration for the literary works of Jorge Luis Borges. According to Alejandro Lo Celso himself, it was "his technique like that of a meticulous jeweler, untiringly polishing to obtain the perfect word" that served as inspiration to him. This dedication makes Borges a clean and refined family, with a large quantity of small idiosyncrasies. These form a contrast with other details of more classic cuts, like, for example, the design of its uppercase, reminiscent of the Roman square, which is typical of Renaissance typeface designers.

Other aspects of Borges's design are also inherited from this style; the most significant characteristics are the oblique axis, the strong modulation, and the curved beaks. Its main exponents are the typeface Garamond, of dubious origin, although officially attributed to Claude Garamond (1500–1561), and the Bembo, designed by Francesco Griffo (1450–1518). However, Borges cannot be labeled as Renaissance or humanist because it is a typeface that shows the unmistakable style of its creator, who recognizes also being influenced by contemporary Dutch typography.

Borges was designed as a typeface for long text; hence the open counters, the ample x-height, and the color given to the page from its modest contrast and relaxed modulation. Its legible and gentle texture provides us with pleasurable reading. This typeface also tackles issues related to economy of space. Its relatively short descenders and ascenders afford the composition tight leading. This makes it especially reliable in circumstances when a large quantity of information has to fit into a small space, often the case in newspapers or reference books.

Despite the fact that Borges started as a modest project aimed at being a text typeface, it ultimately expanded to the point of offering four different weights and two display variants: Borges Título Blanca, which is finer and with highly defined features, and Borges Título Hueca, based on the tradition of stone inscriptions.

Borges

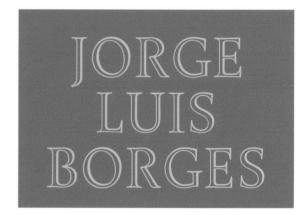

Family: Borges
Variants: Borges Blanca, Borges Blanca Itálica, Borges Gris, Borges Gris Itálica, Borges Negra, Borges Negra Itálica, Borges Super Negra, Borges Super Negra Itálica, Borges Título Blanca, and Borges Título Hueca
Designer: Alejandro Lo Celso
Year: 2002
Distributor: Myfonts, Fonts
Use: Long text
Other uses: Display, in its Título variants
Advice or considerations: Do not use the text variants for display, or vice versa.

Borges Blanca, *Blanca Itálica*,
Borges Gris, *Gris Itálica*,
Borges Negra, *Negra Itálica*
Borges SuperNegra, *SupNg It*
Borges Título Blanca
Borges Título Hueca

Borges Blanca

ABCDEFGHIJKLMNÑOPQRSTUVWXYZ
abcdefghijklmnñopqrstuvwxyz
1234567890!@#$%&()=?

Borges Blanca Itálica

ABCDEFGHIJKLMNÑOPQRSTUVWXYZ
abcdefghijklmnñopqrstuvwxyz
1234567890!@#$%&()=?

Borges Gris

ABCDEFGHIJKLMNÑOPQRSTUVWXYZ
abcdefghijklmnñopqrstuvwxyz
1234567890!@#$%&()=?

Borges Gris Itálica

ABCDEFGHIJKLMNÑOPQRSTUVWXYZ
abcdefghijklmnñopqrstuvwxyz
1234567890!@#$%&()=?

Borges Negra

ABCDEFGHIJKLMNÑOPQRSTUVWXYZ
abcdefghijklmnñopqrstuvwxyz
1234567890!@#$%&()=?

Borges Negra Itálica

ABCDEFGHIJKLMNÑOPQRSTUVWXYZ
abcdefghijklmnñopqrstuvwxyz
1234567890!@#$%&()=?

Borges Super Negra

ABCDEFGHIJKLMNÑOPQRSTUVWXYZ
abcdefghijklmnñopqrstuvwxyz
1234567890!@#$%&()=?

Borges Super Negra Itálica

ABCDEFGHIJKLMNÑOPQRSTUVWXYZ
abcdefghijklmnñopqrstuvwxyz
1234567890!@#$%&()=?

Borges Título Blanca

ABCDEFGHIJKLMNÑOPQRSTUVWXYZ
abcdefghijklmnñopqrstuvwxyz
1234567890!@#$%&()=?

Borges Título Negra

ABCDEFGHIJKLMNÑOPQRSTUVWXYZ
abcdefghijklmnñopqrstuvwxyz
1234567890!@#$%&()=?

Hamburgefont
Hamburgefont
Hamburgefont
Hamburgefont
Hamburgefont
Hamburgefont
Hamburgefont
Hamburgefont

Details

Una tipografía para la

BIBLIOTECA DE BABEL

Applications

Borges is a typography intended for use in a continuous text. The generosity of its height and its open eyes allow pleasant reading. It is the result of the admiration that Alejandro Lo Celso has for the literary works of Jorge Luis Borges.

SO merely by tracking down the clues in

language itself

— a blurred, but revealing trail! —

one can see how a crudely changed meaning has every-where usurped the function of far subtler messages now quite lost to us, that ever-perceptible but

never quite tangible

nexus of things.

ROBERT MUSIL
The man without qualities
translation by Sophie Wilkins

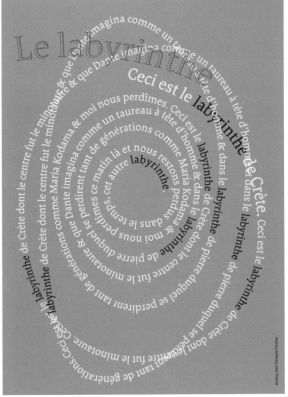

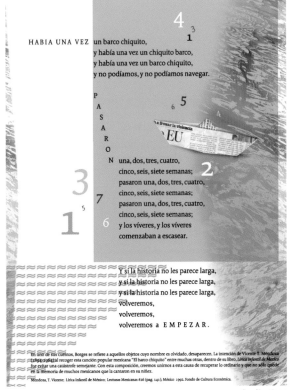

HABIA UNA VEZ un barco chiquito,
y había una vez un chiquito barco,
y había una vez un barco chiquito,
y no podíamos, y no podíamos navegar.

PASARON una, dos, tres, cuatro,
cinco, seis, siete semanas;
pasaron una, dos, tres, cuatro,
cinco, seis, siete semanas;
pasaron una, dos, tres, cuatro,
cinco, seis, siete semanas;
y los víveres, y los víveres
comenzaban a escasear.

Y si la historia no les parece larga,
y si la historia no les parece larga,
y si la historia no les parece larga,
volveremos,
volveremos,
volveremos a E M P E Z A R.

En uno de sus cuentos, Borges se refiere a aquellos objetos cuyo nombre es olvidado, desaparecen. La intención de Vicente T. Mendoza (1894-1964) al recoger esta canción popular mexicana "El barco chiquito" entre muchas otras, dentro de su libro, *Lírica Infantil de México* fue evitar una catástrofe semejante. Con esta composición, creemos unirnos a esta causa de recuperar lo ordinario y que no sólo quede en la memoria de muchos mexicanos que la cantaron en su niñez.
Mendoza, T. Vicente; Lírica Infantil de México; Lecturas Mexicanas #26 (pag. 141); México 1992. Fondo de Cultura Económica.

Applications

After spending his first years as a typeface designer experimenting with display typefaces, Stefan Hattenbach decided to enter a different world, that of typefaces for texts. Delicato, the product of this change, is a traditional typeface in many ways, although with some elements from more contemporary constructions.

There are countless typefaces that are based on previous work, a common practice that allows the designer to focus on a reference point when creating. In the case of Delicato, the models were two contemporary typefaces, Enigma, designed by Jeremy Tankard, and Pro Forma, from Petr van Blokland.

Delicato, which is rather condensed, with an oblique axis, medium contrast and generous x-height, is a typeface family full of interesting details. One of these is the contrast between its triangular serifs and the variation presented by its terminals, some of which are rectangular and others tear-shaped—especially noticeable in the letters *a, c, f, j, r*, and *y*.

The attention to detail is one of Delicato's strong points. The subtle differences in the size of the dots on the *i* and the *j*, as well as those of the dieresis and the design of the rest of its diacritical marks, is an example of good design practice. In Delicato, Hattenbach paid special attention to the performance of the ink when printed on small bodies, and he provides a series of ink traps for the more problematic areas. This is the case in the letters *A, M, N*, and *V*, which, due to their physical characteristics, can create an excessive smudge in the joins of their diagonal stems.

Delicato presents four different weights and adds a median version to the traditional Regular, Italic, and Bold. It also has small capitals and alternative characters for each weight, which include the typical ligatures of long text typeface—ct, sp, st—as well as other more specific ones—fä and fö—based on the mother tongue of the designer. Finally, Delicato Ornaments provide a wide range of ornaments, arrows, and dingbats, some with a calligraphic nature and others of a more traditional typeface, all of which have been carefully designed.

Delicato

Family: Delicato
Variants: Delicato Regular, Delicato Regular Alt, Delicato Italic, Delicato Italic Alt, Delicato Small Caps, Delicato Medium, Delicato Medium Alt, Delicato Bold, Delicato Bold Alt, Delicato Ornaments
Designer: Stefan Hattenbach
Year: 2004
Distributor: www.fontshop.at
Use: Long text
Other uses: Not recommended
Advice or considerations: Designed for use in books

After decades of revolutionary progress

Bored by the movies

BEN WEBSTER AND ASSOCIATES

Roma – Lazio 2 – 0

The complete guide to Single Malt Scotch

Recorded April 1959 in N.Y.C.

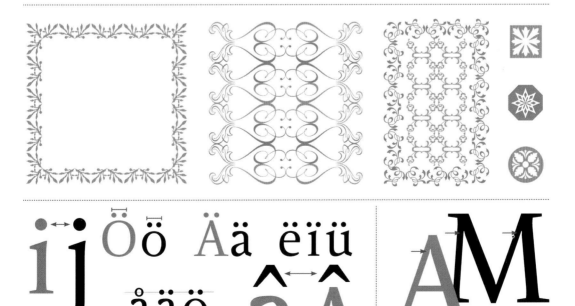

Fabiol, a family that was designed for long text, unites all of the characteristics that make a typeface efficient in the composition of books. Designer Robert Strauch drew his inspiration from old prints dating to the beginning of the Renaissance. On a conceptual level, one of his aims was to reflect the charm of these antique prints, but he also wanted to match the energy exuded by typefaces from these centuries.

However, Fabiol was not designed with the intention to be a work of historical restoration, and although the shapes of its letters are based on those of fifteenth- and sixteenth-century punchcutters, they reveal small and particular details that, upon closer observation, constitute a new interpretation of Renaissance typefaces.

This typeface has a very small x-height and is rather light in color. Its ascenders and descenders are quite long, meaning that the compositions need a generous leading to accomplish optimum results. All of these details combine to endow the page with an elegant look and create a pleasant, soft gray texture. On first sight, Fabiol is reminiscent of the closed types of the punchcutter Nicholas Jonson (1420–1480), one of the best typeface designers known from the Renaissance period.

The Italic version of Fabiol has a sharp inclination, which, together with its condensed and compact look, differentiates it greatly when it is surrounded by the upright version. The carefully designed small capitals offer exactly the same texture as the lower case. The Fabiol bold version, like the italics version, makes a noticeable contrast opposite the upright variant and effortlessly draws the reader's attention.

Fabiol also includes a series of ornaments that complement the antiquated design, giving it an evocatively nostalgic look, reminiscent of a past era when typographic production was so carefully planned.

Fabiol

Today most historians view the Renaissance

as largely an intellectual and ideological change, rather than a substantive one. Moreover, many historians now point out that most of the negative social factors popularly associated with the "medieval" period – poverty, warfare, religious and political persecution, and so forth – seem to have actually worsened during this age of MACHIAVELLI, the Wars of Religion, **the corrupt Borgia Popes,** and the intensified witch-hunts of the 16th century. Eine Voraussetzung für die neue Geisteshaltung der Renaissance waren die Gedanken selbstbewusster italienischer Dichter des 14. Jahrhunderts wie

FRANCESCO PETRARCA,

der durch seine ausgiebige Beschäftigung mit den antiken Schriftstellern und durch seinen Individualismus den Glauben an den Wert der humanistischen Bildung förderte und das Studium der *Sprachen*, der *Literatur*, der *Geschichte* und der *Philosophie* außerhalb eines religiösen Zusammenhangs – als Selbstzweck – befürwortete. Los supuestos históricos que permitieron desarrollar el nuevo estilo

Family: Fabiol
Variants: Fabiol Regular, Fabiol Italic, Fabiol Small Caps, Fabiol Bold and Fabiol Ornaments
Designer: Robert Strauch
Year: 2005
Distributor: Lazydogs Typefoundry
Use: Long text
Other uses: Not recommended
Advice or considerations: Legible from 5 point, works better from 9 to 12 point, with generous leading

artistique était essentiellement tournée vers la religion chrétienne, la Renaissance artistique utilise les thèmes humanistes et mythologiques. Le renouvellement *réflexion philosophique* fournit aux artistes de nouvelles idées : avec le néoplatonisme, l'Homme est au centre de l'univers. L'étude des textes antiques, le renouveau de la philologie, permettent aux architectes d'abandonner les formes gothiques. Ils utilisent les enseignements de PYTHAGORE et de VITRUVE pour élaborer leurs plans. *Den italienska renässansen växte fram på 1300-talet, och utvecklingen nådde Sverige på 1500-talet. För konsten innebar renässansen att konstnärerna steg fram ur anonymiteten, och att porträtt och landskap fick som främsta uppgift att exakt avbilda motivet.* **Typiska för epoken** är universalgenierna MICHELANGELO BUONARROTI och LEONARDO DA VINCI som båda perfekt behärskade en mängd konstarter. Ofte lader man også renæssancens naturvidenskab omfatte KOPERNIKUS, KEPLER og GALILEI. De hævdede, at de samme mekaniske love gjaldt for himmellegemernes bevægelser, som for bevægelserne på jorden. På måde opløste de den middelalderlige etageverden og fratog den kristne himmel- og helvedesforestillinger deres håndgribelighed. ⟿

ABCDEFGHIJKLMNOPQQRRSTUVWXYZÆŒØ 0123456789€$¥£%‰#

ABCDEFGHIJKLMNOPQRSTUVWXYZSSÆŒØÅÇÉÎÑŠÜ & 0123456789

abcdefghijklmnopqrstuvwxyzßæœøıfifl & 0123456789€ $ ¢ ¥ %‰#

fffiflffiffjfftſſſttstſþčtchck

()*,./:;?!@[\]^_{|}~†§•¶®©™aº¿¡‹›«»…–—""''∞
‡·„„""°¬+<=>≠±≤≥÷ƒ/`´ˆ˜¨˙˝„˛˘ ½¼¾¹²³

ÄÅÀÃÂÁÇÊËÈÉÍÎÌÏÑÓÔÕÖÒÚÛÙÛÝ ÐŁPŠŽ

áàâäãåçéèêëíìîïñóòôöõúùûüÿðłþšžΣμπ∏Δ∂ΩΩ◊≈√∫

ABCDEFGHIJKLMNOPQQRRSTUVWXYZÆŒØ

abcdefghijklmnopqrstuvwxyzßæœøıfifl & 0123456789€ $ ¥

fffiflffiffjfftſſſttstſþčtchckgſeſieſigiyggggy

(),./:;?!@[\]^_{|}~†§•¶®©™aº¿¡‹›«»…–—""''∞*
‡·„„""°¬+<=>≠±≤≥÷/`´ˆ˜¨˙˝„˛˘ #%‰½¼¾¹ ² ³

ÄÅÀÃÂÁÇÊËÈÉÍÎÌÏÑÓÔÕÖÒÚÛÙÛÝ ÐŁPŠŽ

áàâäãåçéèêëíìîïñóòôöõúùûüÿðłþšžΣμπ∏Δ∂ΩΩ◊≈√∫

ABCDEFGHIJKLMNOPQRSTUVWXYZÆŒØ

0123456789€$¥£%‰# & 0123456789€ $ ¢ ¥ %‰#

abcdefghijklmnopqrstuvwxyzßæœøıfifl

()*,./:;?!@[\]^_{|}~†§•¶®©™aº¿¡‹›«»…–—""''∞
‡·„„""°¬+<=>≠±≤≥÷ƒ/`´ˆ˜¨˙˝„˛˘ ½¼¾¹²³

ÄÅÀÃÂÁÇÊËÈÉÍÎÌÏÑÓÔÕÖÒÚÛÙÛÝ ÐŁPŠŽ

áàâäãåçéèêëíìîïñóòôöõúùûüÿðłþšžΣμπ∏Δ∂ΩΩ◊≈√∫

the quick
brown
fox
jumps
over the
lazydogs

LAZYDOGS TYPEFOUNDRY

THE AWARD WINNING TYPEFACE
FABIOL

Our foundry opened August 2005 with the award-winning typeface Fabiol. This unconventional oldface concept by Robert Strauch was honored with the most desirable »Certificate of Excellence« in the category »text« at the 2005 TDC² award. Based on this backing, the ›Lazydogs‹ font collection emerges under a high demand for quality and functionality, designed to push forward the standards in todays type design.

Fabiol Regular

The quick brown fox jumps over the lazydogs. Zwei Boxkämpfer jagen Eva quer durch Sylt. Voix ambiguë d'un cœur qui au zéphyr préfère les jattes de kiwis. Es estraño mojar queso en la cerveza o probar whisky de garrafa. The

Fabiol Italic

The quick brown fox jumps over the lazydogs. Zwei Boxkämpfer jagen Eva quer durch Sylt. Voix ambiguë d'un cœur qui au zéphyr préfère les jattes de kiwis. Es estraño mojar queso en la cerveza o probar whisky de garrafa. The quick brown fox jumps over

Fabiol Small Caps

THE QUICK BROWN FOX JUMPS OVER THE LAZYDOGS. ZWEI BOXKÄMPFER JAGEN EVA QUER DURCH SYLT. VOIX AMBIGUË D'UN CŒUR QUI AU ZÉPHYR PRÉFÈRE LES JATTES DE KIWIS. ES ESTRAÑO MOJAR QUESO EN

Fabiol Bold

The quick brown fox jumps over the lazydogs. Zwei Boxkämpfer jagen Eva quer durch Sylt. Voix ambiguë d'un cœur qui au zéphyr préfère les jattes de kiwis. Es estraño mojar queso en la cerveza o probar whisky de garra

Fabiol Ornaments

Applications

Fabiol was designed for long text. Strauch drew his inspiration from Renaissance prints, but close attention to detail ensured a completely modern feel. Fabiol's long ascenders and descenders encourage play, ensuring the font's renewability.

Applications

Paperback is a typeface family that was initially designed for the composition of text—in 8, 9, and 10 point—of rustically bound books, printed at high speed with low quality paper and ink. In the development of this first version, which would later become Paperback 9, the standard size of the text set in the pocket books was taken into account. However, this project ended up developing a family of six variations, each of which was designed for a limited series of bodies. Paperback 6 covers bodies from 5 to 7 point; Paperback 9, from 8 to 10 point. Paperback 12, designed to be used with long text, encompasses 11 to 13 point, while Paperback 24, 48, and 96 cover larger bodies since they are used for creating displays.

The changes from one version to the other, especially in the variants for texts, are extremely subtle, but their influence is unquestionable. As the body of the typeface diminishes in size, the x-height gets larger and the angles become sharper. In the versions for display, however, Paperback refines its strokes and details.

In its series for text, Paperback is very legible and resists the worst printing conditions without losing quality. In general, the family is a little wider than might be expected, but without giving the impression of being an expanded typeface. Paperback draws on the Scotch tradition, represented by William Addison Dwiggins (1880–1956) through designs such as that of Caledonia. Paperback follows this style in its vertical axis, its strong contrast, and its curved beaks.

PAPERBACK

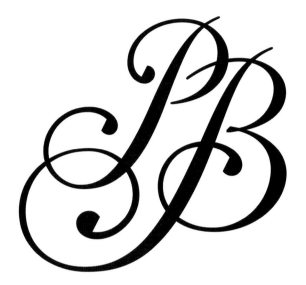

Family: Paperback
Variants: Paperback 6, Paperback 6 Bold, Paperback 6 Italic, Paperback 9, Paperback 9 Bold, Paperback 9 Italic, Paperback 12, Paperback 12 Bold, Paperback 12 Italic, Paperback 24, Paperback 24 Italic, Paperback 48, Paperback 48 Italic, Paperback 96, Paperback 96 Italic
Designer: John Downer
Year: 2005
Distributor: House Industries
Use: Long text and display
Other uses: Not recommended
Advice or considerations: Each variant has been especially designed for a specific range of bodies.

A	B	C	D	E	F	G	H
I			J	K			L
M	H		N	O	O		P
Q	R	S			T	U	V
W	X	Y	U		Z	1	2
3			4	5	E		6
7	S		8	9			0
$	£	€	¥	%	&	!	?

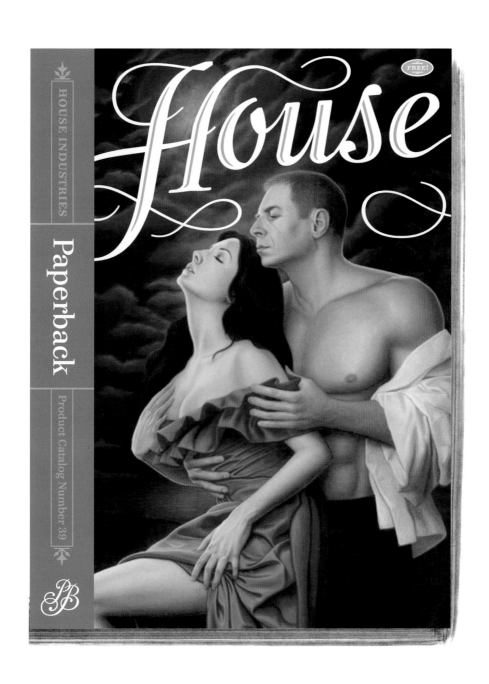

Caslon Old Style is recognized as one of the finest examples of the Old Style group of typefaces. It was originally cut by William Caslon in England in about 1720 and is rated by many authorities as first for all-around usefulness. The inspiration for the design was probably Dutch types, notably those of Bishop Fell.

One of the most noticeable features of Caslon is the lack of uniformity from one size to another. In re-mastering this font for release in 2005, the characters were completely redrawn, based upon the 14 point font for hand composition. This design is closer in spirit to the original Caslon.
The original Caslon issued by Monotype featured short descenders so that the face would fit on a standard alignment; however, Caslon 337 was the first Monotype typeface to offer optional characters with long descenders so as to replicate the original Caslon more faithfully. LTC Caslon comes in both variants.

Caslon's original Italic featured swash characters with an extended flourish for the letters J, Q, T, Y, and H with the final stroke turned inward. Later, plain versions of these letters were added to Caslon fonts. LTC Caslon contains the plain variants as defaults; however, the OpenType version of this font features a "stylistic set" that allows users to emulate the original Caslon more closely.

Additional swash variants for Italic capitals were drawn by a variety of artists for a variety of foundries. The OpenType version of the Italic also features an alternate set of Swash Caps drawn by Carl S. Junge for Barnhart Brothers & Spindler in 1924. These characters are quite noticeably the product of a different time and style from Caslon, but their genius is that they have been designed so as not to require any kerning.

The Declaration of Independence was first printed in Caslon. Ben Franklin used Caslon's types in his print shop. The pound sterling mark for many Caslon fonts was simply the swash J rotated 180 degrees. The OpenType versions of LTC Caslon offer this as an alternate.

Family: LTC Caslon
Weights: LTC Caslon, LTC Caslon Italic, LTC Caslon Long, LTC Caslon Long Italic, LTC Caslon SC, LTC Caslon Italic SC, LTC Caslon Swash, LTC Caslon Swash Long, LTC Caslon Bold, LTC Caslon Bold Italic, LTC Caslon Bold Long, LTC Caslon Bold Long Italic
Designer: Redesigned by Paul Hunt in 2005. First released by Lanston Type Co. (a division of P22 type foundry)
Year: 2005
Distributor: P22 Type Foundry
Uses: Text, headline

A SPECIMEN

By Lanston Type Co. A Division of P22 Type Foundry, Buffalo, NEW YORK.

ABCD
ABCDE
ABCDEFG
ABCDEFGHI
ABCDEFGHIJK
ABCEDFGHIJKLMN
ABCDEFGHIJKLMNOPQRS
ABCDEFGHIJKLMNOPQRSTUVWXYZ

LTC Caslon Long Italic Pro (Opentype) (with all features enabled 32pt.

Questions may be asked: What does a downtempo electronic music duo have to do with a semi-famous 18th century type designer?

LTC Caslon Small Caps 30pt.

NOTHING & EVERYTHING
WOULD BE THE ANSWER.

LTC Caslon Italic 29pt.

William Caslon cut his first typefaces in 1720. For almost 300 years various versions of the Caslon faces have come in and out of style, but always seem to be regarded as a classic type style suitable for many uses, thus the famous quip: "When in doubt, use Caslon"

LTC Caslon Pro (Opentype) (with all features enabled)

Lanston Type Company has digitized a new version of the famous William Caslon fonts. The digital versions from Lanston circa 1980 were true to the design of the originals, but new digital and offset printing methods made these fonts appear thin since the ink gain often seen in commercial letterpress printing was no longer an issue. The new redrawn P22/Lanston versions have a bit more weight plus expanded OpenType versions for even greater design flexibility.

LTC Caslon Long Italic Pro (Opentype) (with all features enabled)

The William Caslon Experience took their name from the same person that these fonts are associated with. The designers at P22 type foundry / Lanston Type Co. listen to large amounts of a variety of music (with excessive amounts of Stereolab) and at some point in time a CD with the William Caslon Experience appeared in the design studio with repeated listenings.

LTC Caslon Italic 9pt.

The synchronicity of the name suggested that P22 should expand its audio offerings at the same time as Lanston re-issued the Caslon fonts. Therefore this specimen sheet liner notes broadside you are holding brings together two relatively unrelated pin points of popular culture.

The William Caslon Experience

LTC Caslon Regular
The william caslon experience is two sleepy under-employed american fellas (Nate Butler & Mart Schaefer) hanging out and twisting knobs on odd weeknights in regular old denver colorado & portland oregon usa.
ABCDEFGHIJKLMNabcdefghijklmnopqrstuvwxyz

LTC Caslon Long Descenders
In a previous lifetime they played together in a post-art-funk-punk band, faex, which was awarded " best weird band of 1989 " in denver, colorado. later on the lads became enchanted with the new electronic studio music they were hearing .
ABCDEFGHIJKLMNabcdefghijklmnopqrstuvwxyz

LTC Caslon Small Caps
ORIGINALLY INSPIRED BY NIGHTLY HELPINGS OF KRUDER & DORFMEISTER AND TOSCA, FILA BRAZILLIA & BABY MAMMOTH, THE HERBALISER AND GOOD DOSES OF PINK FLOYD, BRIAN ENO, HAROLD BUDD, MILES DAVIS, DAVID SYLVIAN, WU-TANG CLAN AND ANTONIO CARLOS JOBIM, THE LADS SET TO BUILDING THEIR OWN STUDIO & LEARNING THEIR NEW GADGETS.
ABCDEFGHIJKLMNOPQabcdefghijklmnopqrstuvwxyz

LTC Caslon Italic
After months of endless dot-pushing and knob-twisting, twce began to take shape. hell, they even started sounding good... sounding sleepy. since 1998, they've completed and self-released 4 full-length cds (via american bacon recordings) which have been warmly received by people around the world – listeners, labels and artists alike...
ABCDEFGHIJKLMNOPQabcdefghijklmnopqrstuvwxyz

LTC Caslon Long Descenders Italic
They then beat down the doors of those who'd inspired them in the first place in order to show off what they'd done, and today have friendships or collaborations with and even remixes from name artists on labels like pork, uniqatune and upstairs recordings.
ABCDEFGHIJKLMNOPQabcdefghijklmnopqrstuvwxyz

LTC CASLON ITALIC SMALL CAPS
THE CASLON SOUND HAS GROWN UP OVER THE YEARS, BUT THE FOCUS HAS ALWAYS BEEN ON CRAFTING THE FINEST QUALITY DOWNTEMPO BEATS IMAGINABLE.
ABCDEFGHIJKLMNOPQabcdefghijklmnopqrstuvwxyz

LTC Caslon Swash Italic
Not content with the paint-by-numbers approach almost universally embraced in electronic music, nate and mart take weeks or months layering, reworking, stripping down and building up the elements required to leave them with a successful track.
ABCDEFGHIJKLMNOPQabcdefghijklmnopqrstuvwxyz

LTC Caslon Swash Italic Long Descenders
Their criteria? simple. 1: that a listener should never know what's around the next corner and 2: that a listener must always be able to take a nap to it should they be so inclined.
ABCDEFGHIJKLMNOPQabcdefghijklmnopqrstuvwxyz

LTC Caslon Bold
NB: caslon music has long been hailed for its relaxing properties - it's eased the journeys of long-haul truckers, soothed savage children and diffused commuter road rage incidents. honestly! it's also perfect accompaniment for those evening smoking sessions, or so thievery corporation has told us.)
ABCDEFGHIJKLMNOQabcdefghijklmnopqrstuvwxyz

LTC Caslon Bold Italic
In september 2002, upstairs recordings (nettwerk), snatched up 2 caslon tracks for their "blue light one" compilation, signalling the lads' first "official" release. reviews were good.
ABCDEFGHIJKLMNOQabcdefghijklmnopqrstuvwxyz

LTC Caslon Bold Long Descenders
2003 has seen them complete their 4th cd, "music for truckers", start work on a 5th, and begin a relationship with dorje records. dorje released 2 caslon 12" singles in december 2003, including long-awaited, previously unreleased remixes by fila brazillia and the herbaliser.
ABCDEFGHIJKLMNOQabcdefghijklmnopqrstuvwxyz

LTC Caslon Bold Italic Long Descenders
discography: 12" singles: arithmétique chinoise dorje 2003; alaska dorje 2003... albums: letterboxing american bacon 1998 ; "the more close than opran" e.p. american bacon 1999; delay pigs american bacon 2000; music for truckers american bacon 2003 ; blue light one compilation upstairs/nettwerk.
ABCDEFGHIJKLMNOQabcdefghijklmnopqrstuvwxyz

ggijppqqyy *ffggijppqqyy* ggijppqqyy *ffggijppqqyy*

LTC Caslon Pro (Opentype)

ABCDEFGHIJKLMNOPQRSTUV
WXYZÀÁÂÃÄÅĀĂĄÆĆĈČĊÇ
ĎĐÈÉÊĚËĒĔĖĘĜĞĠĢĤĦ
ÌÍÎÏĨĪĬĮİĴĶĹĽĻĿŁŃÑŇŊÒ
ÓÔÕÖŌŎŐØŒŔŘŖŚŜŞŠȘŢŤŦ
ÙÚÛÜŨŪŬŮŰŲŴŵŴŴÝŶŸ
ŹŻŽŅÐþabcdefghijklmnopqrstuvw
xyzàáâãäåāăąæçćĉčċďèéêěëēĕėęĝ
ğġģĝĝĝĝĝĝĥħìíîïĩīĭįıĵķĺľļŀŁĺŀĥńñń
òóôõöōŏőøœpqŕŗřśŝşšșßţťŧùú
ûüũūŭůűųŵŵŵŵŵýŷÿźżžŋðþ
þıкàáâãäåāăąæçćĉčċďĐÈÉÊĚËĒĔĖĘ
ĜĞĠĢĤĦÌÍÎÏĨĪĬĮİĴĶĹĽĻĿŁĹŀĽŃŇ
ÒÓÔÕÖŌŎŐØŒPQŔŘŖŚŜŞŠȘßÁÄĚ
Ṫh Ṫh Ṫh Ṫh ﬀﬁ ﬀ ﬀh ﬀh ﬁ ﬁﬁ ﬁ ﬁﬁ ﬁk ﬀk ﬂ
ﬁﬂ st ﬆ ﬀ ﬀh ﬆ ﬁ ﬁﬁ ﬀk ﬁ ﬁﬂ ﬀe ﬁ ﬁﬀ ﬁﬀ
1234567890 1234567890 ᴸ²³⁴⁵⁶⁷⁸⁹⁰
¹/₄ ½ ¾ ‰ ⅓ ⅔ ⅛ ⅜ ⅝ ⅞ % ‰ – + × ÷ = < ≥ ¬
Δ Ω µ π° ≈ ∂ ∫ √ ∑ ∏ ₤ ∫∫ † ‡ § ¶ | ' " © ®
™ ℗ ≈ € ¢ £ ƒ ¥ ¤
· ! " # $ % & ' () * + , - . / : ; < = > ? @ [\] ^ _ { | } ~

LTC Caslon Pro Italic (Opentype)

ABCDEFGHIJKLMNOPQRSTU
VWXYZabcdefghijklmnopqrstuvwxyz
ÀÁÂÃÄÅĀĂĄÆÇÈÉÊĚËĒĔĖĘ
ÒÓÔ×ØÙÚÛÜÝßàáâãäåāăąçèéêěëēĕ
ðñòóôõö÷øùúûüýþÿÀÁÂÃÄĄçĉĈĊČĈ
ĎÄĐÆĚÈÉěÈèÈÉĜĜĜĜĝĝĥĤ
HĥÏÌÍÎĨÌÍĮıIŊ ÿ ĵĴ jK ķk LĹĹĹĿĽĹ
NñŅŇ ñ ñŋ ŋ Ò óÒ ÔÖ œ Ŕ ŕ Ŗ ŕ ŕ Ŕ Š Š
Ŝ š ş Š ŝ Ţ ŧ Ť ŧ Ů Ũ Ù Ü Ü Û Ů Û Ů ŵ Ŵ ŵ
Ŵ ŵ Ŵ ŵ Ŵ ŵ Ý ŷ Ÿ Ž Ž Ż Ż Ž Á Á Æ
Ó ó Š ʒ ˇ ˙ ˚ ˆ ˜ ¯ ̇ Δ Ω π – — ' , " ", † ‡ ... ‰ ' ◁
0 1 2 3 4 5 6 7 8 9 0 1 2 3 4 5 6 7 8 9 ⅓ ⅔ ⅛ ⅜ ⅝ ⅞
∂ ∏ ∑ – √ ∫ ∞ ≤ ≥ ≈ ◦ 0 1 2 3 4 5 6 7 8 9 1 2 3 4 5 6 7 8 9 0
ﬁ ﬀ ﬁﬀ ﬀ ﬁﬁ ﬀ st ﬆ st ﬁb ﬁﬁ ﬁﬀ ﬁ ﬁ ﬁﬀ ﬀk ﬁﬀ ﬀ ﬁﬀ
ﬁ ﬀ ﬀ ﬁﬀ ﬁ ﬁﬀ ﬁﬀ ﬁ ﬀk ﬀ ﬁﬀ ﬀ Ṫh Ṫh Ṫh Ṫh Ṫh
Ṫh Ṫh Ṫh ¢£¤%‰ ℮℗™
ABCDEFGHIJKLMNOPQRSTUVWXYZ
ÀÁÂÃÄÅĀĂĄÆÇĆĈČĊÇĎĐÈÉÊĚËĒĔĖĘ
ĜĞĠĢĤĦÌÍÎÏĨĪĬĮİĴĶĹĽĻĿŁŃÑŇŊÒÓÔÕÖŌŎŐØŒ
ŔŘŖŚŜŞŠȘ Ṫ Ṫ Ŧ Ù Ú Û Ü Ũ Ū Ŭ Ů Ű Ų Ẃ Ŵ Ẁ Ẅ Ý Ŷ Ÿ Ź Ż Ž ŋ ð þ
£ABCDEFGHIJKLMNOPQR
STUUŨ Æ Œ Đ Ł ℧ Š Ÿ Ẑ Ž̧

LTC Caslon Remix
(found on audio CD only)

ABCDEFGHIJKLMNOPQRS
TUVWXYZabcdefghijklmn
opqrstuvwxyz123456789o&'()*,-
./:;<>@·⁰¹‹›¯^~¦
¡†‡·§·B ·· ÆØŒ®©ƒ«»™‼!KẂⱭⱯ
ỹŸ/◊ﬁﬂ$‡‚„‹›" "‹ "!KẂⱭⱯ
℮ẎþÞÐ·I®©™ áàâäãåāçéèêëēōōōö
ùúûüïîíÉÁÆĚÌÍÒÓÔÚ Œ Ǔ Ü
Ä Ă Ç Ŕ Ē Ð Š Ž̧ Ÿÿ ñ Ä ÃÖ ·# $ £

Super-Veloz is a collection of modules designed by Catalan typographer and designer Joan Trochut Blanchart. The typography was, without a doubt, one of the most interesting works done during the difficult times of post-war Spain. It was designed to be an "integral" typography, and its purpose was to be a complete typographic system that helped the small printer in his daily work. It was recovered and digitized by Andreu Balius and Alex Trochut.

Joan Trochut's Super-Veloz was a collection of combinable types, designed "to satisfy the need of publicity and decorative typography", as described by Trochut in the presentation catalogue when it was first produced by the José Iranzo Typographic Foundry. It was a system that was born with the vocation of improving the graphic look of small commercial prints (whether they were cards, signs, tags or commercial stationery), while reducing production costs.

Trochut describes his typographic system as "rigorously integral." Its starting point is a module that gave birth to typography and that builds a system of combinable elements. In Super-Veloz, the lead piece does not refer to a character but to a part of the character; therefore, different characters and alphabets can be built by a combination of different pieces of the Super-Veloz. Secondary traces or elements are added to the main elements, thus giving as a result a myriad of formal possibilities.

The versatility of this system allowed printers to develop alphabets, design logos, and commercial brands without the limitations that usually came with lead types.

Between the years of 1936 and 1952, Estéban and Joan Trochut continued editing albums; four came out during that time and they were known as the NOVADAM. These albums contained examples of commercial stationery, brands, signs, ex-libris, labels, illustrated vignettes, alphabets, all of which showed some of Trochut's typographies. The third album, published in 1948, and the last one, published in 1952, both serve as promotion for the use of this type. The albums also contained articles that expressed the designer's thoughts on typography; Trochut was quite influenced by modern life and design, as Andreu Balius explains.

Family: Super-Veloz
Weights: Family formed by first, second, and third collections with Veloz traces; complements one, two, and three (universal collection + series body 36)
Designer: Andreu Balius, Alex Trochut
Year: 2004
Distributor: TypeRepublic
Uses: Display

SUPER-VELOZ

by: andreu balius & alex trochut

Typeface design & illustrations made by combination of Super-Veloz modules

SUPER VELOZ

BARCELONA

MARIA

TYPOGRAPHY

LUPITA

GULLIVER

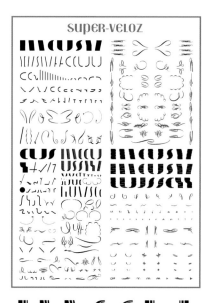

SUPER-VELOZ

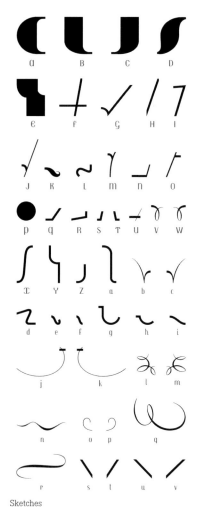

Sketches

This is "integral" type, based on a module that builds a system of combinable elements. This, in turn, allows for decorative plays on the original form, with or without serif.

Applications

Californian was designed as a private commission for the University of California at Berkeley in 1939. It was designed by the prolific type designer Frederic Goudy and is considered to be his finest type design. It was released as a commercial type by Lanston Monotype for general use in design and printing and since then many digital versions have come into existence. However, none are more faithful to the original version than the newly digitized LTC Californian, designed by Paul Hunt; his re-creation used the original patterns from which the metal type was made as a direct reference for digitizing. Keeping true to the details of the original metal type, the face can appear because most metal types were designed with the intention that letterpress printing ink would make the type appear bolder. Moreover, for the purpose of text, a heavier weight was created, while the original weight is still amply suited to display settings and the setting of text for letterpress printing.

Paul Hunt was raised in Arizona and, after working as a graphic designer, later moved to Buffalo, N.Y., where he is a typeface designer for Lanston Type Co. Fascinated by art, language, and culture since he was young, his love and mastery of type design are reflected in his work.

In continuing with Lanston Type's hundred-plus-year tradition of supplying quality type, the Lanston/P22 collection of fonts presents many of Frederic Goudy's famous type designs as well as other typographic classics, updated and digitized for design use today. Frederic Goudy was Lanston's most famous type director and Lanston/P22 faithfully releases all of his typefaces, based on the actual metal patterns that were used to make the master punches from which the types were cast. The P22 versions offer the added feature of Open Type, allowing for the expansion of character sets and including alternates and ligatures. The historical focus of P22's font collection in combination with the typographic classics of the Lanston Monotype Co. offer a myriad ideas and resources for designers and typographers.

Californian

Family: LTC Californian
Weights: LTC Californian Text, LTC Californian Text SC OSF, LTC Californian Text OT, LTC Californian Text Italic, LTC Californian Text Italic Extras, LTC Californian Text Italic OT, LTC Californian Display, LTC Californian Display SC OSF, LTC Californian Display OT, LTC Californian Display Italic, LTC Californian Display Italic Extras, LTC Californian Display Italic OT
Designer: Redesigned by Paul Hunt in 2005. Original by Frederic Goudy in 1939. First released by Lanston Type Co. (a division of P22 type foundry) in 2005
Year: 2005
Distributor: P22 Type Foundry
Uses: Display, letterpress printing

Distinction

Quis ut Deus ex Machina

Cosmonaut Vodka Intelligentsia

Poltergeist Fußball

Above: LTC Californian Pro Display & *Display Italic* at 132 pt., 54 pt., 32 pt., & 74 pt.

From the term "*Cacao*," comes the English word. "*Cocoa*," which is almost universally used in English-speaking countries to designate the seeds of the small tropical tree known to botanists as *THEOBROMA CACAO*, from which a great variety of preparations under the name of cocoa and chocolate for eating and drinking are made. The name "*Chocolatl*" is nearly the same in most European languages, and is taken from the Mexican name of the drink, "*Chocolate*" or "*Cacahuatl*." The Spaniards found chocolate in common use among the Mexicans at the time of the invasion of Cortez in 1519, and it was introduced to Spain immediately after. The Mexicans not only used chocolate as a staple article of food, but they used the seeds of the cacao tree as a medium of exchange.

No better evidence could be offered of the great advance which has been made in recent years in the knowledge of dietetics than the remarkable increase in the consumption of cocoa and chocolate in this country. The amount retained for home consumption in 1860 was only 1,181,054 pounds—about 3·5 of an ounce for each inhabitant. The amount retained for home consumption for the year ending Dec. 31, 1908, was 93,956,721 pounds.—over 16 ounces for each inhabitant.

Although there was a marked increase in the consumption of tea and coffee during the same period, the ratio of increase fell far below that of cocoa. It is evident that the coming American is going to be less of a tea and coffee drinker, and more of a cocoa and chocolate drinker. This is the natural result of a better knowledge of the laws of health, and of the food value of a beverage which nourishes the body while it also stimulates the brain.

LTC Californian Pro Text & *Text Italic*
English

W jednym z tych domków, otoczonym sztachetami brązowej barwy, tonącym w bujnej zieleni ogródka, mieszkała ciotka Agata. Wchodząc do niej, mijaliśmy w ogrodzie kolorowe szklane kule, tkwiące na tyczkach, różowe, zielone i fioletowe, w których zaklęte były całe świetlane i jasne światy, jak te idealne i szczęśliwe obrazy zamknięte w niedościgłej doskonałości baniek mydlanych. W półciemnej sieni ze starymi oleodrukami, pożartymi przez pleśń i oślepłymi od starości, odnajdowaliśmy znany nam zapach.

W tej zaufanej starej woni mieściło się w dziwnie prostej syntezie życie tych ludzi, alembik rasy, gatunek krwi i sekret ich losu, zawarty niedostrzegalnie w codziennym mijaniu ich własnego, odrębnego czasu. Stare, mądre drzwi, których ciemne westchnienia wpuszczały i wypuszczały tych ludzi, milczący świadkowie wchodzenia i wychodzenia matki, córek i synów—otworzyły się bezgłośnie jak odrzwia szafy i weszliśmy w ich życie.

Siedzieli jakby w cieniu swego losu i nie bronili się—w pierwszych niezręcznych gestach wydalinam swoją tajemnicę.

LTC Californian Pro Text & *Text Italic*
Polish

Graças ás intimas relações do nosso paiz com as principaes potencias maritimas da Europa, desde a entrada do seculo XVI, estabelecidas pelos descobrimentos e conquistas dos portuguezes, que fizeram de Lisboa o emporio das mercadorias do Oriente, o movimento scientifico, que lavrava n'aquellas nações, não se demorava muito em se fazer sentir entre nós. *Porém no caso de que trato abreviou esse periodo, sem duvida, a viagem de um nosso compatriota, que alcançou nas letras nome illustre.* André de Rezende, depois de ter cursado a universidade de Salamanca, e de ter tomado capello em theologia, levado do desejo de se instruir, percorreu a França e os Paizes Baixos, demorando-se em Paris e em Bruxellas. O trato que teve n'estas cidades com alguns sabios, suscitou-lhe o amor dos estudos archeologicos.

LTC Californian Pro Text & *Text Italic*
Portuguese

LTC Californian Pro: Full Character Sets

ABCDEFGHIJKLMNOPQRSTUVWXYZabcdefghijklmnopqrstuvwxyzABCDEFGHIJKLMNOPQRSTUVWXYZ`´ˆˇ˜¨
ÀÁÂÃÄÅÆÇÈÉÊËÌÍÎÏÐÑÒÓÔÕÖØÙÚÛÜÝÞßàáâãäåæçèéêëìíîïðñòóôõöøùúûüýþÿÁáÀàÂâĀāÆǽĆćĈĉČčĊċĎďĐđĒēĔĕĖėĘęĚěĜĝĢ
ĞğĠġĤĥĦħÌĩĪīĬĭİıĵĴĶķĸĹĺĻļĽľĿŀŁłŃńŅņÑñŊŋŌōŎŏŐőŒœŔŕŖŗŘřŚśŜŝŞşŠšŢţŤťŦŧŨũŪūŬŭŮůŰűŲųŴŵŶŷŸŹźŻżŽž
&ÀÁÂÃÄÅĀĄÆÆ̆ĆĈČĊÇĎĐÉÈÊËĚĒĔĖĘĘ̆ĜĞĠĢĤĦḢ̆ÌÍÎÏĨĪĬĮİĲĴĶĹĻĽĿŁŃÑŇ ŅÒÓÔÕÖŌŎŐØŒŔŘŖŚŜŠŞȘṢ̆ŤŢÙÚÛÜŨŪŬŮŰŲŴŴ̆ẀẂÝŶŸẎŹŻŽ ᴅᴇᴅ
0123456789₀₁₂₃₄₅₆₇₈₉$¢€£¥ƒ⁰¹²³⁴⁵⁶⁷⁸⁹₀₁₂₃₄₅₆₇₈₉‰%‰¼½¾⅓⅔⅛⅜⅝⅞+−×÷=≠≈<>≤≥¬¯^−#√∕∞◊∂µπ∂∆Ω∏∑`´'⎮ ¦
¶†·…,.„¡¿!'‹›«»·‚''‘'""„‚—–-_·•&*@©®℗™†‡(/)[\]{¦} fffifflffiffl ﬆﬅﬀﬁﬂﬃﬄﬅﬆ ʄʄʄﬁ ﬁﬁﬀ
ABCDEFGHIJKLMNOPQRSTUVWXYZabcdefghijklmnopqrstuvwxyzABCDEGMPQRTgvw`´ˆˇ˜¨
ÀÁÂÃÄÅÆÇÈÉÊËÌÍÎÏÐÑÒÓÔÕÖØÙÚÛÜ ÝÞßàáâãäåæçèéêëìíîïðñòóôõöøùúûüýþÿÁáÀàÂâĀāÆǽĆćĈĉČčĊċÇÇDdĎĐÉÈÊËĚĒĔĖĘĘ̆
Ĝ ĝ Ğ ğ Ġ ġ Ĥ ĥ Ħ ħ Ì Ĩ Ī ī Ĭ ĭ İ ı Įj Ĵ Ķ ķ Ĺ Ļ Ľ Ŀ Ł Ń ń Ñ Ņ ņ Ňň Ŋ ŋ Ō Ō ō Ŏ ŏ Ő ő Œ œ Œ̆ Ŕ Ř Ŗ ŗ Ř ř Ś ś Ŝ Ŝ Ş ş Š š Ş̆ Ţ ţ Ť ť Ŧ ŧ Ũ ū Ŭ ŭ Ů ů Ű ű Ų ų Ŵ Ŵ̆ Ẁ Ẃ Ý ŷ Ÿ Ź ż Ž ž ž
0123456789₀₁₂₃₄₅₆₇₈₉$¢€£¥ƒ⁰¹²³⁴⁵⁶⁷⁸⁹₀₁₂₃₄₅₆₇₈₉‰%‰¼½¾⅓⅔⅛⅜⅝⅞+−×÷=≠≈<>≤≥¬¯^−#√∕∞◊∂µπ∂∆Ω∏∑`´'⎮¦
¶·…,.„¡¿!'‹›«»·‚''‘'""„‚—–-_·&*@©®℗™†‡(/)[\]{¦}ﬀﬁﬂﬃﬄﬅﬆﬆ̆ﬅ̆ʄʄ̆ﬁﬂﬃﬄﬅﬆﬀﬁﬂﬃﬄﬅﬆﬀﬁﬂﬄ ÀÁÂÃÄÅÈÉÊÈ ÆƆ

Arnhem, by Fred Smeijers, was initially designed for the Nederlandse Staatscourant, the daily newspaper of the Dutch state. This typeface can be classified as a very functional design, suitable for setting text in large quantities. The family consists of four weights: Blond, Normal, Bold, and Black. Each weight has Roman and Italic, and both have matching small caps, lining figures, non-lining figures, and small cap figures.

Arnhem Normal has a strong color, which is good especially in small sizes and in less-than-optimal printing circumstances. Arnhem does not have a light weight; instead, there is a blond version. The blond—a bit too heavy to be classified as light—is meant to be used when a strong color is not really wanted or needed.

Arnhem text faces are accompanied by two versions for titles in both Roman and Italic, further explained in the Arnhem Fine type that follows. These were especially designed for use in larger sizes.

The Arnhem Fine fonts are the title companions to the Arnhem family. It is a formal typeface that performs best in sizes larger than 14 point so the design is crisper in details, such as serifs or curve connections. Another important difference concerns the design proportions; the Fine versions have longer ascenders and descenders, and the x-height is smaller compared to Arnhem text fonts.

If you want an impressive title page in which the drawing and general character of the typeface plays an important role, then Fine is the right choice. Arnhem Fine does not have the typical text components, like small caps or non-lining figures; it consists of Normal and Bold versions only, each with matching Italics. Arnhem Fine complements the other Arnhem fonts and completes the Arnhem family.

Arnhem and Arnhem Fine are available in TrueType and PostScript formats, for both PC and Mac platforms, as well as in OpenType Standard.

Arnhem

vermilion

GRASGREEN

ultramarin

YELLOW

violet

black

Family: Arnhem, Arnhem Fine
Weights: Arnhem Blond & LF, Arnhem Blond Italic & LF, Arnhem Normal & LF, Arnhem Normal Italic & LF, Arnhem Bold & LF, Arnhem Bold Italic & LF, Arnhem Black & LF, Arnhem Black Italic & LF; Arnhem Fine Normal, Arnhem Fine Normal Italic, Arnhem Fine Bold, Arnhem Fine Bold Italic
Designer: Fred Smeijers
Year: 2002
Distributor: OurType
Use: text

Arnhem Fine Normal & Arnhem Fine Bold

ABDEHKRVXZ adefgnkoprstvxyz
ABDEHKRVXZ adefgnkoprstvxyz

Arnhem Fine Normal Italic & Arnhem Fine Bold Italic

ABDEHKRVXZ adefgnkoprstvxyz
ABDEHKRVXZ adefgnkoprstvxyz

Arnhem Blond, Normal, Bold & Black

ABDEHKRVXZ adefgnkoprstvxyz
ABDEHKRVXZ adefgnkoprstvxyz
ABDEHKRVXZ adefgnkoprstvxyz
ABDEHKRVXZ adefgnkoprstvxyz

Arnhem Blond Italic, Normal Italic, Bold Italic & Black Italic

ABDEHKRVXZ adefgnkoprstvxyz
ABDEHKRVXZ adefgnkoprstvxyz
ABDEHKRVXZ adefgnkoprstvxyz
ABDEHKRVXZ adefgnkoprstvxyz

Arnhem Small Caps Blond, Normal, Bold & Black

ABDEHKRVXZ ABDEHNKRSTVXZ
ABDEHKRVXZ ABDEHNKRSTVXZ
ABDEHKRVXZ ABDEHNKRSTVXZ
ABDEHKRVXZ ABDEHNKRSTVXZ

Small Caps Blond Italic, Normal Italic, Bold Italic & Black Italic

ABDEHKRVXZ ABDEHNOKRSTVXZ
ABDEHKRVXZ ABDEHNOKRSTVXZ
ABDEHKRVXZ ABDEHNOKRSTVXZ
ABDEHKRVXZ ABDEHONKRSTVXZ

Arnhem figures: non-lining, lining & matching Small Caps figures.

1234567890 @ 1234567890 @&€
1234567890 @ 1234567890 @&€
1234567890 @ 1234567890 @&€
1234567890 @ 1234567890 @&€

All figures of Arnhem fonts are tabular.

1234567890 Ⓐ 11122233344455
1234567890 Ⓐ 11122233344455
1234567890 Ⓐ 11122233344455
1234567890 Ⓐ 11122233344455

character set for Arnhem Fine fonts

ABCDEFGHIJKLMNOPQRSTUVWXYZ abcdefghijklmnopqrs tuvwxyz &1234567890 ÆŒПØ æœnfiflßðø1ªº$¢£¥ƒ€%‰#°·<≤≥±>÷¬≈=≠+∞ ★ ΔΩ´∫ ffiμ.,:;!¡?¿'"‘’,“”„--—◦«»()[]{}/|\..._†‡§¶*·@©®™´ˆˋˋ¨˜¯˘˙ ÁÂÄÀÅÃÇÉÊËÈÍÎÏÌÑÓÔÖÒÕÚÛÜÙŸ áâäàåãçéêëèíîïìñóôöòõúûüùÿ

character set for Arnhem roman & italic fonts

ABCDEFGHIJKLMNOPQRSTUVWXYZ abcdefghijklmnopqr stuvwxyz &1234567890 ÆŒПØ æœnfiflßðø1ªº$¢£¥ƒ€%‰#°·<≤≥±>÷¬≈=≠+∞ΣΔΩ√∫/◊μ.,:;!¡?¿'"‘’,“”„--—◦«»()[]{}/|\..._†‡§¶*·@©®™´ˆˋˋ¨˜¯˘˙ ÁÂÄÀÅÃÇÉÊËÈÍÎÏÌÑÓÔÖÒÕÚÛÜÙŸ áâäàåãçéêëèíîïìñóôöòõúûüùÿ

character set for Arnhem Small Caps fonts

ABCDEFGHIJKLMNOPQRSTUVWXYZ ABCDEFGHIJKLMNO PQRSTUVWXYZ &1234567890 ÆŒПØ æœnfiflßðø1ᴬº$¢£¥ƒ€%‰#°·<≤≥±>÷¬≈=≠+∞ΣΔΩ√∫/μ.,:;!¡?¿'"‘’,“”„--—◦«»()[]{}/|\..._†‡§¶*·@©®™´ˆˋˋ¨˜¯˘˙ ÁÂÄÀÅÃÇÉÊËÈÍÎÏÌÑÓÔÖÒÕ ÚÛÜÙŸ ÁÂÄÀÅÃÇÉÊËÈÍÎÏÌÑÓÔÖÒÕÚÛÜÙŸ

character set for Arnhem LF fonts

ABCDEFGHIJKLMNOPQRSTUVWXYZ abcdefghijklmnopqr stuvwxyz &1234567890 ÆŒПØ æœnfiflßðø1ªº$¢£¥ƒ€%‰#°·<≤≥±>÷¬≈=≠+∞ΣΔΩ√∫/◊μ.,:;!¡?¿'"‘’,“”„--—◦«»()[]{}/|\..._†‡§¶*·@©®™´ˆˋˋ¨˜¯˘˙ ÁÂÄÀÅÃÇÉÊËÈÍÎÏÌÑÓÔÖÒÕÚÛÜÙŸ áâäàåãçéêëèíîïìñóôöòõúûüùÿ

123456789

Bracks POLYUR

abcdefghijklmnñop

[MultiVitómix

2	3	4	5	6	7	8	9	10	11	12	

LLIMETER

0.001MM	0.0028PT	240	239	238	237	236
0.02MM	0.05PT	235	234	233	232	231
0.04MM	0.1PT	230	229	228	227	226
0.06MM	0.15PT	225	224	223	222	221
0.08MM	0.2PT	220	219	218	217	216
0.1MM	0.25PT	215	214	213	212	211
0.12MM	0.3PT	210	209	208	207	206
0.14MM	0.35PT	205	204	203	202	201
0.16MM	0.4PT	200	199	198	197	196
0.18MM	0.45PT	195	194	193	192	191
		190	189	188	187	186
		185				

HANES

tuvwxyz

Dynamic

Íñigo Jerez is the designer behind Textaxis, a typographical project started in 1995. Born in Palma de Mallorca in 1972, he studied Graphic Design at the Massana School in Barcelona and at Parsons. He combines graphic design with various typographical projects. Aside from winning Laus awards for his Dinamo and Suite typography, he is the proud owner of Certificates of Typographical Excellence awarded by AtypI for the Latina and Onserif & Onsans typographies, and a Certificate of Excellence from TDC for the Suite typography. He continues to work on developing new fonts and designing new typefaces for diverse editorial projects from his studio based in Barcelona.

Designed as a display typeface, Block is extremely black and achieves an exaggerated smudge on the page. It is designed to be used with negative leading, allowing its ascending and descending stems to overlap, creating an even darker smudge.

Its structure was designed in all simplicity, and the stroke is thick. The triangular cut stands out in the joins of the stems, allowing the entry of a little white. This helps to define the shape of a particular letter. The curves of the exterior shapes of the letters are interesting because they contrast with the rectangular counters.

Also worthy of note is the solution that Íñigo Jerez gives the design of the *z*, which, in contrast to the *s* and its diacritical marks, has very little space due to Block's short ascenders. This makes its creation difficult, a problem this designer resolves with great efficiency.

Block is a typeface that has its own bold, shameless language. Its strong personality works as well for headings as it does for display, but most important, it was intentionally created to work as the ideal match for Bonus.

Blok

Apparel $wayzak? Burnhill Bracks

Family: Block
Variants: Ultrablock
Designer: Íñigo Jerez
Year: 2004
Distributor: Textaxis
Use: Display
Other uses: Not recommended
Advice or considerations: The ideal match for Bonus

Blok

ABCDEFGH
IJKLMN
OPQRSTU
VWXYZ.&!
abcdefg
hijklmnop
qrstuvw
xyz,áàâäā
1234567
890.?@†"*

Blok: Ultrablok

allien
in the binker
owen
ckillodion

liena

Sketches

Block wants to get an exaggerated stain in the page which makes it ideal for display. Its ascenders and descenders superimpose, creating an even more exaggerated stain. The triangular cut in the unions allows the body to breathe with a bit of white.

Benicàssim ano 10

Magnitud apropiacionista y «nueva» autoría intelectual

De la apropi de la forma a la deforma

Sonidos, arte y morro

T / IVÁN CARBALLIDO

We don't play guitars!

Ni falta que nos hace. Era algo que habíamos visto en películas y series de televisión, encantador de tan absurdo, y que eleva la carne de concurso lo que todos hemos hecho alguna vez en la intimidad de nuestros hogares. El Air Guitar tiene por fin su campeonato en España. Para la relación de este singular modalidad

En ese consume replanteamiento de las formas, revisión de las de las imágenes del pasado, de lo anterior, transciende en la quisido premio de ramificaciones y enlaces que favorecen la posterioridad y decodificación de su complejidad constructora. Han sido los iconos apropiacionistas por excedencia de la producción de arte, como en el desarrollo del término, «apropiación» en y para la producción de arte, como en el desarrollo del término, «apropiación» en y para la producción de arte, como en el desarrollo del término, «apropiación» en y para la producción de arte, creando así ese asociados que resultan a estos profesionales en lugares estetas conmovidos. La transición de Goya a Jake and Dinos Chapman genealidad a John Kelly y otra nueva formulaciones expansivas a través de la figura del constructor, «orientador», «nuevo autor», un acercamiento actual «a manera de sampler» de de aquellos, especie de transmisión cultural analítico concreta que de se aireal una dilatación y enriquecimiento del hecho creativo (naturaleza de la «apropiación» como máscara suplencia de una apropiación del de los convencionalismos acomodarnos por esa nueva del de los convencionalismos acomodarnos por esa nueva del de los convencionalismos acomodarnos por esa nueva que precisa de interacción intelectual >>

ellos han cierta es que los que pensamos básicamente en años, en la Bob Dylan agarrado a su guitarra y cantándole resurgir al viento, en Joan Baez, en Woody Guthrie, en múltiples Alan Lomax, en Tim Hardin... O, para las nuevas ambient/ generaciones, en Will Oldham cantándole con folk pop, voz quebrada a la oscuridad. rock... ¿N Lo que viene a continuación, conviene aclararlo, Power... M rarlo, tiene que ver con el folk sólo tangencial- es irland- mente. Hombres y mujeres de todos los esta- Molina, h dos de la América de hoy tienen la vieja Thomas... necesidad de expresarse a través de una guita- como Edi rra, un piano o incluso un arpa. Unos revisando

Desde que la música es música siempre ha habido gente que ha agarrado un instrumento, se ha encerrado en una habitación y se ha puesto a hacer canciones. De alguna manera, en el siglo XX, a la tradición norteamericana de recuperar raíces a través de una guitarra acústica y cantar por encima letras escritas en vacías liberan que nos hablan de lo político, lo humano y lo divino... a eso, hemos convenido en llamarlo «folk». En verdad, el folk no es norteamericano. Su definición más habla le música tradicional (folk verse de folklore)

NUEVO FOLK AMERICAN

welcome to paradise

Bajo este slogan se presenta una conocida marca de bronceadores. Y no le falta razón, pues para muchos el verano es la mejor estación y algunas playas el paraíso en la tierra. Recordamos esta vez el verano sin fin y las cremas protectoras más pop del mercado o tal vez la promesa de ambos de encontrar el cielo en la tierra en forma de ola°

Applications

The field of Script typefaces is perhaps the one that attracts contemporary typeface designers the most—a fact that can be deduced from the impressive number of script typefaces that has been generated in recent years. This may be due to the possibilities that OpenType makes available to typeface designers, its ability to re-create the spontaneity of handwriting and calligraphy, or maybe the technical challenge of embarking on a complicated design process when creating a family of characters that are seamlessly joined together.

Ángel Koziupa and Alejandro Paul offer us a wide variety of this type of font from their studio at Sudtipos project, the first Argentinean type foundry collective, from which Amorinda stands out as one of their most interesting creations. This typeface of connected writing is, in the words of its designers, "wild and disciplined at the same time." Provided with this versatile character, it can be made to stand out brashly or blend subtly with its surroundings to give it a more human touch.

The strokes show the influence of sign painting tradition; its sharp contrast and loose strokes re-create the effect of having been applied with a brush. Some of its glyphs, especially the uppercase, are quite complex in their structure and look very decorative. Amorinda is ideal for any display work, from product branding to signage. It also includes a series of alternative characters, Armorinda Alternate, which make it perfect for posters that aim to re-create or evoke that handwritten effect.

Its natural flow on the paper and its exaggerated inclination give it a lively and strong dynamic, lending energy to any design that it may be included in.

Amorinda

Todo es más rico con vascolet por las mañanas

Carnaval Gualeguaychú

Wendix

Alternates Alternates

Buenos Aires Salta Tucumán Entre Ríos Chubut

*Kk952@*fi$£ thß*

Family: Amorinda
Variants: Amorinda Regular, Amorinda Alternate
Designers: Ángel Koziupa & Alejandro Paul
Year: 2004
Distributor: Sudtipos/Veer
Use: Display
Other uses: Not recommended
Advice or considerations: Explore the alternative characters.

ABCDEFGHIJKLMN
ÑOPQRSTUVWXYZ

abcdefghijklmnñopqrstuvwxyz

abcdefghijklmnñopqrstuvwxyz

0123456789$%&fi@thtß£¢?¶{

Kenn Munk

"My type designs are best described as systems or puzzles for the graphic designer to work out. These puzzles have endless solutions, but you have to struggle with the fonts to get them to perform," says font and dingbat designer Kenn Munk. Kenn lives, works, and plays in Århus, Denmark. He graduated from Design Seminariet, Hojer, Denmark, in 1998 and has dayjobbed at an advertising agency ever since. In 2000, he launched www.kennmunk.com, where his various font designs can be downloaded. He works on an ancient and unbreakable Powerbook Wallstreet running OS 9.2 and started his one-man company on April 1, 2005, which has since snowballed into a site that offers alternative typefaces, dingbats, and free stencils as well as customized toys and objects, stickers, his photos, clothing designs, and the Versus Project.

Replywood is a monospaced font family that contains five weights; Normal, Alternate, and Thin, and each come in Regular and Bold. The Thin weight is half as thick as the Regular, which is half as thick as the Bold; this allows you to combine the weight of various sizes while maintaining a single stroke width. Replywood also features Kenn Munk's trademark underscore character as a connector—another alternative space character; a free version of Linemap can be downloaded at his site to experiment with that effect.

"The building block approach doesn't just apply to my dingbats. My typefaces usually feature connectors that bind the words together as blocks of letters, much like the way script-based fonts are bound together."

"My dingbats are usually based on the user combining two or more 'characters' in order to get results. The typefaces usually feature connectors that allow the designer using them to build 'word images' rather than just rows of letters. I think a reason for this is that I grew up playing with LEGO bricks, model kits, and homemade cardboard models."

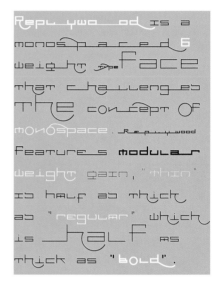

Family: Replywood
Weights: Normal, Alternate, and Thin, Regular and Bold
Designer: Kenn Munk
Year: 2003
Distributor: Kennmunk
Uses: Display

Replywood thin:
AaÁáÀàÄäÂâÅåÃãBbCcÇçDdEeÉéÈèËëÊêEẽFfGgHhIiÍíÌìÏïÎîİıJjKkLl
MmNnÑñOoÓóÒòÖöÔôØøÕõPpQqRrSsTtUuÚúÙùÜüÛûVvWwXxYyZzÆæŒœŸŸ
œßÅå1234567890+!?" "#%¢/[]=,.:;·-_-†|ß«»‹›...

Replywood thin alternate:
AaÁáÀàÄäÂâÅåÃãBbCcÇçDdEeÉéÈèËëÊêEẽFfGgHhIiÍíÌìÏïÎîİıJjKkLl
MmNnÑñOoÓóÒòÖöÔôØøÕõPpQqRrSsTtUuÚúÙùÜüÛûVvWwXxYyZzÆæŒœ
œßÅå1234567890+!?" "#%¢/()=,.:;·-_-†|ß«»‹›...

Replywood regular:
AaÁáÀàÄäÂâÅåÃãBbCcÇçDdEeÉéÈèËëÊêEẽFfGgHhIiÍíÌìÏïÎîİıJjKkLl
MmNnÑñOoÓóÒòÖöÔôØøÕõPpQqRrSsTtUuÚúÙùÜüÛûVvWwXxYyZzÆæŒœ
œßÅå1234567890+!?" "#%¢/[]=,.:;·-_-†|ß«»‹›...

Replywood alternate:
AaÁáÀàÄäÂâÅåÃãBbCcÇçDdEeÉéÈèËëÊêEẽFfGgHhIiÍíÌìÏïÎîİıJjKkLl
MmNnÑñOoÓóÒòÖöÔôØøÕõPpQqRrSsTtUuÚúÙùÜüÛûVvWwXxYyZzÆæŒœ
œßÅå1234567890+!?" "#%¢/()=,.:;·-_-†|ß«»‹›...

Replywood bold:
AaÁáÀàÄäÂâÅåÃãBbCcÇçDdEeÉéÈèËëÊêEẽFfGgHhIiÍíÌìÏïÎîİıJjKkLl
MmNnÑñOoÓóÒòÖöÔôØøÕõPpQqRrSsTtUuÚúÙùÜüÛûVvWwXxYyZzÆæŒœ
œßÅå1234567890+!?" "#%¢/[]=,.:;·-_-†|ß«»‹›...

Replywood bold alternate:
AaÁáÀàÄäÂâÅåÃãBbCcÇçDdEeÉéÈèËëÊêEẽFfGgHhIiÍíÌìÏïÎîİıJjKkLl
MmNnÑñOoÓóÒòÖöÔôØøÕõPpQqRrSsTtUuÚúÙùÜüÛûVvWwXxYyZzÆæŒœ
œßÅå1234567890+!?" "#%¢/()=,.:;·-_-†|ß«»‹›...

www.typography.net

The Shire Types are a collection of six typefaces inspired by a time when England's Midland counties were changing, a time during which parts of rural England exchanged the plough for the steam hammer and swapped the Shire horse for the steam engine. The resulting Shire Types bring together a heavy, solid notion of the Industrial Revolution mixed with ideas about specific localities. The individual typefaces take their names from six of the Shires that are grouped together around the Black Country and the neighboring rural areas.

The concept behind the Shire Types was to create a family of dense, black letterform that would make a dark and tight textural mass when set. The inspiration for the basic shapes came from the Grotesque and Egyptian lettering styles popular in the nineteenth century, as well as from examples of lettering cast in iron, painted on locomotives, shop fascias, and street nameplates.

All these things display the wealth of invention and diversity of lettering artists throughout Britain. The vigor and robustness of these forms belie their beauty. Once commonplace, many examples are now gone, and these letterforms have fallen out of favor.

The intent here was not to produce a pastiche but to revitalize. Reinvigorated letterforms are combined with a series of visual interpretations of the Shires based upon position, industry, dialect, history, and countryside.

There are no ascenders or descenders in the Shire Types, accented characters shrink to fit the character height, and capital letters mix happily with their less stately comrades; it is a classless and caseless system. The word shapes resulting from this linguistic interaction can be both eccentric and interesting or just plain bold—all hybrids of a familiar typescape.

THE SHIRE TYPES

Family: The Shire Types
Weights: Shire-Cheshire, Shire-Derbyshire, Shire-Shropshire, Shire-Staffordshire, Shire-Warwickshire, and Shire-Worcestershire
Designer: Jeremy Tankard
Year: 1998
Distributor: Typography
Use: Display

SHROPSHiRE

MAIN FORMS

aBCDEFGHiJKLMNOP
QRStUVWXYZàáâãäå
ÆÇèéêëìíîïŁñÒóôõö
ØŒùúûüÝÿŽĐÞ

LIGATURES

Fi FL

FIGURES, CURRENCY & RELATED FORMS

0123456789
€$¢£ƒ¥¤
+−±×÷=≠~∧<>≤≥¦¡µ
/ ¼ ½ ¾
% ‰ ° a o

PUNCTUATION & MARKS

_ - – — & () [] {} \ / ‹ › « »
''' '' '' '' ,, , , ; : . -
¡ ! ? ¿ * † ‡ § ¶ • @ © ® tm #

ACCENTS

CHESHiRE

MAIN FORMS

aBCDEFGHiJKLMNOP
QRStUVWXYZàáâãäå
ÆÇèéêëìíîïŁñÒóôõö
ØŒùúûüÝÿŽĐÞ

LIGATURES

Fi FL

FIGURES, CURRENCY & RELATED FORMS

0123456789
€$¢£ƒ¥¤
+−±×÷=≠~∧<>≤≥¦¡µ
/ ¼ ½ ¾
% ‰ ° a o

PUNCTUATION & MARKS

_ - – — & () [] {} \ / ‹ › « »
''' '' '' '' ,, , , ; : . -
¡ ! ? ¿ * † ‡ § ¶ • @ © ® tm #

ACCENTS

DERBYSHIRE

MAIN FORMS

ABCDEFGHIJKLMNOP
QRSTUVWXYZÀÁÂÃÄÅ
ÆÇÈÉÊËÌÍÎÏŁÑÒÓÔÕÖ
ØŒÙÚÛÜÝŸŽĐÞ

LIGATURES

FI FL

FIGURES, CURRENCY & RELATED FORMS

0123456789
€$¢£ƒ¥¤
+−±×÷=≠~∧<>≤≥¦¡µ
/ ¼ ½ ¾
% ‰ ° A O

PUNCTUATION & MARKS

_ - – — & () [] {} \ / ‹ › « »
''' '' '' '' ,, , , ; : . -
¡ ! ? ¿ * † ‡ § ¶ • @ © ® ™ #

ACCENTS

STAFFORDSHIRE

MAIN FORMS

ABCDEFGHIJKLMNOP
QRSTUVWXYZÀÁÂÃÄÅ
ÆÇÈÉÊËÌÍÎÏŁÑÒÓÔÕÖ
ØŒÙÚÛÜÝŸŽĐÞ

LIGATURES

FI FL

FIGURES, CURRENCY & RELATED FORMS

0123456789
€$¢£ƒ¥¤
+−±×÷=≠~∧<>≤≥¦¡µ
/ ¼ ½ ¾
% ‰ ° A O

PUNCTUATION & MARKS

_ - – — & () [] {} \ / ‹ › « »
''' '' '' '' ,, , , ; : . -
¡ ! ? ¿ * † ‡ § ¶ • @ © ® ™ #

ACCENTS

WARWiCKSHiRE

MAIN FORMS

aBCDEFGHiJKLMNOP
QRStUVWXYZàáâãäå
ÆÇèéêëìíîïŁñÒóôõö
ØŒùúûüÝÿŽĐÞ

LIGATURES

Fi FL

FIGURES, CURRENCY & RELATED FORMS

0123456789
€$¢£ƒ¥¤
+−±×÷=≠~∧<>≤≥¦¡µ
/ ¼ ½ ¾
% ‰ ° a o

PUNCTUATION & MARKS

_ - – — & () [] {} \ / ‹ › « »
''' '' '' '' ,, , , ; : . -
¡ ! ? ¿ * † ‡ § ¶ • @ © ® tm #

ACCENTS

WORCESTERSHiRE

MAIN FORMS

aBCDEFGHiJKLMNOP
QRStUVWXYZàáâãäå
ÆÇèéêëìíîïŁñÒóôõö
ØŒùúûüÝÿŽĐÞ

LIGATURES

Fi FL

FIGURES, CURRENCY & RELATED FORMS

0123456789
€$¢£ƒ¥¤
+−±×÷=≠~∧<>≤≥¦¡µ
/ ¼ ½ ¾
% ‰ ° a o

PUNCTUATION & MARKS

_ - – — & () [] {} \ / ‹ › « »
''' '' '' '' ,, , , ; : . -
¡ ! ? ¿ * † ‡ § ¶ • @ © ® tm #

ACCENTS

Ourtype

www.ourtype.be

Versa, designed by Peter Verheul, is the fourth largest font family from OurType, after Arnhem, Fresco, and Sansa.

Versa's character can be best described by thinking of Hermann Zapf's Optima, and then thinking of Albertus, the type designed by Berthold Wolpe. Then, try to think of a third design that would complete or continue this line of humane, charming, but also strong and personally flavored type designs. Looking closely at Versa, there is no doubt that it is a good candidate to make this line complete. But of course, there is more to Versa than this.

Like Fresco, the Versa family brings two big families together—a serif version alongside a real sans serif version. Each of these consists of five weights: Light, Normal, Semi-Bold, Bold, and Black. Each weight has Roman, Italic, and matching small capitals. This goes for the serif as well as the sans serif versions.

All Versa fonts have condensed versions: Roman, Italic, and small capitals. This turns Versa into a super-family, which is extremely suitable for texts in small sizes. At the same time, Versa will perform very well in large sizes, due to its particular but charming character.

Peter Verheul was born in the Netherlands and studied graphic design at the Royal Academy of Art in the Hague. Since 1991, he has taught type design at the Royal Academy at the Hague, where he also lives. He codesigned Jan Middendorp's book, *Dutch Type* (2004), which is set in Open-Type Versa, one of his own typefaces. He is known for outstanding craftsmanship in lettering, type design, and graphic design. His FF New Berlin was one of the first fontfont releases and was part of the new wave of Dutch design. It was soon followed by FF sherrif, another example of the exceptionally strong and personal character of his designs.

Family: Versa
Weights: Versa Light, Versa Light Italic, Versa Normal, Versa Normal Italic, Versa Semi Bold, Versa Semi Bold Italic, Versa Bold, Versa Bold Italic, Versa Black, Versa Black Italic, Versa Sans Light, Versa Sans Light Italic, Versa Sans Normal, Versa Sans Normal Italic, Versa Sans Semi Bold, Versa Sans Semi Bold Italic
Designer: Peter Verheul
Year: 2004
Distributor: OurType
Use: For book typography, but it is also an excellent typeface for corporate identities.

CHARACTER SET FOR VERSA ROMAN FONTS

ABCDEFGHIJKLMNOPQRSTUVWXYZ abcdefghijkmnopqrstuvw
xyz & 1234567890 ÆŒØæœ®fiflß∂∂ı ªº$¢£¥ƒ€ %‰#°·
‹≤≥±›÷¬≈≠+∞√ʃ/µ .,:;!¡?¿'"‹'›,""„-–—‹›«»() []{}/|\…_†‡§¶*·
@©®™´^¨`˜˘˙° ÁÂÄÀÅÃÇÉÊËÈÍÎÏÌÑÓÔÖÒÕÚÛÜÙÝ áâäàã
çéêëèíîïìñóôöòõúûüùÿ

VERSA LIGHT, NORMAL, SEMIBOLD, BOLD & BLACK

ABDEGHKNORSVXYZabcdefghkoprstvxyz
ABDEGHKNORSVXYZabcdefghkoprstvxyz
ABDEGHKNORSVXYZabcdefghkoprstvxy
ABDEGHKNORSVXYZabcdefghkoprstv
ABDEGHKNORSVXYZabcdefghkoprst

VERSA CONDENSED LIGHT, NORMAL, SEMIBOLD, BOLD & BLACK

ABDEHKNORSVXYZabcdefghkoprstvxyz
ABDEGHKNORSVXYZabcdefghkoprstvxyz
ABDEGHKNORSVXYZabcdefghkoprstvxyz
ABDEGHKNORSVXYZabcdefghkoprstvxyz
ABDEGHKNORSVXYZabcdefghkoprstvxy

VERSA OFFERS NON-LINING AND SMALL CAPS FIGURES

1234567890 &£$€ @ 1234567890 &£$€ @
1234567890 &£$€ @ 1234567890 &£$€ @
1234567890 &£$€ @ 1234567890 &£$€ @
1234567890 &£$€ @ **1234567890 &£$€ @**
1234567890 &£$€ @ **1234567890 &£$€ @**

CHARACTER SET FOR VERSA SMALL CAPS FONTS

ABCDEFGHIJKLMNOPQRSTUVWXYZ ABCDEFGHIJKLMNOPQRSTU
VWXYZ & 1234567890 ÆŒØÆŒ® FIFLSS∂∂ı ªº$¢£¥ƒ€ %‰#°·
‹≤ ≥±›÷¬≈≠ +∞√ʃ/µ .,:;!¡?¿'"‹'›,""„-‹›«»()[]{}/|\…_†‡§¶*·
@©®™´^¨`˜˘˙° ÁÂÄÀÅÃÇÉÊËÈÍÎÏÌÑÓÔÖÒÕÚÛÜÙÝ ÁÂÄÀÅÃ
ÇÉÊËÈÍÎÏÌÑÓÔÖÒÕÚÛÜÙÝ

VERSA LIGHT ITALIC, NORMAL ITALIC, SEMIBOLD ITALIC, BOLD ITALIC & BLACK ITALIC

ABDEGHKNORSVXYZabcdefghkoprstvxyz
ABDEGHKNORSVXYZabcdefghkoprstvxyz
ABDEGHKNORSVXYZabcdefghkoprstvxyz
ABDEGHKNORSVXYZabcdefghkoprstvxyz
ABDEGHKNORSVXYZabcdefghkoprstvxyz

VERSA CONDENSED LIGHT ITALIC, NORMAL ITALIC, SEMIBOLD ITALIC, BOLD ITALIC & BLACK ITALIC

ABDEGHKNORSVXYZabcdefghkoprstvxyz
ABDEGHKNORSVXYZabcdefghkoprstvxyz
ABDEGHKNORSVXYZabcdefghkoprstvxyz
ABDEGHKNORSVXYZabcdefghkoprstvxyz
ABDEGHKNORSVXYZabcdefghkoprstvxyz

1234567890 &£$€ @ *1234567890 &£$€ @*
1234567890 &£$€ @ *1234567890 &£$€ @*
1234567890 &£$€ @ *1234567890 &£$€ @*
1234567890 &£$€ @ ***1234567890 &£$€ @***
1234567890 &£$€ @ ***1234567890 &£$€ @***

ned *ned*

ned ned

dagen

dagen

dagen

dagen

a nerkotsyb

lmigf jzxvw

æfiœ Hfl fc,.

The strength of Versa is evident in large x-heights, as used in headlines or posters. The sobriety of its forms and its delicate character also make it appropriate for the composition of texts in shorter x-heights.

Applications

Stefan Hattenbach

www.macrhino.com

A painstaking collaboration between MRF and Psy/Ops Type Foundry produced Sophisto. It was born from a search for a sans serif with a strong character but humble enough to be functional for most uses. It grew into an extensive family of 21 fonts, made to work well in both text and display settings. Corresponding buttons, images, and patterns make Sophisto even more useful as a complete type system.

MRF (MAC Rhino Fonts) was established in 2003, but founder Stefan Hattenbach has been producing fonts ever since 1997. The foundry operates as an independent studio, collaborating with its partners in various disciplines whenever necessary.

MRF has accelerated its type design efforts in recent months. This will continue, along with advertising and graphic design work. In most cases, MRF typefaces are available from a variety of quality vendors: Fountain Type Foundry, PsyOps Type Foundry, and Veer. You'll find a link to respective resellers on each typeface page.

In the future, a unique collection of typefaces will be available exclusively through MRF.

MRF also specializes in custom type design. The company can customize existing designs or create original typefaces for a variety of uses, such as corporate branding.

Over the years, the MRF typefaces have won recognition and a reputation for quality and style. Apart from being used by graphic designers around the globe, MRF typefaces have also been presented, displayed, and mentioned in various publications.

Sophisto

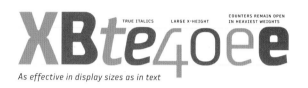

TRUE ITALICS LARGE X-HEIGHT COUNTERS REMAIN OPEN IN HEAVIEST WEIGHTS

As effective in display sizes as in text

Family: Sophisto
Weights: A gauge small caps, B gauge small caps, C gauge small caps, buttons A, buttons B, buttons C, A gauge expert, B gauge expert, C gauge expert, images, patterns, A gauge, B gauge, C gauge, D gauge, D' gauge, A gauge italic, B gauge italic, C gauge italic, D gauge italic, D' gauge italic
Designer: Stefan Hattenbach
Year: 2003
Distributor: Psy/Ops Type Foundry, Psyops
Use: Magazines, corporate identities, annual reports, etc.

A GAUGE SMALL CAPS	A GAUGE EXPERT	A GAUGE	A GAUGE ITALIC
SPANGLE	½⅔¾ftfffj	spangle	*spangle*
B GAUGE SMALL CAPS	B GAUGE EXPERT	B GAUGE	B GAUGE ITALIC
SPANGLE	½⅔¾ftfffj	spangle	*spangle*
C GAUGE SMALL CAPS	C GAUGE EXPERT	C GAUGE	C GAUGE ITALIC
SPANGLE	½⅔¾ftfffj	spangle	*spangle*
BUTTONS A	IMAGES	D GAUGE	D GAUGE ITALIC
		spangle	*spangle*
BUTTONS B		D GAUGE	D GAUGE ITALIC
		spangle	*spangle*
BUTTONS C	PATTERNS	D GAUGE	D GAUGE ITALIC
		spangle	*spangle*

[MultiVitómix]

quasi-hazardous soft epoxy resins, containing traces of

POLYURETHANES

ACTIVE INGREDIENTS: perjon butoxide guar gum

Take only as directed

lanolin alcohol

lauric acid, glycerine, métrolatum, red dye #34

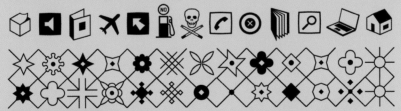

XBte4oee

TRUE ITALIC LARGE X-HEIGHT

As effective in display sizes as in text

Applications

American Airlines uses Sophisto in *Nexos* magazine, which is complementary on Spanish-speaking fights. Sophisto's functional character allows for use inside the magazine as well as on the cover.

Gerard Unger

www.gerardunger.com

BigVesta could be defined as the Vesta with a large x-height. It was created by Gerard Unger, who has worked as a freelance designer since 1975 and whose talent covers a wide variety of fields, from stamps, coins, magazines, newspapers, books, and logos to corporate identities, annual reports, and other objects, along with many typefaces. He teaches as a visiting professor at the University of Reading, UK, Department of Typography and Graphic Communication, and as a professor of typography at the University of Leiden, Netherlands.

Vesta, originally conceived for Rome on the occasion of the 2000 jubilee, was this project's normal alternative to Capitolium, a roman typeface also designed for that occasion. It was designed freely, as a normal typeface for general use. It is a strong performer for use in magazines and newspapers as well as in corporate identities. It also combines well as a typeface for headings with other Gerard Unger designs.

In comparison with Vesta, BigVesta is larger and darker (in its regular versions). Its counters are more open than those of many other normal typefaces, lending it greater legibility. The letterforms of BigVesta can be easily condensed without distortions, thus making the number of variations much larger than the standard fourteen. It offers a pleasant texture that encourages reading. The contrast between its thin and thick strokes, also uncommon in normal typefaces, is heightened, especially in the joins between the curves and straight lines of certain letters, such as the *b*, *d*, *p* and *q*, among others. However, its modulation is gentle, affording the design elegance.

A simple glance could give the impression that BigVesta is a typeface of simple design, but if carefully observed, its countless details are instantly recognizable. For example, the design of the stem of the italic *b* at its lower part is a feature from roman typefaces. The experience and skill of this designer are clearly visible in these details, which make BigVesta a high-quality and versatile typeface, offering a wide range of variations and providing an exceptional typographical palette for all manner of uses, from long text to headings.

BigVesta

abcd
mno

Family: BigVesta
Variants: BigVesta Light, BigVesta Light Italic, BigVesta Regular, BigVesta Regular Italic, BigVesta Medium, BigVesta Medium Italic, BigVesta Semi Bold, BigVesta Semi Bold Italic, BigVesta Bold, BigVesta Bold Italic, BigVesta Extra Bold, BigVesta Extra Bold Italic, BigVesta Black, BigVesta Black Italic
Designer: Gerard Unger
Year: 2003
Distributor: Gerardunger
Use: Display and long text
Other uses: Any
Advice or considerations: Designed to be combined with the Swift 2.0, Gulliver, Capitolium, and Coranto families

ABCDEFGHIJ
KLMNOPQRS
TUVWXYZ&

abcdefghijkl
mnopqrstuv
wxyzæœß/@
Ø(–).:;!?€¥§
1234567890

AlpineStars

Photography, Videography, Graphic an

Physiologie
de la lecture

A storm aproaching fi

der frühling ist shon

Repub

sea

ca-

Playful

As is the case with its older sister EtalageScript, the DF-Ariënne family was developed and inspired by the existing typography on the stencils used by farmer Boelema to mark his grain sacks at Lalleweer.

It takes its name from the graphic designer Ariënne Boelens, for whom the type was custom made and created with a wink to the 'lost' display types in her display window. In return for this custom type, she created the Web site at www.lalleweer.nl for designer Ko Sliggers.

The typeface consists of only one family so far because it is a derivation of the EtalageScript font, which already has two weights. It nevertheless has its own strong personality, more enchanting and ornate than its sibling.

After setting up his one-man studio in 2002, Sliggers started marketing commercial fonts at www.lallerweer.nl, a site named after Lallerweer, a hill in the northeastern part of Holland on top of which his studio is based. More recently, he started distributing fonts he designs through www.dutchfonts.com.

His signature sophisticated style is subtly structured but unconventional. "Dutchfonts is typically Dutch in the sense that it combines precision and rationality with Dada-like anarchism and irreverence," says Dutch designer and writer Jan Middendorp, editor of *Druk*, a magazine about type and visual culture.

Ariënne shares this contradictive trait in the way that it combines a delicate and exquisite structure with a far more cheeky and seductive look, giving an urbane touch to any display work it may be used in.

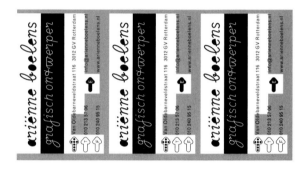

Family: DF-Ariënne™
Weights: Regular
Designer: Ko Sliggers
Year: 2003
Distributor: Dutchfonts
Use: Display

Ariënne™

postscript Type 1 Font design bo sliggers 2002-2003

dutch fonts studio

aA	bB
aA	bB

cC	dD	eE	fF	gG	hH	iI	jJ
cC	dD	eE	fF	gG	hH	iI	jJ

kK	lL	mM	nN	oO	pP	qQ	rR
kK	lL	mM	nN	oO	pP	qQ	rR

sS	tT	uU	vV	wW	xX	yY	zZ
sS	tT	uU	vV	wW	xX	yY	zZ

character set

1234567890§=[({})]a
bcdefghijklmnopqrs
tuv wxyz:\:,./+!@#$
&·ABCDEFGHIJKLM
NOPQRSTUVWXYZ;¨
‹›?®©™·ÆŒ£¥ßæœçi
«»ÂÁÇ£ÑÖÚ áàâáäã
éèéêïiíïôòóöøúûùü
ÀÒÿÿßÂ£ÀÉÈÌÌ Ó ●●●
ùûü¨`´˘¨

www.dutchfonts.com 2005

characteristics

7/9 pt

Ut primum alatis tetigit Magalia plantis, Aeneam fundantem arces ac tecta novantem conspicit. Atque illi stellatus iaspide fulva ensis erat Tyrioque ardebat murice laena demissa ex numeris, dives quae munera. Dido fecerat, et tenui telas discreverat auro. Continuo invadit tu nunc Karthaginis altae fundamenta locas pulchramque uxorius urbem exstruis? Heu, regni rerumque oblite tuarum! Ipse deum tibi me claro demittit Olympo regnator, caelum et terras qui numine torquet, ipse haec ferre iubet celeres mandata per auras: quid struis?

8/10 pt

Aut qua spe Libycis teris otia terris? Si te nulla movet tantarum gloria rerum, Ascanium surgentem et spes heredis Iulirespice, cui regnum Italiae Romanaque tellus debetur Tali Cyllenius ore locutus, mortales visus medio sermone reliquit et procul in tenuem ex oculis evanuit auram. At vero Aeneas aspectu obmutuit amens, arrectaeque horrore comae et vox faucibus haesit. Ardet abire fuga dulcesque relinquere terras, attonitus tanto monitu imperioque deorum. Heu quid agat?

9/11 pt

Ut primum alatis tetigit Magalia plantis, Aeneam fundantem arces ac tecta novantem conspicit. Atque illi stellatus iaspide fulva ensis erat Tyrioque ardebat murice laena demissa ex numeris, dives quae munera. Dido fecerat, et tenui telas discreverat auro. Continuo invadit tu nunc Karthaginis altae fundamenta locas pulchramque uxorius urbem exstruis? Heu, regni rerumque oblite tuarum! Ipse deum tibi me claro demittit Olympo regnator, caelum et terras qui numine torquet, ipse haec ferre iubet celeres mandata per auras: quid struis?

10/12 pt

Aut qua spe Libycis teris otia terris? Si te nulla movet tantarum gloria rerum, Ascanium surgentem et spes heredis Iulirespice, cui regnum Italiae Romanaque tellus debetur Tali Cyllenius ore locutus, mortales visus medio sermone reliquit et procul in tenuem ex oculis evanuit auram. At vero Aeneas aspectu obmutuit amens.

18/18 pt

Ut primum alatis tetigit Magalia plantis, Aeneam fundantem arces ac tecta novantem conspicit.

24/24 pt

Aut qua spe Libycis teris otia terris? Ascanium surgentem et spes heredis cui regnum.

This family, as its name suggests, makes reference to the novel *Rayuela* (1963), by Julio Cortázar, a literary piece that gives this typeface certain concepts as raw material for its design. One of these is the conception of life as a game and the vision of man as persecutor. The family Rayuela is the result of the graphical exploration of the philosophical and aesthetical concepts of Cortázar's literature, mixed with the point and view and skills of Alejandro Lo Celso. His design began as part of the requirements for a Masters in Typeface Design at the University of Reading, in the UK.

Rayuela is a typeface family that exudes dynamism. None of its stems are straight; they all have a gentle playful curve, which gives them movement. In the composition of texts, this creates an interesting texture. The contrast, although almost nonexistent, is sufficient; its modulation is soft due to the light contrast between the thick and thin strokes. All these characteristics, together with the serif design, make you wonder whether Rayuela is a roman typeface or a normal one. In fact, it is neither one nor the other. Rayuela has its own identity, which means it does not fit into any typeface classification, either from an aesthetic or a historical point of view. Apart from its informality, it also creates the impression on paper of being inclined. In addition, the shape of its characters is very close to handwriting, which is easily visible in letters like *n*, *k*, *p*, and *v*. All this creates a certain tension on the page.

Considering these alternative characteristics, it is difficult to believe that this family was initially created for text. Although it works surprisingly well in small bodies, its aesthetic appearance makes it ideal for displays, since it shows the elegance of all its details.

Rayuela is, without a doubt, an original typeface that explores frontiers by working with normal typeface elements. Incorporated with these are attributes of long text, traditionally occupied by purely roman typefaces.

Rayuela

Un gros cochon à cigare qui me prenait pour sa chose et m'obligeait à toutes ses saletés.

Ça n'a pas été long qu'il m'a posé ses conditions. Je devais acheter ma dope de lui, lui verser un montant par jour pour la location de la chambre, un autre pour sa protection et un pourcentage de l'argent que je faisais des clients. Il me restait pas grand-chose. C'était pour mon bien, pour ma protection... En fait de protection j'ai eu plus de coups du proxo que des clients, une bande de désœuvrés riches qui ne savent plus à quels divertissements se vouer. Il y avait dans ces professeurs d'université et des juges pires encore que les petits ouvriers du coin. J'ai pas eu beaucoup de petits ouvriers, ils n'ont pas d'argent à gaspiller peut-être ou ils ont d'autres divertissements. [...]

En plus de la drogue, je me suis mise à l'alcool parce que je ne pouvais pas me regarder en pleine face faire ce que je faisais. Vous devez vous demander comment ça se fait que j'en suis sortie. Un jour ma mère s'est suicidée et ça a été un choc, mon père, un gros bonnet des affaires, ne voulait plus rien savoir de moi depuis longtemps. Toute seule pour vivre cet événement... Une fois j'ai dépassé les bornes et il y a quelqu'un qui m'a trouvée inconsciente sur la rue et m'a conduite au centre social au lieu de la police. J'étais pas en mesure de décider quel que chose par moi-même, ils m'ont mise dans une maison où un travailleur social me visitait régulièrement. C'est bien l'un des rares gars qui n'a pas essayé de profiter de la situation. Parfois, c'était une travailleuse sociale et parfois les deux à la fois, ils travaillaient en équipe. Aussi bien vous dire qu'ils ne m'en ont pas fait accroire, ils m'ont donné l'heure juste. T'as 20 ans, qu'ils ont dit, t'es capable de te sortir de cet enfer — pas de philosophie sur le travail du sexe travail comme un autre, pas de propos complaisants pour m'amadouer et de grandes rationalisations pour que je ne pense pas qu'ils jugent. **La vérité en pleine face.** On peut t'aider, mais seulement si tu le veux, c'est ta vie, pas la nôtre, t'es en train de te détruire, mais si c'est ça que tu veux continuer, c'est ton affaire. Mais tu vas pas vivre vieille du train que t'es partie. Si tu veux t'en sortir, on va t'aider. T'es pas obligée de décider tout de suite, on va revenir et tu nous le diras. Mais fais-nous pas des accroire sur la soi-disant libération dans la prostitution, on connaît la chanson, t'es pas la première qu'on voit.

J'ai été dans cette maison de transition pendant des mois, j'étais fuckée complètement, pour faire une histoire courte j'ai été en désintox et ai rechuté. Je me suis sauvée et je suis revenue, des allers et retours plusieurs fois. Les travailleurs sociaux étaient patients, pas surpris des rechutes et des retours. [...] Au bout du compte j'ai fini par étudier, j'avais bien du retard, j'ai fait le tour pas me manquait, il fallait que je traîne aussi les conséquences de mes années de drogue, d'alcool, les coups, le sexe à répétition, ça use. **Mais j'ai fini par m'en sortir, un jour j'ai su qu'il y avait un point de non-retour [...]**

Family: Rayuela
Weights: Rayuela Regular, Rayuela Regular Itálica, Rayuela Regular Versalitas, Rayuela Ligera, Rayuela Ligera Itálica, Rayuela Ligera Versalitas, Rayuela Chocolate, Rayuela Luz, Rayuela Misceláneas
Designer: Alejandro Lo Celso
Year: 2000
Distributor: Myfonts, Fonts
Use: Long text
Other uses: Display, in Chocolate, Luz y Misceláneas
Advice or considerations: Can be used for display in its text versions.

Rayuela Ligera

ABCDEFGHIJKLMNÑOPQRSTUVWXYZ
abcdefghijklmnñopqrstuvwxyz
1234567890!@#$%&()=?

Rayuela Ligera Versalitas

ABCDEFGHIJKLMNÑOPQRSTUVWXYZ
ABCDEFGHIJKLMNÑOPQRSTUVWXYZ
1234567890!@#$%&()=?

Rayuela

ABCDEFGHIJKLMNÑOPQRSTUVWXYZ
abcdefghijklmnñopqrstuvwxyz
1234567890!@#$%&()=?

Rayuela Versalitas

ABCDEFGHIJKLMNÑOPQRSTUVWXYZ
ABCDEFGHIJKLMNÑOPQRSTUVWXYZ
1234567890!@#$%&()=?

Rayuela Luz

ABCDEFGHIJKLMNÑOPQRSTUVWXYZ
ABCDEFGHIJKLMNÑOPQRSTUVWXYZ
1234567890!@#$%&()=?

Rayuela Miscelánea

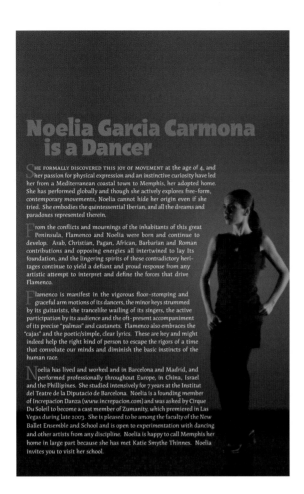

Noelia Garcia Carmona is a Dancer

She formally discovered this joy of movement at the age of 4, and her passion for physical expression and an instinctive curiosity have led her from a Mediterranean coastal town to Memphis, her adopted home. She has performed globally and though she actively explores free-form, contemporary movements, Noelia cannot hide her origin even if she tried. She embodies the quintessential Iberian, and all the dreams and paradoxes represented therein.

From the conflicts and mournings of the inhabitants of this great Peninsula, Flamenco and Noelia were born and continue to develop. Arab, Christian, Pagan, African, Barbarian and Roman contributions and opposing energies all intertwined to lay Its foundation, and the lingering spirits of these contradictory heritages continue to yield a defiant and proud response from any artistic attempt to interpret and define the forces that drive Flamenco.

Flamenco is manifest in the vigorous floor-stomping and graceful arm motions of its dancers, the minor keys strummed by its guitarists, the trancelike wailing of its singers, the active participation by its audience and the oft-present accompaniment of its precise "palmas" and castanets. Flamenco also embraces the "cajas" and the poetic/simple, clear lyrics. These are key and might indeed help the right kind of person to escape the rigors of a time that convolute our minds and diminish the basic instincts of the human race.

Noelia has lived and worked and in Barcelona and Madrid, and performed professionally throughout Europe, in China, Israel and the Phillipines. She studied intensively for 7 years at the Institut del Teatre de la Diputacio de Barcelona. Noelia is a founding member of Increpacion Danza (www.increpacion.com) and was asked by Cirque Du Soleil to become a cast member of Zumanity, which premiered in Las Vegas during late 2003. She is pleased to be among the faculty of the New Ballet Ensemble and School and is open to experimentation with dancing and other artists from any discipline. Noelia is happy to call Memphis her home in large part because she has met Katie Smythe Thinnes. Noelia invites you to visit her school.

NO
ME
PIERDAS
COMO
UNA
MÚSICA
FÁCIL

NO
SEAS
CARICIA
NI
GUANTE

TÁLLAME
COMO
UN
SÍLEX

DESESPÉRAME

Extracto de: ENCARGO, poema de Julio Cortázar *(Paris 1951/1952)*

Rayuela is characterized by a dynamic character that turns it into an ideal typography for display. It does not have any straight lines, and it plays with the movement of light curves, thus giving a soft modulation to the composition of the texts.

Pollen has been designed intentionally for long text, although its informal nature and almost infantile feel also make it ideal for use with many larger bodies, such as display typeface.

It is closely linked to calligraphy since its creator, Eduardo Berliner, began the design process of this family practicing with different types of pens and brushes, tools that were a base for drawing letters in pencil. According to the designer himself, this calligraphic exercise helped him to understand structure and typographical proportions.

The details of Pollen reveal the use of the different techniques that Berliner applies when creating the basic structure of this typeface. Normally a typeface family is derived from the influence of a single tool; however, in this case the pen and brush create an interesting fusion.

In some letters, for example the *a*, the brush stroke can be clearly seen as it flows, creating terminals that are typical of this tool. Other shapes reveal the use of the pen, for example, the letter *n*, which has a more typographical structure. Finally letters like *k* show that the combination of these two tools is not just possible in the same typeface, but that it can also occur in the same glyph.

Another important characteristic of Pollen is the design of certain letters (like the *e*, *g*, *v*, *w* and *y*, among others) in their Roman and Bold versions, which are very similar to Italic forms. All these peculiarities combine to lend this family a playful and cheerful nature. Berliner demonstrates that he has the ability to take various elements from different fonts and join them in an exceptional way, creating a unique typeface with a strongly human character, which flows across the page like brush strokes over a canvas.

Pollen

Family: Pollen
Weights: Pollen Roman, Pollen Bold, Pollen Italic
Designer: Eduardo Berliner
Year: 2003
Distributor: eduardoberliner@hotmail.com
Use: Long text
Other uses: Display
Advice or considerations: Do not use in bodies smaller than 7 point

Pollen

Regular

My dog with a metal structure on its leg to fix a broken bone, broken tile on the bottom of a swiming pool, red soil and a waste deposit with huge empty packages of dog food with a picture of a dog with colors faded by sun light. Streets illuminated by a yellowish mercury light, an ambulance in front of the building next to mine with lights turning on the top but making no sound, an old black car parked under the mid-day sun with a metallic shade on the front window to prevent overheating.

Bold

A storm aproaching from the sea and sound of thunder echoing on the mountains, a turtle in the ocean showing its face for a second and desappearing, Lucia with red eyes, turtles on card boxes covered by newspaper, lettuce and excrement.

Italic

A humming bird hitting its head on the window trying to get away. One day I held a dead one in my hand. Its tongue was long, black and thin. In Caraiva there is no eletricity, but the reflection of the moonlight on the white sand is so bright that you can identify shapes in the dark. Mrs. Stevan ironing clothes and listening to the radio histories about love and murder. Waterfall. Airport.

Applications

Eduardo Berliner started creating this typography while practicing calligraphy with different types of quills and brushes in order to understand the typographic proportions.

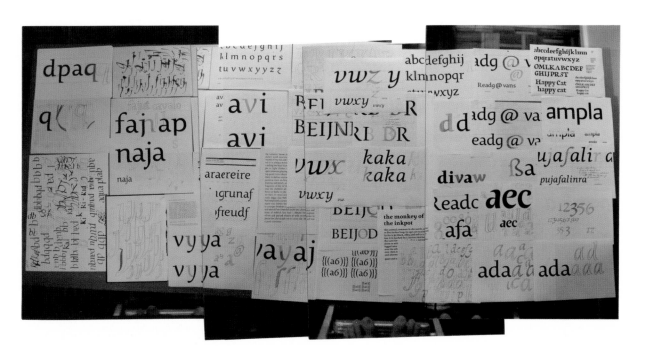

Sketches

After the Staple Mono, Ko Sligger's answer to the commercial typewriter-style fonts, comes the Staple Text. The DF-StapleTXT™ is a transformation from Dutchfont's monospaced typewriter font DF-Staple mono™ to a type that's better suited to text use.

The mono skeleton was replicated as much as possible, although some characters were slightly altered and adapted in order to obtain more regularity. However, the slight alterations that make the difference do so without letting the font lose its specific typewriter effect because they only involve a little variation in character widths. The font has lining figures, and it works very well as a text system in combination with the Staple mono.

The family contains 30 styles in total, providing many options for designing text. Five different weights come in both Roman and Italic, each with small caps and expert styles. They can be purchased as an integrated family package as well as separately.

Once again Ko Sliggers provides an excellent font inspired by everyday objects and of a somewhat accidental nature. In this case, his design is derived from a typeface based on the shapes that were created with a simple staple. "My career path intentionally happened by accident, or in other words was an accidental intention. Beware: I'm switching back to food in the future," says the former chef of a professional life split between graphic design, typography, and the culinary world. "I raised two wonderful pigs, and I was really impressed by the *profondeur* of getting to understand both the outside and inside of this wonderful creature. One hundred percent organic, of course. I'm preparing a book about the whole project, which will be released in October 2007."

In the words of its designer, Staple Text is a "female but economical linear sans." It is designed for and well suited to text, especially since its many weights and versions contain many options for highlighting passages.

Staple TXT

Family: StapleTXT™
Weights: Regular, Regular Italic, Medium, Medium Italic, Bold, Bold Italic, Heavy, Heavy Italic, Black, Black Italic
Designer: Ko Sliggers
Year: 2005
Distributor: Dutchfonts
Use: Display, text

Staple TXT™ medium

Windows TrueType, Postscript Type 1 & MacOS Postscript Type 1 font

design ko sliggers 2003-2005

aA	bB
aA	bB

cC	dD	eE	fF	gG	hH	iI	jJ
cC	dD	eE	fF	gG	hH	iI	jJ

kK	lL	mM	nN	oO	pP	qQ	rR
kK	lL	mM	nN	oO	pP	qQ	rR

sS	tT	uU	vV	wW	xX	yY	zZ
sS	tT	uU	vV	wW	xX	yY	zZ

character set

www.dutchfonts.com 2005

abcdefghijklmnopqrst
uvwxyzABCDEFGHIJKL
MNOPQRSTUVWXYZ123
4567890ÄÀÂÃÁÉÊÊÈ
ÍÎÏÌÖÔÕÒÚÛÜÙÑÇŸÆŒ
Øæœáâàãäåéêèëíìîïóòô
õöúùûüñçÿ€£¥$§&#Ω!?
¿¡=±%ˆˋ\‹«|»›/_+:˜˝®
©™´fi[({†})]fl1µ∂∑π∏ʃªº
Ø√ƒ=∆≠∞;ˋˋ,.ˆˉ¨˘˙

characteristics

ak
gt

7/9 pt
Ut primum alatis tetigit Magalia plantis, Aeneam fundantem arces ac tecta novantem conspicit. Atque illi stellatus iaspide fulva ensis erat Tyrioque ardebat murice laena demissa ex numeris, dives quae munera Dido fecerat, et tenui telas discrevat auro. Continuo invadit: 'tu nunc Karthaginis altae fundamenta locas pulchramque uxorius urbem exstruis? Heu, regni rerumque oblite tuarum! Ipse deum tibi me claro demittit Olympo regnator, caelum et terras qui numine torquet, ipse haec ferre iubet celeres mandata per auras: quid struis?

8/10 pt
Aut qua spe Libycis teris otia terris? Si te nulla movet tantarum gloria rerum, Ascanium surgentem et spes heredis Juli respice, cui regnum Italiae Romanaque tellus debetur'. Tali Cyllenius ore locutus, mortales visus medio sermone reliquit et procul in tenuem ex oculis evanuit auram. At vero Aeneas aspectu obmutuit amens, arrectaeque horrore comae et vox faucibus haesit. Ardet abire fuga dulcesque relinquere terras, attonitus tanto monitu imperioque deorum. Heuquid agat?

9/11 pt
Ut primum alatis tetigit Magalia plantis, Aeneam fundantem arces ac tecta novantem conspicit. Atque illi stellatus iaspide fulva ensis erat Tyrioque ardebat murice laena demissa ex numeris, dives quae munera Dido fecerat, et tenui telas discrevat auro. Continuo invadit: 'tu nunc Karthaginis altae fundamenta locas pulchramque uxorius urbem exstruis? Heu, regni rerumque oblite tuarum! Ipse deum tibi me claro demittit Olympo regnator, caelum et terras qui numine torquet.

10/12 pt
Aut qua spe Libycis teris otia terris? Si te nulla movet tantarum gloria rerum, Ascanium surgentem et spes heredis Juli respice, cui regnum Italiae Romanaque tellus debetur'. Tali Cyllenius ore locutus, mortales visus medio sermone reliquit et procul in tenuem ex oculis evanuit auram.

18/18 pt
Ut primum alatis tetigit Magalia plantis, Aeneam fundantem arces ac tecta novantem conspicit.

24/24 pt
Aut qua spe Libycis teris otia terris? Ascanium surgentem et spes heredis cui regnum.

36/36 pt
Ut primum alatis teti git Magalia fundantem conspicit.

Thomas Huot-Marchand

Every typeface designer is characterized by his desire to take on new challenges. Thomas Huot-Marchand is no exception. With Minuscule—a typeface family designed especially for use in extremely small bodies that can be between 2 and 6 point—he has developed a project of extreme complexity, whose initial phase took place in the Atelier National de Recherche Typographique, in Nancy (France). The designer immersed himself in the texts of Émile Javal, a French ophthalmologist who, in 1905, published *Physiologie de la lecture et de l'écriture*, which, for the first time, explained the reading process from a scientific standpoint.

Minuscule has very open counters and an exaggerated x-height, which increases its legibility. In such small bodies, it is crucial to increase the size of the more significant elements of each of the characters. For this, Huot-Marchand decided to carry out a process of simplification, which consisted of keeping only those elements needed to recognize each glyph. Work on such a small scale requires the reduction of ascenders and descenders. However, as in the reading process, the human eye focuses on the upper half of the letters. Thus, the ascenders cannot be reduced in proportion to the descenders, since the latter have less influence on the recognition of a particular letter. Their shape and size, therefore, hardly affect the reading.

Minuscule is a project with limited use; however, it is an interesting typeface that teaches us how to resolve legibility problems under extreme conditions. Minuscule can therefore be defined as a highly rigorous scientific exercise in nanotypology.

Minuscule

AN ORIGINAL DESIGN BASED ON ÉMILE JAVAL'S WORK, A 19TH CENTURY OPHTALMOLOGIST, WHO PUBLISHED IN 1905 AN AMAZING BOOK ENTITLED

Physiologie de la lecture et de l'écriture

BIBLIOTHÈQUE SCIENTIFIQUE INTERNATIONALE, PARIS, ÉD. ALCAN

FIVE FONTS DEVELOPPED IN OPENTYPE FORMAT WITH EXTENSIVE CHA RACTER SETS INCLUDING LINING & OLD STYLE FIGURES EXPERT SETS, FRACTIONS, AND MORE

Family: Minuscule
Variants: Minuscule Six, Minuscule Cinq, Minuscule Quatre, Minuscule Trois, Minuscule Deux
Designer: Thomas Huot-Marchand
Year: 2002–2005
Distributor: Foundry 256
Use: Text in an extremely small size, between 2 and 6 point
Other uses: Not recommended
Advice or considerations: Use each typeface in the specific size it has been designed for.

Minuscule Quatre Minuscule Trois

ep ep

Typographie
Typographie
Typographie
Typographie
Typ■graphie

ABCDEFGHIJKLMNOPQRSTUVWXYZ

ABCDEFGHIJKLMNOPQRSTUVWXYZ

abcdefghijklmnopqrstuvwxyzæœ

0123456789&0123456789

ÆÇŒØ§¥¢£$

ÁÀÂÄÃÅĀĂĄÆĆČĈĊĎÐÉÈÊËĔĚĖĘĜĜĢĠĦĤÍÌÎÏİĮĨĬĹĽĻŁŊÑŊŃŇŅ

ÓÒÔÖÕŐŐ ŌŔŘŖŚŜŞŠŤŦŢÚÙÛÜŬŰŪŲŮŨŴŶÝŸŽŹŻÐÞ

ÆŒÇÐÁÀÂÄÃÅÉÈÊËÌÍÎÏŁÑÓÒÔÖÕÚÙÛÜŸÝŽÞ!?¡¿

æáàâäãåāăąæçćčĉċďđéèêëĕěėēęfiflffffiffl ğĝ ģġ ħ ĥí ì î ï ī į ĩ ĵ ķ ĸ íľ ļłŋñ ŋ ń ň ņ

œóòôöõőőōøǿŕřŗśŝŝ šßʃ ŧ ťţúùûüŭűūųůũŵ ŷ ý ÿ ž ź ż ð þ

#´()*+,-./:;<=>!?¿¡&[\]†®©™¶°•´¨ˆ≠«»…--—˝˝˝`'÷/‹›‡·%‰

{0123456789/0123456789} abdeilmorst

½ ¼ ¾ ⅛ ⅜ ⅝ ⅞ ⅓ ⅔ ↖↗↙↘↓↑→←

à cette échelle,
Minuscule Six, 6 & 60 pts

à cette échelle,
on lit surtout
la différence
entre les lettres.

on lit surtout
Minuscule Cinq, 60 & 5 pts

la différence
Minuscule Quatre, 4 & 60 pts

entre les lettres.
Minuscule Trois, 3 & 60 pts

At this scale, we mainly read the difference between letters.

At this scale, we mainly read the difference between letters.
Minuscule Deux, 12 & 2 pts

Sample

This typography is the result of a complex research process, and it is used in very short x-heights. The use of Minuscule is limited, but it solves legibility problems in extreme situations.

Revue Suisse de l'Imprimerie 2 2004

Swiss Typographic Magazine

Typographische Monatsblätter

TM
Typographische Monatsblätter
Zeitung für Schrift, Typografie, Gestaltung und Sprache
Herausgegeben von der Medienqewerkschaft comedia zur Förderung der Berufsbildung

STM
Swiss Typographic Magazine
Journal for Lettering, Typographic Composition, Design and Communication
Published by the Union comedia of Switzerland for the advancement of education

RSI
Revue pour la lettre, la typographie, la conception graphique et le langage
Éditée par le syndicat des médias comedia pour l'éducation professionelle

TM RSI STM 2 2004

Applications

Suiteserif is an elegant typographic family comprising four variations created especially to be used in texts for the fashion magazine *Suite*, edited in Barcelona since 2001.

The magazine has a meticulous image. Its graphic identity is based on a particular use of white, the generation of tension on the page and on the typographical personality. Suiteserif contributes towards the latter, which, in terms of the composition of the magazine's texts, takes the headlining role. It carries this off with great efficiency, providing an uncluttered and clean-cut look to the typographic element, which balances and complements the layout.

Its design is elegant and clean; its open and rectangular counters make it ideal for use with small bodies of text. The angles of the counters contrast with their curves, a pattern echoed in the way its soft spurs set off the rigidity of its serifs.

When closely observed, many high-quality details such as these can be appreciated. Another example of small detail work can be seen taking a look at the asymmetrical serifs—which closely resemble the calligraphic terminals that would be produced by a broad nib pen—or the solution for the upper part of the letter *f*.

The Italic version of the family is halfway between italic and upright type. It presents both italic forms, which is the case for the letters *a* and *e*, for example, as well as forms that are closer to being upright, as seen in the letters *s*, *v*, *w*, *y* and *z*, among others. Its terminals in the letters *a*, *d*, *h*, *i*, *k*, *l*, *m*, *n* and *u*, which are fairly rigid, are also quite close to being upright. The terminals of the italic typefaces are generally of a looser stroke since they are more closely related to calligraphy.

SuiteSerif

Herbaliser_* Mogwai; &!?1.723@ **Winnipeg.**

Family: Suiteserif
Weights: Suiteserif Regular, Suiteserif Italic, Suiteserif Bold, Suiteserif Bold Italic
Designer: Íñigo Jerez
Year: 2003
Distributor: Textaxis
Use: Long text
Other uses: Display
Advice or considerations: Designed especially for the magazine *Suite*

Domenica in città

as jornadas de duro trabajo, nada mejor que vestirse con las mejores galas para bajar
ier un helado y pasear del brazo de las amigas. Momentos de nostalgia, posguerra de
carencias y mujeres tan exuberantes como hermosas.

SuiteSerif

ABCDEFGHI
JKLMNOP
QRSTUVWX
YZ.&§!?@†
abcdefghi
jklmnopqrstu
vwxyz.fiflß
1234567890
áàâäãå}»%*

a ejksájicn,
c

cigkar, s jirba

sējkiar
reijak

abcdefghijklmnopqrstuvwxyz

Marc

Setm

r, r c
ralk

cajkr, npe

Sketches

The composition of the texts of the Barcelona magazine *Suite* shows the clean and elegant character of this typography with its rectangular shapes and open eyes. With details like asymmetrical serifs of great quality, its shapes make it ideal for texts in short x-heights.

Applications

Elena Albertoni

Dolce began as a research project exploring the possibilities of OpenType, in the Department of Typeface Design of L'École Estienne, in Paris. The resulting typeface, Dolce, attempts to find a balance between tradition and technology with the aim of clarifying what it means to design a Script typeface today.

Dolce mixes aspects of a typographical nature with characteristics influenced by handwriting. Finding the middle ground between these aspects, according to Elena Albertoni, took half of the time that was dedicated to the project.

The choice of creating a Script typeface was the result of the designer wanting to show the full possibilities of this new typeface format. The re-creation of handwriting allows the generation of endless alternative characters. For example, there is the possibility of designing a different glyph for a particular letter, depending on whether it appears at the beginning, in the middle, or at the end of a word. It is also possible to generate, for a single letter, a large number of glyphs, which through OpenType appear only when certain combinations of letters are typed.

Dolce includes an enormous set of ligatures and alternative characters, which appear automatically in the text composition. Its small capitals are accessible through OpenType; however, Elena Albertoni makes them appear automatically when text is typed in uppercase (the idea is that uppercase will combine with lowercase). According to the designer, the uppercase letters should not be set next to each other.

In terms of its design, Dolce is a typeface with charm and a lot of movement. The terminals of its long strokes flow naturally across the page. Its enormous variety makes it ideal for the graphic designer.

Dolce

der frühling ist shon da!
la primavera, che bellezza!
Bonheur et fleures...
Happy Spring
to all of you!

Family: Dolce
Weights: Thin
Designer: Elena Albertoni
Year: 2004
Distributor: Anatoletype
Use: Display
Other uses: Short text
Advice or considerations: This typeface is based on OpenType format

yeux dandy
rayon il y a

à á â ä ą ā å æ ç è é ê ę
ú û ü ý ÿ À Á Â Ä Æ
Ó Ò Ô Ö Ù Ú Û Ü Ý Ÿ
Ò Ô Ö Ù Ú Û Ü Ÿ a a a
v e e e eé et f f f ff
g g g g g g g g g g
h i i l l l l l ll m m n
on ow p pp pp pr r̃ s
tt ou ups v v v v v
em o̅ oo ve er ol c.v.d.
a des non non a d e
t u a b d c o u

CES MAISONS SUSPENDUES À
TA POITRINE DISENT-ELLES QUE
RETIRER LA TÊTE OU LA COUPER
C'EST COMME PLONGER UNE
SONDE DANS LE COEUR OU
UN COUTEAU OU LA BRANCHE
D'UN ARBRE AFIN QUE PASSENT
DE TOI À MOI LE NORD ET
L'ORAGE ET QUELQUES GOUTTES

Speech comes out of
our mouths, our hands,
our eyes in something
like a liquid form and
then evaporates at once.

ι ì í ï ñ ó ò ô ö ō œ ù
Ç È É Ê Ë Ę Ɉ Ɉ Ɉ
À Á Â Ä Ç È É Ê Ë Ì Í Î Ï Ó
alle b b b br c d e e
ffi ffl ffr fi fl fr g g
g g g g g 88 gg h
n n o of of ol ol on
s ss st str t ti ti tr
v v x x y y y y z
Sig. Arrivederci Sig.a
è f g i m n o p r
e h i m n o p s t

Once again Alejandro Lo Celso draws on literature to create a typeface family, this time based on the texts of Argentine writer Roberto Arlt, who started a renaissance of Latin American literature with his boundless imagination, his loveable characters from the underworld—people who go through all manner of misery—and with the introduction of "lunfardo" (slang from Buenos Aires dating back to the nineteenth century).

The designer's creativity and desire to experiment have lead him, in the case of the Arlt family, to offer us a visual display consisting of the unexpected change of the thick strokes and the thin strokes. At an angle of 45 degrees, the axis of this typeface is completely diagonal. It is a daring proposal that Lo Celso very calmly controls.

Its terminals re-create brush strokes while its serifs, with curved beaks on the left side and 90 degree angles on the right, are more reminiscent of the broad nib pen. Lo Celso also plays with the proportions of some letters, as is the case with the *a*, whose upper stroke appears to be disproportionately wide when compared with the lower half of the letter. The *s* is also interesting. Its proportions have been exchanged between the bottom and top half, giving the impression that it is back to front. Some of the letters draw attention because of their beauty, such as the *g* (both in its upright and italic version), whose spur appears to be trying to escape, and the *f*, with its expressive double curve, apparent in the inner part of the upper half. The classically cut uppercase, which combines perfectly with an innovative lowercase, its punctuation marks and its diacritical marks also stand out.

Arlt is, in the words of the designer, "a first attempt at baroque but with an expressionist's spirit." The uprights show the expressionism and the Italics, although created with the same creative freedom, exhibit the more baroque character of the family. Its terminals are finer and have more contrast in general. The beauty of certain letters stands out such as, the *g*, *v*, *w* and, above all the *z*, which shows off the baroque splendor.

Arlt

This writer, an Argentine *novelist* from the 30's and 40's, was *very* important as he was the *introducer* of the 'lunfardo' Buenos Aires' spicy *argot* from the 19th century, into Argentine literature. His œuvre *happily refreshed Hispanic letters.*

Family: Arlt
Versions: Arlt Redonda, Arlt Cursiva and Arlt Versalitas (the designer is in process of developing its four weights: White, Gray, Black and Superblack)
Designer: Alejandro Lo Celso
Year: 2005–2006
Distributor: Myfonts, Veer
Use: Long text
Other uses: Not recommended

afg kms Arlt W!

Arlt Blanca (juego completo de caracteres)

š Ý ý Ž ž – × ł ! " # $ % & ' () * + ,
– . / 0 1 2 3 4 5 6 7 8 9 : ; < = ≈ > ∂ ¬ ∫
√ ? @ A B C D E F G H I J K L M
N O P Q R S T U V W X Y Z [\]
_ ` a b c d e f g h i j k l m n o p q r s t
u v w x y z { ~ } Ä Å Ç É Ñ Ö Ü á à
â ä ã å ç † ° ¢ £ § • ¶ ß ® © ™ ´ ¨ ≠
Æ Ø ∞ ± ¥ Ω Σ Π π µ ª º æ ø ¿ ¡ ƒ
« » … À Ã Õ Œ œ – " " ' ' ÷ ÿ Ÿ / ‹
› fi fl ‡ · , „ ‰ Â Ê Á Ë È Í Î Ï Ì Ó Ô
Ò Ú Û Ù ı ^ ˜ ¯ ˘ ˙ ˚ ¸ ˝ ˛ ˇ Ð é è ê
ë í ì î ï ò ù ó ô ö õ ü û ú ñ € þ Þ ð Ł

Arlt Blanca Itálica (juego completo de caracteres)

š Ý ý Ž ž – × ł ! " # $ % & ' () * + ,
– . / 0 1 2 3 4 5 6 7 8 9 : ; < = ≈ > ∂ ¬ ∫
√ ? @ A B C D E F G H I J K L M
N O P Q R S T U V W X Y Z [\]
_ ` a b c d e f g h i j k l m n o p q r s t u
v w x y z { ~ } Ä Å Ç É Ñ Ö Ü á à â
ä ã å ç † ° ¢ £ § • ¶ ß ® © ™ ´ ¨ ≠
Æ Ø ∞ ± ¥ Ω Σ Π π µ ª º æ ø ¿ ¡ ƒ
« » … À Ã Õ Œ œ – " " ' ' ÷ ÿ Ÿ / ‹
› fi fl ‡ · , „ ‰ Â Ê Á Ë È Í Î Ï Ì Ó Ô
Ò Ú Û Ù ı ^ ˜ ¯ ˘ ˙ ˚ ¸ ˝ ¿ ˇ Ð é è ê
ë í ì î ï ò ù ó ô ö õ ü û ú ñ € þ Þ ð Ł

Dutchfonts

www.dutchfonts.com

As we have come to expect from Dutch Fonts, the typeface DF-Staple Mono is a peculiar and personal manifestation of how its author, Ko Sliggers, interprets found or already existing letterforms

In this case, it is a personal answer to the antiquated and moderate forms of typewriter typefaces, such as Courier or American Typewriter. The inspiration came from the simplest of office supplies in all its unpretentious glory—the staple. The form of the staple and all its possible transformations and manipulations were the basic model behind the whole design process.

A recurring trait in his work, the reinterpretation of everyday objects (potato cuts in the case of Pommes and lettering stencils in the case of KoFamily) marks one of many interesting features in Ko Sligger's professional career. After winning a D&AD Silver Award for the stationery Studio Dunbar (where Sliggers worked for two years), he spent the rest of his career alternating between the design world and the culinary world, where he worked as a chef (a passion to which he is planning to return eventually). It's a rather unusual résumé for a renowned designer who has worked in two of Holland's top design studios (Dunbar and Studio Anthon Beeke), but without a doubt one that corresponds to his body of work, which, in stark contrast to the historical focus and rationality expected of Dutch design, stands out for its punch and unconventionality.

Sliggers's Staple Mono consists of four weights, all monospaced: Staple Mono Regular, Staple Mono Medium, Staple Mono Bold, and Staple Mono Heavy. Each different weight comes complete with a real Italic, making staple Mono a large family of eight variants. It is suitable for text, but it performs better still when it is used for headlines or just small bodies of text, as well as all matter of display.

Staple mono

Het National Institute of Design (NID) is gevestigd in de binnenstad van Ahmedabad, een miljoenenstad met textielindustrie. Het instituut biedt studenten een opleiding die sterk leunt op de Indiase cultuur, maar zich even sterk richt op de wereld buiten India. De campus ligt aan de rivier de Sabarmati. Even verderop doen dhobi-mannen tegen betaling de was voor anderen, bij hun slums met drogend wasgoed. De NID-campus, waar een deel van de studenten en de staf woont, is een oase van rust temidden van het drukke stadsgewoel: goed onderhouden gazons en weelderig groen omkaderen er een ruïneuze moslimtombe met koepeldak.

Family: Staple Mono™
Weights: Regular, Regular Italic, Medium, Medium Italic, Bold, Bold Italic, Heavy, Heavy Italic
Designer: Ko Sliggers
Year: 2003
Distributor: Dutchfonts
Use: Display

Staple mono medium™

postscript Type 1 Font design ko sliggers 2003

aA	bB
aA	bB

cC	dD	eE	fF	gG	hH	iI	jJ
cC	dD	eE	fF	gG	hH	iI	jJ

kK	lL	mM	nN	oO	pP	qQ	rR
kK	lL	mM	nN	oO	pP	qQ	rR

sS	tT	uU	vV	wW	xX	yY	zZ
sS	tT	uU	vV	wW	xX	yY	zZ

character set

abcdefghijklmnopq rstuvwxyzABCDEFGH IJKLMNOPQRSTUVWXY Z1234567890ÄÅÁÀÃÂ ÉÊÈËÍÎÌÏÖÕÓÒÔÚÙÛÜ ÑÇŸÆŒØœçáàâãäåéèê ëíìîïóòôõöúùûüñçÿ €£¥$§&#Ω!?¿¡=±%^` \<«‹|»›/_+:"˜®©™´ˆ [({†})]flᵈµ∂∑π∫´¸ ø√ƒ=∆≠∞˙¨˚ˆ˜

www.dutchfonts.com 2005

characteristics

te
xa

7/9 pt
Ut primum alatis tetigit Magalia plantis. Aeneam fundantem arces ac tecta novantem conspicit. Atque illi stellatus iaspide fulva ensis erat Tyrioque ardebat murice laena demissa ex numeris. dives quae munera Dido fecerat, et tenui telas discrevat auro. Continuo invadit: 'tu nunc Karthaginis altae fundamenta locas pulchramque uxorius urbem exstruis? Heu, regni rerumque oblite tuarum! Ipse deum tibi me claro demittit Olympo regnator, caelum et terras qui numine torquet. ipse haec ferre iubet celeres mandata per auras: quid struis?

8/10 pt
Aut qua spe Libycis teris otia terris? Si te nulla movet tantarum gloria rerum, Ascanium surgentem et spes heredis Juli respice, cui regnum Italiae Romanaque tellus debetur'. Tali Cyllenius ore locutus, mortales visus medio sermone reliquit et procul in tenuem ex oculis evanuit auram. At vero Aeneas aspectu obmutuit amens, arrectaeque horrore comae et vox faucibus haesit. Ardet abire fuga dulcesque relinquere terras, attonitus tanto monitu imperioque deorum. Heuquid agat?

9/11 pt
Ut primum alatis tetigit Magalia plantis. Aeneam fundantem arces ac tecta novantem conspicit. Atque illi stellatus iaspide fulva ensis erat Tyrioque ardebat murice laena demissa ex numeris. dives quae munera Dido fecerat, et tenui telas discrevat auro. Continuo invadit: 'tu nunc Karthaginis altae fundamenta locas pulchramque uxorius urbem exstruis? Heu, regni rerumque oblite tuarum! Ipse deum tibi me claro demittit Olympo regnator, caelum et terras qui numine torquet.

10/12 pt
Aut qua spe Libycis teris otia terris? Si te nulla movet tantarum gloria rerum, Ascanium surgentem et spes heredis Juli respice, cui regnum Italiae Romanaque tellus debetur'. Tali Cyllenius ore locutus, mortales visus medio sermone reliquit et procul in tenuem ex oculis evanuit auram. At vero Aeneas aspectu obmutuit amens.

18/18 pt
Ut primum alatis tetigit Magalia plantis, Aeneam fundantem arces ac tecta novantem conspicit.

24/24 pt
Aut qua spe Libycis teris otia terris? Ascanium surgentem et spes heredis cui regnum.

Ut primum alatis
tetigit Magalia
plantis, Aeneam
fundantem arces
ac tecta novantem

Influe

abcdeefgghhij

RÆRUM.
ASCÆNIUM
SURGÆTÆM
ÆT SPÆS HÆ
RÆÍS

I DON'T have
FOR the
OR
for you

I ♥ Bea

quietly communicating

2 3 4 5 6 7 8 9 10 11 12

LLIMETER.

0.001MM	0.0020PT
0.02MM	0.05PT
0.04MM	0.1PT
0.06MM	0.15PT
0.08MM	0.2PT
0.1MM	0.25PT
0.12MM	0.3PT
0.14MM	0.35PT
0.16MM	0.4PT
0.18MM	0.45PT

240	239	238	237	236
235	234	233	232	231
230	229	228	227	226
225	224	223	222	221
220	219	218	217	216
215	214	213	212	211
210	209	208	207	206
205	204	203	202	201
200	199	198	197	196
195	194	193	192	191
190	189	188	187	186

ea

l you that

l public and

fined public

ie is one

Happy

The Dada aesthetic is essentially an anti-aesthetic, (that is, random or chance selection, so well exhibited by the works of Marcel Duchamp, Hans Arp, Richard Huesselbeck, and the collage works of Kurt Schwitters), and it is the basis for this font. The typography of the Dadaists using random lettering styles and uneven composition, was highlighted in many of the Futurist posters and poetry works, which also featured onomatopoetic devices within their compositions.

The P22 Dada font was first designed by Richard Kegler in 1995–1996. It was initially made as an experiment and then in a limited quantity for one or two museum gift shops. Not included in P22 catalogs, the font P22 Dada (the menu name was P22 Dada UltraDemiBoldMediumObliqueCondensed) took a Dadaist approach to font design. It uses the PostScript bitmap limitation to its fullest. In the contemporary Mac OS, the screen font features bitmaps for each size of the font. This way, 10- or 12 point fonts can be hand-modified to be more readable. The Dada font has 10 sizes of bitmaps. Each size renders the font in a different way. Some substitute letters or images, and some shift the position up or down. If something is set in 12 point and zoomed in 200 percent, the 24-point bitmaps would take over.

More mischievous than most fonts, this could prove frustrating to a designer intent on actually using it to design with. The original Read Me file stated: "Macintosh users who use PostScript fonts will have an especially amusing/frustrating time with this font. The on-screen bitmaps may not coincide with what prints out. Do not call technical support—they are instructed to hang up on you. ...There is no need to design a page while using this font. Just type and print. Chance will design your page."

Version 2 was made in 1998. It was the same font as Version 1 but packaged as a bonus font with the Futurismo soundtrack audio CD. Version 3 was made in 2006. The original idea of the Dada font and its randomness was given new life with the introduction of OpenType programming. The new version includes more than 500 glyphs of letters and images, and can be used to create Dada-inspired typography by simply selecting various features.

Family: Dada
Weights: P22 Dada, P22 Dada Alt, P22 Dada Pro (OpenType)
Designer: Redesigned by Colin Kahn in 2005–2006. Original by Richard Kegler in 1995. P22 type foundry release in Spring 2006
Year: 2006
Distributor: P22 Type Foundry
Uses: Display

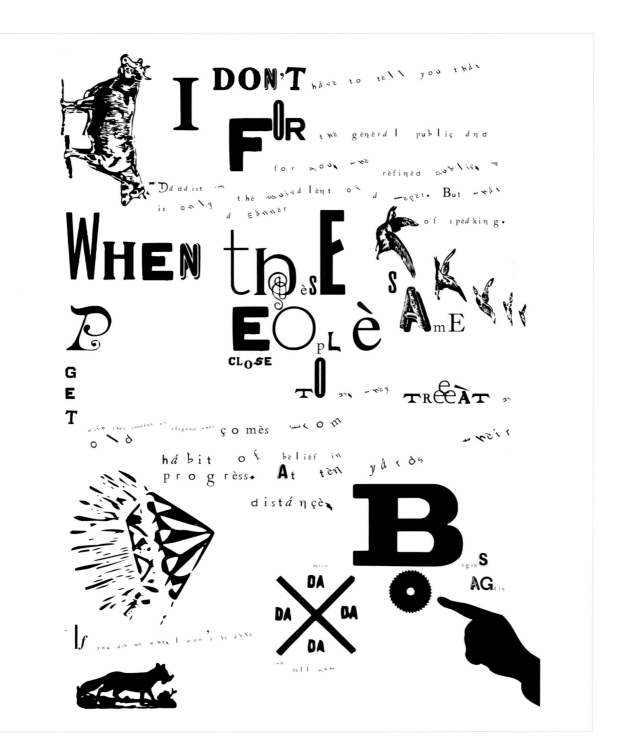

I DON'T have to tell you that FoR the gènèrál publiç ánd for you the rèfinèd publiç Dàddist is only the eauivàlènt of a ṟeper. But ṟhát á Ebnnèr of spèdking.

WHEN thèsE SAmE PEOplè CLOSE GET TO TREEAT old with that ṟẉọdnt of elegance çomès ṟɾom ṟheir hábit of belief in progrèss. At tèn yárds distánçè

B ègins AGáin

DA DA DA DA

If you ask me why I won't be able ṟo tell ṉow.

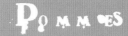

Dutchfonts

Pommes™ takes its origins from the humble art of potato stamps. It is the result of a trajectory that started with Ko Sliggers's mid-1970s potato punchcutting projects made at art school. He happily continued, since he lives in a potato republic (in the northeastern part of the province of Groningen) until this pastime bloomed into a full-grown typographic family, complete with six variants.

Sliggers prepared, or as he puts it, "cooked," this culinary alphabet as a tribute to the all-around wonderful vegetable that is the potato, helped by Belgian and French recipes (that vary in how thickly the potatoes should be chopped) to select and cut the six styles: the DF-Pommes-Alumettes, the DF-Pommes-Alumettes Italic, the DF-Pommes-Frites, the DF-Pommes-Frites Italic, the DF-Pommes-Dauphine, and the DF-Pommes-Dauphine Ultra Heavy.

Pomme-Alumettes is the finest variant followed by Pommes-Frites, which presents a bulkier body, nonetheless retaining the elegance of Alumette. Pommes-Dauphine marks a much darker and blotted style, the one that most resembles an actual potato punchcutting, while Pomme-Dauphine Ultra heavy takes it a step further in matters of smudges and blotches. This last variation can be placed as a layer behind the less visually noisy Pomme-Dauphine to create a layered effect. "Too many eggs added," says the designer and former chef, who refers to this lovable ultra-heavy font as a Culinary Poetic Catastrophe. Finally, each of the six variants contains a full set of punctuation marks, numerals, foreign accents, and monetary symbols.

Definitely not suited for the meek, the Pommes family is an audacious and slightly anarchistic font. At the same time, it is just as carefully organized and fully practical, thanks to its various weights. It is ideal for display and headlines and holds the potential to give designers many a creative push.

Family: Pommes
Weights: Alumettes, Alumettes Italic, Frites, Frites Italic, Dauphine, Dauphine Ultra Heavy
Designer: Ko Sliggers
Year: 2003
Distributor: Dutchfonts
Use: Display

Pommes Dauphine™

postscript Type 1 Font

Aa Bb
Aa Bb
Cc Dd Ee Ff Gg Hh Ii Jj
Cc Dd Ee Ff Gg Hh Ii Jj
Kk Ll Mm Nn Oo Pp Qq Rr
Kk Ll Mm Nn Oo Pp Qq Rr
Ss Tt Uu Vv Ww Xx Yy Zz
Ss Tt Uu Vv Ww Xx Yy Zz

24/28 pt

Iaspide fulva
obsis erat
Tyrioque ardebat
murice laena de
missa ex numeris. Divos quae

Rorum, Ascanium surgentem et spes hae redis

12/13 pt Ur primum alaris tegigit Magalia plateis. Aeneam fundar-tem arcos ac tecta novantem conspicit. Atque illi stellatus iaspide fulva obsis erat Tyrioque ardebat murice laena de missa ex numeris. Divos quae mutera

18/21 pt Atque illi stellatus iaspide fulva obsis erat Tyrioque arde

38/36 pt

Aut qua spedibyctis teris otia terris? Si tenulla mo vor tanta rum gloria

Aeneam mfundan tem arcos tecta

"Circlejerk is based on strict rules and dogma which, in a twisted way, is freedom: The more rules you obey, the less you have to think for yourself. It is also based on some Burmese license plates I once saw that were written in Sanskrit, and the baseline is at the x-height," explains Kenn Munk. The Circlejerk family comes in two weights and features alternate characters, accents for various European languages, and some special characters. Circlejerk doesn't have upper- and lowercase in the ordinary sense, or even in the common sense. Instead, there are a number of random letters that have an alternative version.

Munk lives in Denmark, in Aarhus to be precise, which is the home of the creative headquarters where he has been making alternative fonts and dingbats since 2000. His foundry, www.kennmunk.com, launched that same year, also marked the beginning of the ongoing Versus project and the opening of a small shop on his Web site. His designs are usually based on an underlying system that allows the user to build words or, in the case of dingbats, images. Munk says his obsession is probably due to the hours and hours spent playing with LEGO blocks and plastic model kits during his childhood, resulting in a peculiar taste for the process of customizing.

Munk was born in Kolding, Denmark, in 1974 and studied graphic design at Design Seminariet, Hojer, Denmark, between 1995 and 1998. From 1998 onwards, he has worked mainly in advertising, but in his spare time, and sometimes at night, he works on less commercially influenced and more personal projects, such as the design of clothing, customized toys, and fonts.

Circlejerk is an unusual and contemporary font that comes in Light and Bold options. It is especially fitted for display and decorative purposes as well as titles.

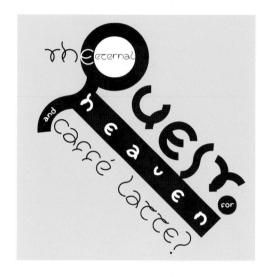

Family: Circlejerk
Weights: Circlejerk Light, Circlejerk Bold
Designer: Kenn Munk
Year: 2003
Distributor: Not available
Use: Display
Other uses: Very good for writing names of coffee-based drinks such as Latte, Cappuccino, and the like

circlejerk light

abcdeefggħhijʈl
lmmnoppqqrstru
vwxxyyzæœøởȧ,.!?
1234567890

circlejerk bold

abcdeefggħhijʈl
lmmnoppqqrstru
vwxxyyzæœøởȧ,.!?
1234567890

Since this family was essentially created for use in books, Underware had to consider what versions had to be designed to satisfy the needs of this particular field. For this family, the versions include: Regular, for text; Italics and Bold, to make information on a page stand out; and small capitals, for headings. It has Old Style figures, and since the intention is to set them into long text, it is not necessary to design a set of figures for uppercase.

Dolly is a text typeface with the distinct Underware style, contemporary and with countless details, which, while they are invisible in small bodies, make the typeface ideal for use in displays where these details show off its full beauty.

Its contrast is low and the x-height is sufficiently big to make it legible in relatively small bodies. The innovative design of both the serifs and the terminals stands out among its most significant characteristics, which appear as though they were brush strokes. This can especially be appreciated in the design of the punctuation marks, as well as in other characters such as the & that are generally used less in the composition of text. Since these characters do not affect the legibility of the typeface too much, the designer feels freer to exercise more creativity.

The Italic version of Dolly does not require too much inclination, since the distinctive form of its glyphs, its narrower proportions, and its lighter color differentiate it enough when used along with the roman version. The Bold version is considerably black, leaving a strong contrast on the page when set together with Dolly Regular.

Dolly, although intentionally designed for text, is actually an all-purpose typeface that proves to be as flexible and versatile as it is disposed of a fresh personality and a cheerful, soft, and warm appearance.

DOLLY

tie had gedaan voor **Lassie**. Zo graag had ze beroemd willen worden. En dan niet zo zeer voor het geld, de media-aandacht of die onuitputtelijke voorraad pens, maar eerder voor de *starfuckers*. Al die hitsige mannetjes die nu met een opgeheven snuit een ruime boog om haar heen lopen, geeneens twijfelend om maar één seconde aan haar kont te willen ruiken, zouden dan wel geil en gewillig zijn.

Family: Dolly
Variants: Dolly Regular, Dolly Italic, Dolly Bold, Dolly Small Caps
Designer: Underware
Year: 2001
Distributor: Underware
Use: Long text
Other uses: Display
Advice or considerations: Designed for use in books

ABCDEFGHIJKLMNOP
QRSTUVWXYZŒÆÇ &
abcdefghijklmnopqr
stuvwxyzœæç (fiflß)
[¶] {0123456789};:?!*
àáäâãåèéëêùúüûõòó
öôøñ "$£€ ƒ¢" «©†@»

DOLLY ROMAN 40|48 PTS

**ABCDEFGHIJKLMNOP
QRSTUVWXYZŒÆÇ &
abcdefghijklmnopqr
stuvwxyzœæç (fiflß)
[¶] {0123456789};:?!*
àáäâãåèéëêùúüûõòó
öôøñ "$£€ ƒ¢" «©†@»**

DOLLY BOLD 40|48 PTS

*ABCDEFGHIJKLMNOP
QRSTUVWXYZŒÆÇ &
abcdefghijklmnopqr
stuvwxyzœæç (fiflß)
[¶] {0123456789};:?!*
àáäâãåèéëêùúüûõòó
öôøñ "$£€ ƒ¢" «©†@»*

DOLLY ITALIC 40|48 PTS

ABCDEFGHIJKLMNOP
QRSTUVWXYZŒÆÇ &
ABCDEFGHIJKLMNOPQR
STUVWXYZŒÆÇ (FIFLSS)
[¶] {0123456789};:?!*
ÀÁÄÂÃÅÈÉËÊÙÚÜÛÕÒÓ
ÖÔØÑ "$£€ ƒ¢" «©†@»

DOLLY SMALL CAPS 40|48 PTS

Created as a display font, Soap draws on an old favorite, Cooper Black, designed in 1922 by Oswald Bruce Cooper for Barnhart Brothers & Spindles Type Founders, located in Chicago. However, Soap is different from its predecessor in that its design is much slicker, softer, and less defined, and it is unicase, that is, equipped with only one case.

Soap was designed by Ray Larabie, creator of more than 300 freeware fonts and the mind behind Typodermic, a high-quality commercial font site, since fall 2001. The designer's intention is that Soap should be squeezed together and laid out with zero or negative leading, thereby providing a heavy texture. Larabie intentionally gives Soap tight spacing to help lend it a pseudo-1970s look. Its numerals and capitals also line up, making it ideal for those 1970s T-shirts and titles.

Both the spur-shaped tail and the softness of the joins between the stems stand out. Apart from a full alphabet, Soap comes with numerals, punctuation, and monetary symbols. It also contains a whole series of accents, with accents included for: Albanian, Catalan, Danish, Dutch, English, Estonian, Finnish, French, German, Icelandic, Italian, Norwegian, Spanish, and Swedish.

Soap is in general a cheerful typeface that aspires to be used on large bodies such as billboards and posters, without forgetting to have a sense of humor.

Typodermic has become a popular company for commissioning custom-made fonts. It has myriad typographic projects under its belt that vary from designing fonts for video games, electronic devices, software packages and Web sites to signage, teaching aids, industrial applications, and publishing, in a palette of styles ranging from brush script and Old Style to graffiti. Special needs are taken care of; the company has, for instance, foreign characters available and can adapt to different media, from print to video production.

SOAP

Family: Soap
Variants: Soap Regular
Designer: Ray Larabie
Year: 2005
Distributor: Typodermic
Use: Display
Other uses: Not recommended
Advice or considerations: See its dingbats

TRY IT, YOU'LL LIKE IT
I SHOT JR
DO IT IN THE DARK
NEWPORT 1976
I ♥ BEANS
VIRGINIA IS FOR
LOVERS
MAKIN' BACON
JUST PASSIN' THRU
BLONDIE
aquatic

SOAP @ 64 POINT

ABCDEFGHIJKL
MNOPQRSTUV
WXYZ01234567
89&@!?,."-#$%¾*†
‡¥£€()[]{}àæê
ñóœøÜçþŁ♥✸

★✿✳✸⬬ 👤 📺 🚲

CGS

👤✿✳♥✸⬬✸@t

Influenza is another atypical font by young Danish designer Kenn Munk. Influenza, which means the Flu in various languages, inspired the name because the characteristics of the flu virus change every time it comes around, a trait shared by this transformable font. It was originally based on his font design for Linemap; a 9-pixel bitmap font that combines the thought of a bitmapped font with a script. Influenza presents a stripped-down and bold version of Linemap, and features Munk's signature underscore that allows the user to connect the letters with an underscore.

Although it contains such staple Kenn Munk traits, Influenza marks a break from his usual system of connected building blocks. One of the reasons for this difference is the fact that Influenza is based on a stripped-down version of an earlier font. This simplification calls for the removal of the connectors, which takes the typeface a step farther away from the connected look by modeling each letter to make it stand alone as an independent angular structure.

Some of the characters have a stylized black letter feature, while some are very close to being bitmapped, and others are a free mix of upper- and lowercase. "If you write a word like *Love* it would be entirely bitmapped, while *Kilt* would feature only black letter, serifed characters. The more text you set in Influenza, the more homogenous it becomes," says Munk.

The family is composed of six variants, going from lightest to heaviest weight: Stratum Thin, Stratum Light, Stratum Regular, Stratum Medium, Bryant Stratum Bold, and Stratum Black. It is a modern and eye-catching font that is especially suitable for display. In the words of its designer, "Some letters don't look like they belong in the same family, but the more you write in Influenza, the more everything comes together."

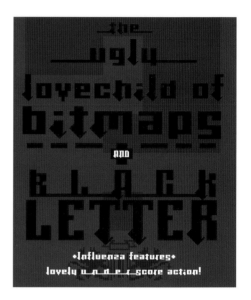

Family: Influenza
Variants: Stratum Thin, Stratum Light, Stratum Regular, Stratum Medium, Bryant Stratum Bold, Stratum Black
Designer: Kenn Munk
Year: 2002–2005
Distribution: Kennmunk
Use: Display, both onscreen and in print
Other uses: Signage
Advice or considerations: It works well when used in bodies of up to 8 point.

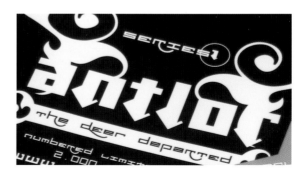

Influenza:
AaÄäÂâÀàÃãÅåB
bCcÇçDdEeÉéÈè
ËëÊêFfGgHhIiÍí
ÌìÏïÎîJjKkLlMm
NnÑñOoÓóÒòÕõÖö
ÔôØøPpQqRrSs
TtUuÚúÙùÜüÛû
VvWwXxYyZz
ÆæØøŒœÅå
1234567890+!""""
%&*/[]=,.:;-—–†|ß...

Dutchfonts

The DF-EtalageScript™ was drawn for the first time in the year 2000, based on an early twentieth-century lettering stencil that farmer Boelema, at Lalleweer, used to write on his sacks of grain.

Designer Ko Sliggers eventually developed this script letter as a typeface, with a wink to the "lost" display types, for graphic designer Ariënne Boelens who, in exchange, designed the Web site www.lalleweer.nl. EtalageScript is also the original font from which the DF-Ariënne, another Dutchfonts design, evolved. The EtalageScript family was recently expanded to include two weights: Medium and Bold.

Ko Sliggers was born in Bloemendaal, The Netherlands, and in 1980 he was one of the iconoclastic young designers who contributed to what has since become known as the Dumbar style. After a couple of years working at Studio Dumbar (1979–1981), Sliggers started to work as an independent designer. However, a slight change in career orientation led him to becoming a professional cook in Rotterdam, as well as in Italy and France.

By 1995, he had switched back from the gastronomical world to the world of design, and he was again producing challenging visuals, this time at Studio Anthon Beeke. In 2002, he started his one-man studio and typographic foundry in Lalleweer, in the northern province of Groningen, Holland; which would eventually become his current company, Dutchfonts.

Although he was taught and coached by Chris Brand at the St. Joost Academy in Breda, Netherlands, Sliggers has strayed from the Dutch tradition of typography design that is heavily inspired by literary and historical sources. The fonts he designs are mainly inspired by found letterforms instead, and they always stand out for their energy and unconventionality.

EtalageScript has a neat, chic, dainty look (Sliggers refers to it as "elegant power girl") and that works well for all kinds of display, lending a stylish and ornamental look.

Family: DF-EtalageScript™
Weights: Medium and Bold
Designer: Ko Sliggers
Year: 2003
Distributor: Dutchfonts
Use: Display

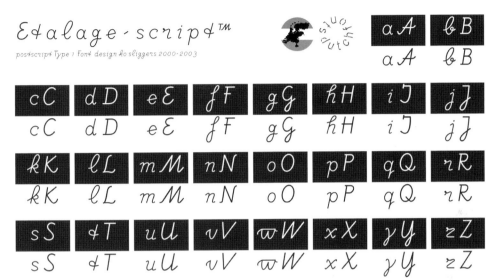

Etalage-script™

postscript Type 1 Font design ko sliggers 2000-2003

aA	bB
aA	bB

cC	dD	eE	fF	gG	hH	iI	jJ
cC	dD	eE	fF	gG	hH	iI	jJ

kK	lL	mM	nN	oO	pP	qQ	rR
kK	lL	mM	nN	oO	pP	qQ	rR

sS	tT	uU	vV	wW	xX	yY	zZ
sS	tT	uU	vV	wW	xX	yY	zZ

character set

1234567890$=[({})]a
bcdefghijklmnopqrs
tuvwxyz:`\,./+!@#$
&.·.ABCDEFGHIJKL
MNOPQRSTUVWXY
Z:`¬‹›?©®™`ÆØ€£œ«»`Á
ÀÇÉÑØÛàáâãäåçèéêëì
íïñöóôõüûúÀÀØÝÝÆ
ÆÉÏJJJØØØûûû`¨^`.,`

www.dutchfonts.com 2005

characteristics

7/9 pt

Ut primum alatis tetigit Magalia plantis. Aeneam fundantem arces ac tecta novantem conspicit. Atque illi stellatus taspide fulva ensis erat Tyrioque ardebat murice laena demissa ex numeris. dives quae munera Dido fecerat, et tenui telas discreverat auro. Continuo invadit. tu nunc Karthaginis altae fundamenta locas pulchramque uxorius urbem exstruis? Heu. regni rerumque oblite tuarum! Ipse deum tibi me claro demittit Olympo regnator. caelum et terras qui numine torquet. ipse haec ferre iubet celeres mandata per auras: quid struis?

8/10 pt

Aut qua spe Libycis teris otia terris? Si te nulla movet tantarum gloria rerum. Ascanium surgentem et spes heredis Juli respice. cui regnum Italiae Romanaque tellus debetur. Tali Cyllenius ore locutus. mortales visus medio sermone reliquit et procul in tenuem ex oculis evanuit auram. At vero Aeneas aspectu obmutuit amens. arrectaeque horrore comae et vox faucibus haesit. Ardet abire fuga dulcesque relinquere terras. attonitusque tanto monitu imperioque deorum. Heuquid agat?

9/11 pt

Ut primum alatis tetigit Magalia plantis. Aeneam fundantem arces ac tecta novantem conspicit. Atque illi stellatus taspide fulva ensis erat Tyrioque ardebat murice laena demissa ex numeris. dives quae munera Dido fecerat, et tenui telas discreverat auro. Continuo invadit. tu nunc Karthaginis altae fundamenta locas pulchramque uxorius urbem exstruis? Heu. regni rerumque oblite tuarum! Ipse deum tibi me claro demittit Olympo regnator. caelum et terras qui numine torquet. ipse haec ferre iubet celeres mandata per auras: quid struis?

10/12 pt

Aut qua spe Libycis teris otia terris? Si te nulla movet tantarum gloria rerum. Ascanium surgentem et spes heredis Juli respice. cui regnum Italiae Romanaque tellus debetur. Tali Cyllenius ore locutus. mortales visus medio sermone reliquit et procul in tenuem ex oculis evanuit auram. At vero Aeneas aspectu obmutuit amens.

18/18 pt

Ut primum alatis tetigit Magalia plantis. Aeneam fundantem arces ac tecta novantem conspicit.

24/24 pt

Aut qua spe Libycis teris otia terris? Ascanium surgentem et spes heredis cui regnum.

When something isn't provided, sometimes you must supply it yourself. The long and frustrating search undertaken by Letterbox to find a dynamic, monoline script denoted the lack of such a typeface. It was this absence that prompted the studio to create Terital, a combined creation by Wendy Ellerton and Stephen Banham that takes its name from an advertisement for a 1960s Italian overcoat style of the same name. This was the source of inspiration for the typeface.

Victorian typographer Wendy Ellerton graduated from Monash University, Australia, in 2002 with a Bachelor of Visual Communication. She established The Public Foundry and has since worked as a graphic designer on a freelance basis. Before beginning her Type Media studies she also worked as a lecturer at Monash University.

Endlessly fascinated by letters, Stephen Banham of the Letterbox studio is also the author behind a continuing series of self-published books documenting or referencing typography. The acclaimed QWERTY booklets, a series of six issues each titled after one of the word's letters, and the Ampersand series, of equal cult status, have recently been followed by the book *Fancy*, a collection of true and not-so-true stories about or relating to typography.

Terital presents a style close to Thirst Type's *Radio* and Type-o-Tone's *Me Mima*, although in a more mechanical yet expressive script. The family consists of three weights; Linking, Incoming, and Outgoing. The formulation of Incoming and Outgoing weights allows the sophisticated solution of the Linkage variant, a very challenging and prickly characteristic in scriptface design, which probably explains why there are so few available. This feature allows the user to manipulate the links between letterforms at their ease, lending greater versatility and creative freedom. Terital is especially suited to titles, among other display uses.

terital

Family: Terital
Weights: Outgoing, Linking, and Incoming
Designer: Wendy Ellerton and Stephen Banham
Year: 2004
Distributor: Letterbox
Use: Titling, highlights through text

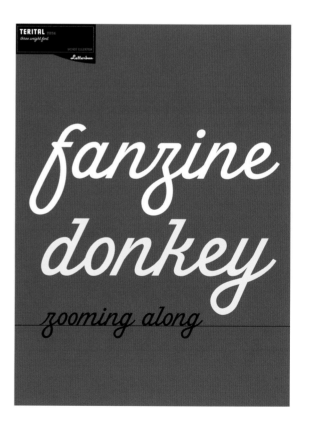

abcdefghijklmnopqrstuvwxyz 1234567890

doom
winke
foundry

catalogues
architectural
memories
quietly communicating
walking dolphin fonts named
numeral publication messenger chunky

Don't hang up. It's

Suddenly the situation seemed complex.

c a f

AfterSun!

Ut primum
tetigit Mag
plantis. Ae
fundantem
ac tecta n
conspicit.

Hamburgefons

Italics, SMALL CAPS *&* expert

```
    2       3       4       5       6       7       8       9      10      11      12
ILLIMETER

        0.001MM              0.0020PT
        0.02MM               0.05PT
        0.04MM               0.1PT
        0.06MM               0.15PT
        0.08MM               0.2PT
        0.1MM                0.25PT
        0.12MM               0.3PT
        0.14MM               0.35PT
        0.16MM               0.4PT
        0.18MM               0.45PT
```

240	239	238	237	236
235	234	233	232	231
230	229	228	227	226
225	224	223	222	221
220	219	218	217	216
215	214	213	212	211
210	209	208	207	206
205	204	203	202	201
200	199	198	197	196
195	194	193	192	191
190	189	188	187	186

you!

Mellow

C4 is the typeface that gives Channel 4's new image its identity. The new image of this British television channel, launched in 2005 with the coming of the New Year, is radically contemporary, and its logo and graphic image work well with C4, the typeface family that acts as a nexus of all the elements that compose Channel 4's identity.

The commission was formulated with the following words: C4 has to be "something large, audacious, and attractive." As well as serving this premise, C4 had to match the channel's new logo, which, based on the original designed 20 years before, possesses a certain angularity that lends depth, creating a three-dimensional effect. C4 was not meant to overlap the logo nor was it to be completely unconnected. The designer Jason Smith managed to harmonize the typeface and logo, thanks to a pragmatic although flexible solution that is very contemporary and has plenty of personality.

In terms of design, a project with these characteristics has to be highly aesthetic, considering it has to encompass a great deal of conceptual content to carry out its main function: to confer an identity. The typeface for Channel 4 had to be different and exclusive while at the same time hip enough to impress a young and, to a degree, culturally savvy audience. It had to be a unique design, totally clear and legible, but with some added distinctive elements that also make it versatile and provocative.

Smith achieves both of these things, creating a youthful typeface with a tranquil but provocative character. The balance between the rounded and squared forms is the key to achieving this serene atmosphere, a halfway point between the coldness of the straight lines and the softness of the curves.

C4 includes 10 variants (from the versions for Text and Italics to a series of Condensed versions), and all of these are presented in various weights, providing a range that is big enough to cover all of Channel 4's needs, both onscreen and on paper.

C4 Headline

7.30am
Friends

8.00am
Big Brother's
Little Brother

next
Big Brother

9.00am
Beat The
Nation

9.30am
Will and
Grace

Family: C4
Variants: C4 Text Regular, C4 Text Italic, C4 Medium, C4 Medium Italic, C4 Text Bold, C4 Text Bold Italic, C4 Condensed Regular, C4 Condensed Italic, C4 Condensed Bold, C4 Condensed Bold Italic
Designer: Jason Smith
Year: 2005
Distributor: Custom work
Use: Display, both onscreen and printed
Other uses: It can be used for short texts
Advice or considerations: In its regular text variants, it works well when used in bodies of up to 7 point.

Friends

8.00am
Big Brother's
Little Brother

next
Big Brother

9.00am
Beat The
Nation

9.30am
Will and

C4 Text Regular

ABCDEFGHIJKLMNÑOPQRSTUVWXYZ
abcdefghijklmnñopqrstuvwxyz
1234567890!@#$%&()=?

C4 Text Italic

ABCDEFGHIJKLMNÑOPQRSTUVWXYZ
abcdefghijklmnñopqrstuvwxyz
1234567890!@#$%&()=?

C4 Medium

ABCDEFGHIJKLMNÑOPQRSTUVWXYZ
abcdefghijklmnñopqrstuvwxyz
1234567890!@#$%&()=?

C4 Medium Italic

ABCDEFGHIJKLMNÑOPQRSTUVWXYZ
abcdefghijklmnñopqrstuvwxyz
1234567890!@#$%&()=?

C4 Text Bold

ABCDEFGHIJKLMNÑOPQRSTUVWXYZ
abcdefghijklmnñopqrstuvwxyz
1234567890!@#$%&()=?

C4 Text Bold Italic

ABCDEFGHIJKLMNÑOPQRSTUVWXYZ
abcdefghijklmnñopqrstuvwxyz
1234567890!@#$%&()=?

C4 Condensed Regular

ABCDEFGHIJKLMNÑOPQRSTUVWXYZ
abcdefghijklmnñopqrstuvwxyz
1234567890!@#$%&()=?

C4 Condensed Italic

ABCDEFGHIJKLMNÑOPQRSTUVWXYZ
abcdefghijklmnñopqrstuvwxyz
1234567890!@#$%&()=?

C4 Condensed Bold

ABCDEFGHIJKLMNÑOPQRSTUVWXYZ
abcdefghijklmnñopqrstuvwxyz
1234567890!@#$%&()=?

C4 Condensed Bold Italic

ABCDEFGHIJKLMNÑOPQRSTUVWXYZ
abcdefghijklmnñopqrstuvwxyz
1234567890!@#$%&()=?

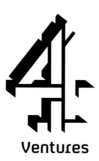

International Ventures

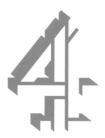 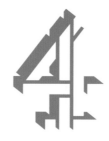

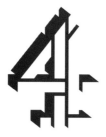

Logo, Channel Four

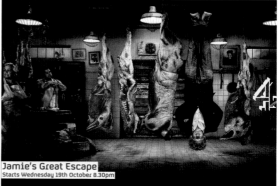

Applications

One of the purposes was to obtain a typography that reflected a contemporary graphic image, but respected the old Channel 4 logo, built 20 years ago. The image required a high degree of aesthetics, which was achieved with angles creating a 3D effect.

Channel Four Television Corporation
Luke Johnson, Chairman. Barry Cox, Deputy Chairman.
Andy Duncan, Chief Executive. David Scott, Managing Director and Deputy Chief Executive. Andrew Barnes, Sales Director.
Kevin Lygo, Director of Television. Rob Woodward, Commercial Director.
Sue Ashtiany, Karren Brady, Andrew Graham, Robin Miller, Andy Mollett, Ian C Ritchie.
Paola Tedaldi, Secretary.

INVESTOR IN PEOPLE

POSITIVE ABOUT DISABLED PEOPLE

Applications

This typeface family stemmed from a proposal to design the logo for the cocktail bar Bagua Café in Barcelona, which showcases an oriental-themed decor and a feng shui spirit, defined by basic colors and simple lines that produced a minimalist, sober, and elegant look. The logo, together with its accompanying graphic image, drew from these concepts, which were also used as a source of inspiration for the subsequent Bagua typeface family.

The challenge of designing a typeface family with these characteristics lies in the process of creating all of the characters based on a single element—a highly discrete curve—which is minimalist in itself.

Sobriety, elegance, simplicity, and legibility are the basic concepts that Marc Salinas has used to carry out this design, which at first glance seems relatively simple. If carefully observed, it is of a much more complex nature.

Letters like k, s, v, w and x, which need more complicated elements than those available to Bagua, posed a problem when configuring the structure with the limits that Salinas imposed on himself during the development of this project.

Bagua reflects the concept of simplicity in its character set since this typeface does not have an uppercase. Using a commonsense approach straight from the purest Bauhaus style, Salinas asked: "Why design two alphabets, an uppercase and a lowercase, when one (the lowercase for example) is enough to successfully communicate the message?" This is the question that followers of the New Typeface movement asked themselves towards the end of the 1920s. Salinas likes to remind us of this through the Bagua typeface.

This designer allows Bagua to display, beyond its minimalist attributes, a welcoming feeling of hospitality. The family invites, Zen-like, to come in and relax. Its subtle curves were a wise choice, arranged in such a way that they appear to form a box that inflates and give life as if the type were a breathing, living organism. It is a typeface with a pure and individual personality.

Family: Bagua
Variants: Bagua Light, Bagua Regular, Bagua Bold
Designer: Marc Salinas
Year: 2004
Distributor: Cuerpodoce
Use: Display
Other uses: Not recommended
Advice or considerations: Do not use in bodies smaller than 10 point.

bagua light
abcdefghijklmnopqrstuvwxyz

bagua regular
abcdefghijklmnopqrstuvwxyz

bagua bold
abcdefghijklmnopqrstuvwxyz

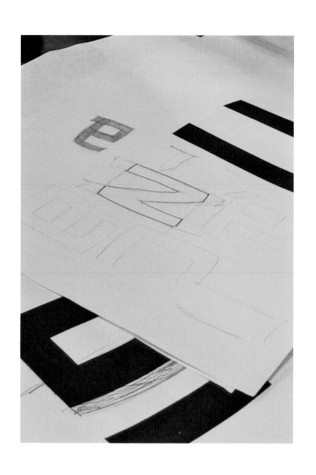

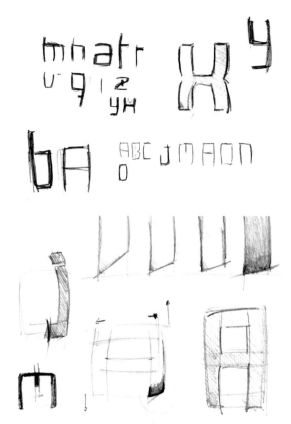

Sketches

This typography had to respect the simple and elegant image of the Bagua Café cocktail bar. The almost straight curves of the typography are discrete, and it does not have an uppercase.

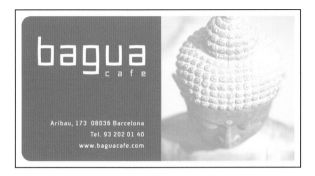

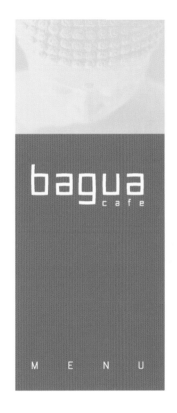

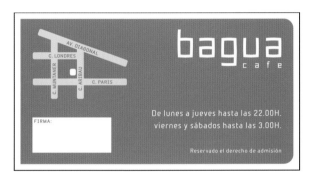

Applications

Bonus is a normal typeface created exclusively for the Barcelona magazine *Suite* as a complementary type for SuiteSerif. According to Íñigo Jerez, the designer behind Bonus, it aims at achieving maximum clarity and homogeneity in the text. This prolific Barcelona-based designer, who has created various typefaces for different publications, successfully achieves this homogeneity through a simple and tranquil design with a contemporary aesthetic.

This typeface embodies some characteristics that are quite unquestionably in the style of its creator, as seen in other samples of his work, as in the contrast between the use of curves and angles. The shapes of its letters are quite straight and rectangular, and the joins with the stems have triangular notches, an added contrast in comparison with the subtlety of the curves of the counters.

When closely observed, Bonus is full of countless small details. One particular feature is the ink-traps, which are carefully designed so that, in addition to carrying out their technical function, they also help to accentuate the legibility of the text and give added value to the general aesthetics of this typeface.

As it usually happens with all of his typographical designs, Íñigo Jerez surprises us with innovative details of a personal nature. In the case of Bonus, the solution of the *ç* stands out among the other letters. Its Old Style figures are also very interesting along with the % symbol, which is joined by a stroke in its upper section, a curious detail that is more typical in roman typefaces.

Bonus is a clean and elegant typeface ideal for use in text, especially in combination with Block, another Íñigo Jerez design. It comes in two variants, each with its own set of punctuation marks.

Bonus

Dwellings
Kreidler
Bungalow←
R.Dijkstra

Family: Bonus
Variants: Regular and Bold
Designer: Íñigo Jerez
Year: 2004
Distributor: Textaxis
Use: Display
Other uses: Not recommended
Advice or considerations: Goes perfectly with Block

Mike Swa

■■■■ Este miembro del cole
Five acaba de aterrizar en Ba

Bonus

ABCDEFGHI
JKLMNOP
QRSTUVWX
YZ.&§!?@†
abcdefghi
jklmnopqrstu
vwxyz.fiflß
1234567890
áàâäãå}»%*

Bonus: Regular **& Bold**

cr
nk
nn

billiank is own ejiffian on eccidiona lower erraticadomus riwaerjur

abcdefghijklmnopqrstuvwxyz

swnkér,

firkanv 23 ojp

rok

Sketches

Bonus was created for *Suite* magazine, and it has an unmistakable image, built from the contrast between the use of curves and angles typical of sans serif typographies. It has details such as ink-traps.

Athelas is a reaction to many years of work closely related to digital media. It is an attempt to go back to the beauty of fine book printing, and paper and ink. It is essentially an escape from the technical restrictions of low-resolution graphics.

These principles have given Athelas the open counters, elegant curves, and graceful serifs that characterize it. Athelas has fluid shapes in its Roman variant that meet their counterpart in a more angular Italic.

It was designed by José Scaglione, a typeface, graphic, and web designer who has also worked as a teacher at the University of Reading, UK, and the University of Rosario, in his native Argentina. All this makes him a versatile designer with extensive international experience.

Athelas takes full advantage of typographic silence, such as the white space in margins; between columns, lines, words, lettershapes; and the blank space within characters themselves. It also takes advantage of the many advances made in offset printing.

Athelas has a large character set that covers most languages using the Latin script. The typeface respects the cultural values behind different languages, where diacritical marks play an utterly important role. Accents were designed to behave harmoniously with the rest of the character set.

The main concepts behind Athelas are fluidity and grace. Serifs have a combination of curves on the inside and corners on the outside. The same combination of elements exists in all other components of the font, such as accents, symbols, and numerals. These details are almost imperceptible at text sizes, but they allow Athelas to perform with outstanding elegance at display sizes, thus extending its usage for more general purposes.

Athelas

When the black breath blows
and death's shadow grows
and all light pass,
come Athelas! come Athelas!
Life to the dying
in the king's hand lying.

Family: Athelas
Weights: Regular, Italic, Book, Bold
Designer: José Scaglione
Year: 2003
Distributor: Josescaglione
Uses: Text

ìíîĩïıiı̇

áñÉ *áñÉ* **áñÉ**

ABCDEFGHIJKLMNOPQRSTUVWZYZ
abcdeffghijklmnopqrstuvwxyz
ÀÁÂÄÃĂÅÅĄĆĈČÇĎĐÈÉÊĚËĒĔĖĘ
ĜĞĠĢĤĦÌÍÎĬĨĪİĮĴĶĹĽĿŁŃŇÑŅÒÓÔÔ
ÖŌŎŐØŹŔŘŖŚŜŠŞŠŢŤŦÚÚÛŨÜŨŬŮ
ŰŲŴẂŴẄŶÝŶŸŹŽŻÐÞÆÆŒ
àáâäãăååąæćĉčçďđèéêěëēĕėęĝğġģĥħ
íîîĩīïįıijĵķĺľŀłńňñņòóôõōŏőøœŕřŗśŝšşş
ßŧţţúúûũüūŭůűųẁẃŵẅỳýŷÿźžżŋđþ
fififlflfffbffbfkffkfjffjfhffhff
&`´^˘˙˜¯˝˚�”′¸‚„:;:....-!¡?¿'“”„„‹›«»
•·()[]{}*†‡§¶′″@©®™¤€$¢£ƒ¥
#0123456789 0123456789ªº
/¼½¾%‰
+−±×÷=≠≈<>≤≥¬/|–—∧~¦_

ABCDEFGHIJKLMNOPPQRSTUVWZYZ
abcdefghijklmnopqrstuvwxyzzz
ÀÁÂÄÃĂÅÅĄĆĈČÇĎĐÈÉÊĚËĒĔĖĘ
ĜĞĠĢĤĦÌÍÎĬĨĪİĮĴĶĹĽĿŁŃŇÑŅÒÓÔÔ
ÖŌŎŐØŹŔŘŖŚŜŠŞŠŢŤŦÚÚÛŨÜŨŬŮ
ŰŲŴẂŴẄŶÝŶŸŹŽŻÐÞÆÆŒ
àáâäãăååąæćĉčçďđèéêěëēĕėęĝğġģĥħìíîĩī
īïįıijĵķĺľŀłńňñņòóôõōŏőøœŕřŗśŝšşşßŧţţúúûû
üūŭůűųẁŕŵûẅỳýŷÿźžżŋđþ
fififlflfffbffbfkffkfjffjfhffh
&`´^˘˙˜¯˝˚˚”′¸‚„:;:....-!¡?¿'“”„„‹›«»
•·()[]{}*†‡§¶′″@©®™¤€$¢£ƒ¥
#0123456789 0123456789ªº
/¼½¾%‰
+−±×÷=≠≈<>≤≥¬/|–—∧~¦_

ABCDEFGHIJKLMNOPQRSTUVWZYZ
abcdeffghijklmnopqrstuvwxyz
ÀÁÂÄÃĂÅÅĄĆĈČÇĎĐÈÉÊĚËĒĔĖĘ
ĜĞĠĢĤĦÌÍÎĬĨĪİĮĴĶĹĽĿŁŃŇÑŅÒÓÔÔ
ÖŌŎŐØŹŔŘŖŚŜŠŞŠŢŤŦÚÚÛŨÜŨŬŮ
ŰŲŴẂŴẄŶÝŶŸŹŽŻÐÞÆÆŒ
àáâäãăååąæćĉčçďđèéêěëēĕėęĝğġģĥħ
íîîĩīïįıijĵķĺľŀłńňñņòóôõōŏőøœŕřŗśŝšşş
ßŧţţúúûũüūŭůűųẁẃŵẅỳýŷÿźžżŋđþ
fififlflfffbffbfkffkfjffjfhffhff
&`´^˘˙˜¯˝˚˚”′¸‚„:;:....-!¡?¿'“”„„‹›«»
•·()[]{}*†‡§¶′″@©®™¤€$¢£¥ª
Ø0123456789 0123456789º#
/¼½¾%‰
+−±×÷=≠≈<>≤≥¬/|–—∧~¦_

ABCDEFGHIJKLMNOPQRSTUVWZYZ
abcdeffghijklmnopqrstuvwxyz
ÀÁÂÄÃĂÅÅĄĆĈČÇĎĐÈÉÊĚËĒĔĖĘ
ĜĞĠĢĤĦÌÍÎĬĨĪİĮĴĶĹĽĿŁŃŇÑŅÒÓÔÔ
ÖŌŎŐØŹŔŘŖŚŜŠŞŠŢŤŦÚÚÛŨÜŨŬŮ
ŰŲŴẂŴẄŶÝŶŸŹŽŻÐÞÆÆŒ
àáâäãăååąæćĉčçďđèéêěëēĕėęĝğġģĥħ
íîîĩīïįıijĵķĺľŀłńňñņòóôõōŏőøœŕřŗśŝšşş
ßŧţţúúûũüūŭůűųẁẃŵẅỳýŷÿźžżŋđþ
fififlflfffbffbfkffkfjffjfhffh
&`´^˘˙˜¯˝˚˚”′¸‚„:;:....-!¡?¿'“”„„‹›«»
•·()[]{}*†‡§¶′″@©®™¤€$¢£ƒ¥
#0123456789 0123456789ªº
/¼½¾%‰
+−±×÷=≠≈<>≤≥¬/|–—∧~¦_

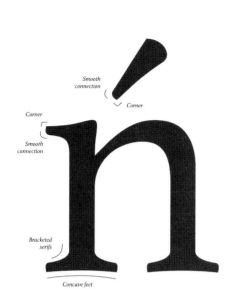

Smooth connection

Corner

Corner

Smooth connection

Bracketed serifs

Concave feet

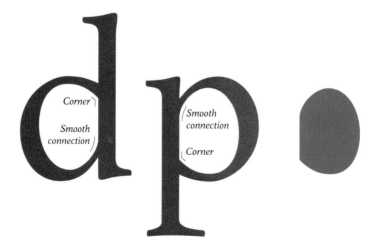

Corner

Smooth connection

Smooth connection

Corner

Details

Sample of one of the publications of the Sociedad de Bibliófilos de Argentina, in which Athelas has been used for the composition of texts. Paused curves, as well as elegant serifs, make this typography one of the most appropriate for text composition.

CHAPTER ELEVEN

During these last few months, all but one of his close friends of the had been killed in action. Partly as an act of piety to their memory, but also stirred by reaction against his war experiences, he had already begun to put his stories into shape, … in huts full of blasphemy and smut, or by candle light in bell-tents, even some down in dugouts under shell fire [Letters 66]. This ordering of his imagination developed into the Book of Lost Tales (not published in his lifetime), in which most of the major stories of the Silmarillion appear in their first form: tales of the Elves and the "Gnomes", (i. e. Deep Elves, the later Noldor), with their languages Qenya and Goldogrin. Here are found the first recorded versions of the wars against Morgoth, the siege and fall of Gondolin and Nargothrond, and the tales of Túrin and of Beren and Lúthien.

Throughout his illness kept recurring, although periods of remission enabled him to do home service at various camps sufficiently well to be promoted to lieutenant. It was when he was stationed at Hull that he and Edith went walking in the woods at nearby Roos, and there in a grove thick with hemlock Edith danced for him. This was the inspiration for the tale of Beren and Lúthien, a recurrent theme in his "Legendarium". He came to think of Edith as Lúthien and himself as Beren. Their first son,

 THE POET

eventually he was indeed sent to active duty on the Western Front, just in time for the Somme offensive.

"After four months in and out of the trenches, he succumbed to "trench fever, a form of typhus-like infection common in the insanitary conditions, and in early November was sent back to England, where he spent the next month in Birmingham— By Christmas he had recovered sufficiently to stay with Edith at Great Haywood in Staffordshire. During these last few months, all but one of his close friends"

"Of the "T. C. B. S." had been killed in action. Partly as an act of piety to their memory, but also stirred by reaction against his war experiences"

"The had already begun to put his stories into shape— in huts full of blasphemy and smut, or by candle light in bell-tents, even some down in dugouts under shell fire."

"This ordering" Of his imagination developed into the Book.

[81]

SCHATZKAMMER DER SCHREIBRUNST

MEISTERWERKE DER KALLIGRAPHIE AUS VIER JAHRHUNDERTEN AUR ZWEIHUNDERT TAFELN

AUSCEWAHLT UND EINGBLEITET VON JAN TSCHICHOLD

VERLAG DIRKHAUSER • BASEL • MCMXLV

Applications

Dutchfonts

The Ko-family™ was developed to be used for the text posters of the 1997 edition of the Holland Festival. It bases its design on filling the spaces of a simple lettering stencil, rendered unconventional by using pens of different thicknesses, which give it an edgy and irregular look. The DF-KoHeavy and the DF-KoKAP1 were the first two weights; the family was completed in 2002 with a DF-KoLight, a second DF-KoKAP2 and two italics: DF-KoHeavy Italic and DF-KoLight Italic.

DutchFonts is a type foundry set up by Ko Sliggers to develop and sell his type designs after doing so through www.lalleweer.nl, which also showcases his other projects in design and animation. Typography has always been a vital ingredient in his graphic design since he started in 1979.

His work has an unmistakable typographic identity that is readily recognizable. A trademark in his work is the aspect of letterforms that look as if they have been painted or drawn. Altering a character from an existing typeface with a less traditional adaptation was never a problem for Sliggers, if the desired form asked for it. A good example of this kind of fresh makeover is the Ko Family.

Since 1997, his design projects have been carried out using his series of self-designed typefaces. A constant characteristic in the various typefaces he has developed is the aim to bring back irregularity as an articulation of a personal handmade, human approach and expression that is more interested in handiwork and craftsmanship. Many of the fonts are partially based on and inspired by existing, found, local letterforms.

The Ko Family is a singular and unusual font that is nevertheless easily decipherable as well as very designer friendly thanks to its many weights. It works very well for display and titles, contributing a clever and atypical look.

Family: DF-Ko™
Weights: KoLight, KoLight Italic, KoHeavy, KoHeavy Italic, KoKAP1, KoKAP2
Designer: Ko Sliggers
Year: 2003
Distributor: Dutchfonts
Use: Display

KoLight™

postscript Type 1 Font design ko sliggers 1997-2003

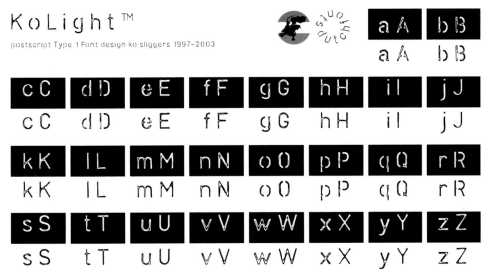

a A b B
a A b B

c C d D e E f F g G h H i I j J
c C d D e E f F g G h H i I j J

k K l L m M n N o O p P q Q r R
k K l L m M n N o O p P q Q r R

s S t T u U v V w W x X y Y z Z
s S t T u U v V w W x X y Y z Z

character set

1234567890¶=abc
defghijklmnopqrst
uvwxyz:'\`../±!@#
$%`&`_+ABCDEFGHI
JKLMNOPQRSTUVW
XYZ:"|`<>?®©™´Æ0€
£¥µæ¿¡«»ÄÅÇÉÑÖÜ á
â ã ã ä å ç é è ê ë í í î ï ñ ó
ò ô õ ö ú ù û ü Ã Õ ÿ Ÿ fi fl æ å
Â Ê Á Ë Ê Í Î Ì Ï Ò Ó Ô Õ Û Ù · ^ ˜ `
` ´ [({ })]

www.dutchfonts.com 2005

characteristics

7/9 pt

Ut primum alatis tetigit Magalia plantis. Aeneam fundantem arces ac tecta novantem conspicit. Atque illi stellatus iaspide fulva ensis erat Tyrioque ardebat murice laena demissa ex numeris. dives quae munera Dido fecerat. et tenui telas discrevat auro. Continuo invadit: 'tu nunc Karthaginis altae fundamenta locas pulchramque uxorius urbem exstruis? Heu. regni rerumque oblite tuarum! Ipse deum tibi me claro demittit Olympo regnator. caelum et terras qui numine torquet. ipse haec ferre celeres mandata per auras: quid struis?

8/10 pt

Aut qua spe Libycis teris otia terris? Si te nulla movet tantarum gloria rerum. Ascanium surgentem et spes heredis Juli respice. cui regnum Italiae Romanaque tellus debetur'. Tali Cyllenius ore locutus. mortales visus medio sermone reliquit et procul in tenuem ex oculis evanuit amens. At vero Aeneas aspectu obmutuit amens. arrectaeque horrore comae et vox faucibus haesit. Ardet abire fuga dulcesque relinquere terras. attonitus tanto monitu imperioque deorum. Heuquid agat?

9/11 pt

Ut primum alatis tetigit Magalia plantis. Aeneam fundantem arces ac tecta novantem conspicit. Atque illi stellatus iaspide fulva ensis erat Tyrioque ardebat murice laena demissa ex numeris. dives quae munera Dido fecerat. et tenui telas discrevat auro. Continuo invadit: 'tu nunc Karthaginis altae fundamenta locas pulchramque uxorius urbem exstruis? Heu. regni rerumque oblite tuarum! Ipse deum tibi me claro demittit Olympo regnator. caelum et terras qui numine torquet. ipse haec ferre iubet celeres mandata per auras: quid struis?

10/12 pt

Aut qua spe Libycis teris otia terris? Si te nulla movet tantarum gloria rerum. Ascanium surgentem et spes heredis Juli respice. cui regnum Italiae Romanaque tellus debetur'. Tali Cyllenius ore locutus. mortales visus medio sermone reliquit et procul in tenuem ex oculis evanuit auram. At vero Aeneas aspectu obmutuit amens.

18/18 pt

Ut primum alatis tetigit Magalia plantis. Aeneam fundantem arces ac tecta novantem conspicit.

24/24 pt

Aut qua spe Libycis teris otia terris? Ascanium surgentem et spes heredis cui regnum.

Fedra Sans was originally commissioned by Paris-based Ruedi Baur Integral Design and developed as a corporate font for Bayerische Rück, a large German insurance company, as part of their new visual identity. According to the client, the objective was to "de-Protestantize Univers," the typeface Bayerische Rück had been using since Otl Aicher designed their first visual identity in the 1960s. The typeface reflects the original intention: It humanizes the communicated message and adds simple, informal elegance. Another important criterion was to create a typeface that worked equally well on paper and the computer screen. The idea was to allow smooth circulation of information in all available media, that would also be consistent across diverse computer platforms.

After the first versions of the typeface were completed and digitized, the project was canceled when Bayerische Rück was acquired by another bigger, more aggressive multinational corporation. This put an early end to the story of this custom font.

Since a lot of work had been done already, Bilak decided to complete the typeface, adding extra weights and expert fonts, and optimizing it for the computer screen, thus creating a truly contemporary font. Shortly before the planned release of the typeface, someone broke into the designer's studio, and the computers and backup system containing all the font data were stolen. This incident significantly delayed publication and allowed him to look more closely at some early design decisions, made under an assumption that the font would never be publicly available. As a result, Bilak changed the spacing of the font, as well as the angle of the italics. Many characters were redrawn creating a more flexible type family.

Fedra takes into account vast possibilities of type usage today and has been designed accordingly. Because of its increased x-height, it functions well under severe circumstances, such as faxing and low-resolution printing. It remains very legible on the computer screen, yet it is most beautiful in print.

Family: Fedra
Weights: Book, Normal, Medium, Bold, Book Italic, Normal Italic, Medium Italic, Bold Italic, Book SC, Normal SC, Medium SC, Bold SC
Designer: Peter Bilak
Year: 2001
Distributor: Typotheque
Uses: Text; good for faxing and printing

Fedra Sans

by Peter Bil'ak

A new sans serif, originally designed as a corporate font for one of those huge companies; now completed, updated, and ready to use in all formats. *Available in five weights, with three different numeral systems, real italics, small capitals, and expert sets full of ligatures, fractions, arrows, symbols and other useful little things.*

Aa *Aa*

Fedra Sans *Light*
Fedra Sans Book
Fedra Sans *Normal*
Fedra Sans *Medium*
Fedra Sans Bold

← ↖ ↑ ↗ → ↘ ↓ ↙

Ð	đ	Ł	ł	Š	š	Ý	ý	Þ	þ	Ž	ž	½	¼		¾	'		¦	
~	×	!	#	$	%	&	'	()	"	+	,	-	.	/	0	1	2	
3	4	5	6	7	8	9	:	;	=	>	<	?	@	A	B	C	D	E	
F	G	H	I	J	K	L	M	N	O	P	Q	R	S	T	U	V	W		
Z	Y	[\]	^	_	`	a	b	c	d	e	f	g	h	i	j	k	
l	m	n	o	p	q	r	s	t	u	v	w	x	y	z	{			}	~
Ä	Å	É	Ñ	Ö	Ü	á	à	â	ä	ã	å	ç	é	è	ê	ë	í		
ì	î	ï	ñ	ó	ò	ô	ö	õ	ú	ù	û	ü	†	°	¢	£	§		
¶	ß	®	©	™	´	¨	≠	Æ	Ø	∞	±	≤	≥	¥	µ	Σ	Π		
π	∫	ª	º	Ω	æ	ø	¿	¡	¬	√	ƒ	≈	Δ	«	»	…	Á	Ã	
Õ	Œ	œ	–	—	'	'	"	"	◊	ÿ	Ÿ	⁄	€	‹	›	ﬁ	ﬂ		
ﬂ	ﬃ	ﬄ	ﬀ	ﬁk	ﬁh	ﬁj	‡	·	‚	„	‰	Â	Ê	Á	Ë	È	Í	Î	
Ï	Ì	Ó	Ô	g	Ò	Ú	Û	Ù	ı										

A new typeface by Peter Bil'ak coming in Book, Normal, Medium and Bold including *Italics*, SMALL CAPS & expert fonts with plenty of ligatures, alternate characters and two construction variants.

Fedra Serif A

—— & Et & ﬆ & & & & et & ——

Fedra Serif B

Instead of seeking inspiration in the past, *Fedra Serif* is a synthetic typeface where aesthetic and technological decisions are linked. *Fedra Serif* combines seemingly contradictory ways of constructing characters in one harmonious font. Its *humanistic roots* (rhythm of the handwriting) is balanced with *rational drawing* (a coarse computer-screen grid). *Fedra Serif* has 4 weights, italics, small caps, and expert sets for each weight and three different numeral systems (proportional, lining figures; old style figures; and tabular, fixed-width figures). The font also comes in two different versions with different lengths of the ascenders and descenders (stem lengths). Version A matches the proportions of Fedra Sans, with a large x-height and short stem length. Version B prolongs the stem lengths up to 12%, and increases the contrast making it suitable for traditional book printing. Combined, these variants result in a typeface suitable for solving complex typographic problems. • WWW.TYPOTHEQUE.COM

minimum

Sample	Size:90 Font:FedraSerifA-BookItalic3
	Text:minimum
	Printed by Fontographer 4.1.5 on 30/9/02 at 18:53

minimum

Sample	Size:90 Font:FedraSerifA-BookItalic3
	Text:minimum
	Printed by Fontographer 4.1.5 on 30/9/02 at 18:58

minimum

Sketches

As we can see in the multiple examples below, the aim to rework Otl Aicher's original Univers into a warmer, de-Protestantized font was a complete success. It offers an extremely smooth read in print as well as on the computer screen.

Applications

Apart from being a large family, Auto is the bold proposal from Underware to break with familiar typeface structures. It is the first typeface family to have three sets of italics that can easily be used with the upright versions.

In general, Auto is a tranquil and legible typeface, which is intended for both text and display. It has a large character set covering all European languages. It also has four numeral sets, Old Style for upper- and lowercase, tabular and proportional, as well as small capitals in all their weights and variants.

Its three series of italics have very different characters, bestowing great variety. Auto 1 Italic has a static character; it is clearly a normal italic, elegant and practical. Auto 2 Italic possesses a rather more informal character; it shows details more typical of roman italics than normal ones, with calligraphic terminals for letters like *a* and *d*. Finally, Auto 3 Italic is the most informal with a clear link to hand-writing and presenting details like the "cuts" in certain letters, such as *a* and *d*. These three italics can be used at any time depending on the mood of the user or the conceptual characteristics of the graphic project they are being used in.

Through Auto, Underware proposes a new way of seeing typefaces and offers the graphic designer a large typographical palette. This, together with the extensive character set it presents, makes this family an all-purpose typeface that is ideal for any situation.

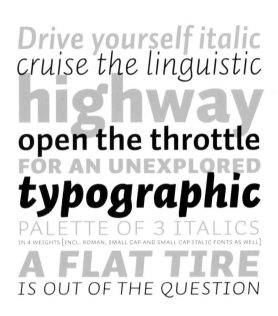

Family: Auto

Variants: Auto 1 Light, Auto 1 Light LF, Auto 1 Light Small Caps, Auto 1 Light Italic, Auto 1 Light Italic LF, Auto 1 Light Italic Small Caps, Auto 1 Regular, Auto 1 Regular LF, Auto 1 Regular Small Caps, Auto 1 Regular Italic, Auto 1 Regular Italic LF, Auto 1 Regular Italic Small Caps, Auto 1 Bold, Auto 1 Bold LF, Auto 1 Bold Small Caps, Auto 1 Bold Italic, Auto 1 Bold Italic LF, Auto 1 Bold Italic Small Caps, Auto 2 Light, Auto 2 Light LF, Auto 2 Light Small Caps, Auto 2 Light Italic, Auto 2 Light Italic LF, Auto 2 Light Italic Small Caps, Auto 2 Regular, Auto 2 Regular LF, Auto 2 Regular Small Caps, Auto 2 Regular Italic, Auto 2 Regular Italic LF, Auto 2 Regular Italic Small Caps, Auto 2 Bold, Auto 2 Bold LF, Auto 2 Bold Small Caps, Auto 2 Bold Italic, Auto 2 Bold Italic LF, Auto 2 Bold Italic Small Caps

Designer: Underware

Year: 2004

Distributor: Underware

Use: Long text and display

Other uses: Any

Advice or considerations: Explore the linguistic and typographical possibilities of the three italics.

Suddenly the situation seemed complex. It was midnight, and a moonless chill whispered his bones freezin'. Buildings were closed off, restaurants did not serve anymore, and Harold was ready for a snack. On his back he had his sick grandaddy, who sighed: "where is mommy?". It all seemed to be running out of hand, but along came a steel-plated rescue. It was a taxi.

AUTO 1 ITALIC IS FORMAL – AN ITALIC WHICH YOU CAN TRUST AT THE SPEED OF 240 KM/H

Suddenly the situation seemed complex. It was midnight, and a moonless chill whispered his bones freezin'. Buildings were closed off, restaurants did not serve anymore, and Harold was ready for a snack. On his back he had his sick grandaddy, who sighed: "where is mommy?". It all seemed to be running out of hand, but along came a steel-plated rescue. It was a taxi.

AUTO 2 ITALIC IS FLAVOURABLE – IT GIVES A STRONG CONTRAST NEXT TO ROMAN FONTS

Suddenly the situation seemed complex. It was midnight, and a moonless chill whispered his bones freezin'. Buildings were closed off, restaurants did not serve anymore, and Harold was ready for a snack. On his back he had his sick grandaddy, who sighed: "where is mommy?". It all seemed to be running out of hand, but along came a steel-plated rescue. It was a taxi.

AUTO 3 ITALIC DEMANDS YOUR ATTENTION – IMPRESS YOUR GRANDPA WITH THIS ONE

THE ZOOM-IN SHEETS STORY TOLD BY *Ashley Ringrose*

I HEARD
THE DADDY
was found
talking
TO THE AUTO
LATE AT NIGHT

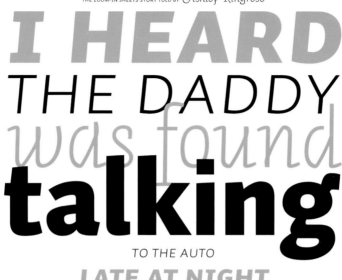

SHARED WITH AUTO 1 2 AND 3

Road 72 72	Road 72 72	**Road 72 72**	**Road 72 72**
AUTO 1/2/3 LIGHT	AUTO 1/2/3 REGULAR	AUTO 1/2/3 BOLD	AUTO 1/2/3 BLACK
ROAD 72	ROAD 72	**ROAD 72**	**ROAD 72**
AUTO 1/2/3 LIGHT SC	AUTO 1/2/3 REGULAR SC	AUTO 1/2/3 BOLD SC	AUTO 1/2/3 BLACK SC
ROAD 72	ROAD 72	**ROAD 72**	**ROAD 72**
AUTO 1/2/3 LIGHT ITALIC SC	AUTO 1/2/3 REGULAR ITALIC SC	AUTO 1/2/3 BOLD ITALIC SC	AUTO 1/2/3 BLACK ITALIC SC

AUTO 1

Road 72 72	Road 72 72	*Road 72 72*	***Road 72 72***
AUTO 1 LIGHT ITALIC	AUTO 1 ITALIC	AUTO 1 BOLD ITALIC	AUTO 1 BLACK ITALIC

AUTO 2

Road 72 72	Road 72 72	*Road 72 72*	***Road 72 72***
AUTO 2 ITALIC LIGHT	AUTO 2 ITALIC	AUTO 2 BOLD ITALIC	AUTO 2 BLACK ITALIC

AUTO 3

Road 72 72	Road 72 72	*Road 72 72*	***Road 72 72***
AUTO 3 ITALIC LIGHT	AUTO 3 ITALIC	AUTO 3 BOLD ITALIC	AUTO 3 BLACK ITALIC

Specimens

Auto gives the designer a wide typographical palette that can be used in multiple applications, such as posters, corporate elements, or simple texts. It has three sets of italics that are quite different from each other.

Applications

Xavier Dupré

www.emigre.com

In general, the typeface designer is a peculiar being who cannot disconnect from his profession, basically because the love of letters is much more than a job–it means absolute devotion and becomes a way of life. Xavier Dupré developed the concept of Vista in 2002, when he did the sketches of a few glyphs in a notebook during a holiday in Sumatra. Most of the signboards in the shops of Sumatra draw on the American Far West as well as a wide variety of other forms; these are quite uncommon from a Western point of view and so captured this designer's attention.

Vista is the result of an exercise, which consisted in looking for a design that would work for both text and display. The direct source of inspiration was FF Meta–designed by Erik Spikerman. According to Dupré, it combines the humanist touch of calligraphic forms with the pragmatism and simplicity of normal typefaces. However, in 2004 Xavier Dupré revised his sketches and decided to redesign all the characters, transforming this first approach into something completely different. Although it is possible to observe some influence from Spikerman in Vista, FF Meta is not a direct reference in its design.

The result of this work is Vista Sans, a family composed of uprights, italics, and small capitals–all of which are alternative characters. These include six different weights ranging from the light version to the black one and offer a wide variety in their composition. Although it is more effective as a typeface for display, Vista Sans can be used in short texts and in relatively small bodies.

Vista Sans is quite compact, has squarish forms and presents endless unusual details, especially in its alternative characters. These contain curved terminals like brush strokes, which give the family movement and create an interesting tension between the fluidity and rigidity of some of the glyphs.

VISTA

VISTA SANS
A family of 36 fonts
DESIGNED BY
Xavier Dupré
Licensed by Emigre Fonts

Family: Vista Sans
Variants: Vista Sans Light, Vista Sans Book, Vista Sans Regular, Vista Sans Medium, Vista Sans Bold, Vista Sans Black
Designer: Xavier Dupré
Year: 2005
Distributor: Emigre Inc.
Use: Display
Other uses: Not recommended
Advice or considerations: This font is recommended for texts that are not too long and bodies that are not too small.

A A B B C D D E F G H H I J J K K L M M N N O P P Q Q
R R S T T U U V V W W X X Y Y Z Z
Æ Œ Á Â Ä À Å Ã Ç Ð É Ê Ë Í Î Ì Ï Ł Ñ Ó Ô Ò Ö Õ Ø Š Ú
Û Ù Ü Ý Ž & 1 2 3 4 5 6 7 8 9 0 % ‰ # € ¥ ¢ S £ ƒ

a a b c d d e f f g ǧ h i j k l m n o p q r s t u v w x y z
fi fl ß æ œ á â à ä å ã ç é ê è ë ð í î ì ï ł ñ ó ô ò ö õ ø
š ú û ù ü ÿ ý ž ə 1 2 3 4 5 6 7 8 9 0

A B C D E F G H I J K L M N O P Q R S T U V W X Y Z
1 2 3 4 5 6 7 8 9 0 % ‰ # € ¥ ¢ S £ ƒ

Vista light Vista light

Vista light italic *Vista light italic*

Vista book Vista book

Vista book italic *Vista book italic*

Vista regular Vista regular

Vista regular italic *Vista regular italic*

Vista medium **Vista medium**

Vista medium italic ***Vista medium italic***

Vista bold **Vista bold**

Vista bold italic ***Vista bold italic***

Vista black **Vista black**

Vista black italic ***Vista black italic***

BKQZ&afgk → BKQZ∂afgk
BKQZ&afgk → BKQZ∂afgk
BKQZ&afgk → BKQZ∂afgk
BKQZ&afgk → *BKQZ∂afgk*
BKQZ&afgk → **BKQZ∂afgk**
BKQZ&afgk → **BKQZ∂afgk**

1234567890 → 1234567890

ABC?¡ξ(◆◇‖↓ → ABC?¡ξ(◆◇‖↓

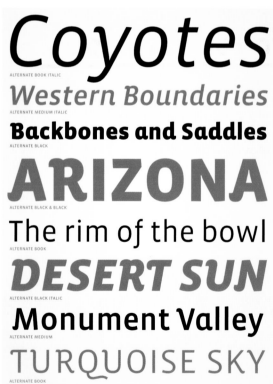

Coyotes
ALTERNATE BOOK ITALIC

Western Boundaries
ALTERNATE MEDIUM ITALIC

Backbones and Saddles
ALTERNATE BLACK

ARIZONA
ALTERNATE BLACK & BLACK

The rim of the bowl
ALTERNATE BOOK

DESERT SUN
ALTERNATE BLACK ITALIC

Monument Valley
ALTERNATE MEDIUM

TURQUOISE SKY
ALTERNATE BOOK

Samples

Summer draws on, the shrill song of the *cicadas* is over, and the scarlet cactus blooms are gone. Columbine and Sego Lily have vanished, too. Now only sunflower, and in shaded canyons, the Scarlet Bugler, are found. In these last few days the heat has been intense, and *siestas* have been in order. I have traversed only at dawn and evening, often at sunset, under the stars. I shall never forget coming down the *Lukachukai Mountains* at dusk, with the blood-red moon falling through the pine branches as I descended.

VISTA SANS BOOK & BOOK ITALIC WITH ALTERNATE BLACK ITALIC 18/26 POINT

Vista is ideal for text and display. Although it is a bit condensed and has slightly square forms, it has myriad details, especially alternative characters in which the curved ends give movement to the entire text.

Applications

Directory

Elena Albertoni
Anatoletype
Hirtenstraße 15
10 178 Berlin
Germany
info@anatoletype.net
www.anatoletype.net

Andreu Balius
C/ Milà i Fontanals 14-26, 2ⁿ 2ª
08012 Barcelona
Spain
Tel:+34 93 459 16 52
mail@andreubalius.com
www.andreubalius.com

Eduardo Berliner
Rua Bogari 15/103 Lagoa
Rio de Janeiro 22471 340
Brazil
Tel: +55 21 2266 2448
eduardiberliner@hotmail.com

Peter Bilak
Zwaardstraat 16
Lokaal 0.11
2584 TX The Hague
The Netherlands
Tel: +31 70 322 61 19
Fax: +31 84 831 67 41
peterb@peterb.sk
www.peterb.sk

Veronika Burian
1250 18th Street, apt. 3
80302 Boulder CO
United States
Tel: +1 303 786 1613
vik@type-together.com
www.type-together.com
www.vikburian.net

Pilar Cano
Rec 60, principal 1ª
08003 Barcelona
Spain
Tel: +34 93 315 16 61
pilar@midoristudio.net
www.midoristudio.net

Cape Arcona Type Foundry
Margaretenstraße 24
45145 Essen
Germany
general@cape-arcona.com
www.cape-arcona.com

Iván Castro
C/ Castillejos 250, bajos 2
08013 Barcelona
Spain
typofreak@terra.es

Cuerpodoce
Marc Salinas
de l'Església, 4-10, 4° C bis
08024 Barcelona
Spain
Tel: +34 606 872 191
marcsalinas@cuerpodoce.com
www.cuerpodoce.com

Xavier Dupré
Chaussée d'Alsemberg 295
1190 Bruxelles
Belgium
Tel: +32 2346 83 54
xxdupre@yahoo.com

Dutch fonts
Ko Sliggers
Lalleweer 2
9949 Ta Borgsweer
The Netherlands
Tel: +31 59 660 19 49
Fax: +31 59 660 19 06
kosliggers@lalleweer.nl
www.dutchfonts.com

Fontsmith
Ground Floor
62 Southwark Bridge Road
SE1 0AS London
United Kingdom
Tel: +44 20 7401 8886
info@fontsmith.com
www.fontsmith.com

Stefan Hattenbach
MRF [MAC Rhino Fonts]
Tulegatan 29, SE-113 53
Stockholm
Sweden
Tel: +46 8 31 50 31
info@macrhino.com
www.macrhino.com

House Industries
1145 Yorklyn Road
PO Box 166
Yorklyn, Delaware
United States
Tel: +1 302 234 2356
news@houseind.com
www.houseind.com

Thomas Huot-Marchand
27, Rue Bersot
25000 Besançon
France
Tel: +33 3 81 83 19 22
Fax: +33 6 60 92 40 66
thomas@256tm.com
www.256tm.com

Michael Ives
153 Grove Lane
SE5 8BG London
United Kingdom
Tel: +44 785 907 4266
micthemod@hotmail.com

Jeremy Tankard Typography Ltd
The Old Fire Station
39 Church Lane
LN2 1QJ Lincoln
Lincolnshire
United Kingdom
Tel: +44 (0) 1522 805 654
Fax: +44 (0) 1522 805 628
info@typography.net
www.typography.net

Íñigo Jerez Quintana
C/ Quintana 3, 2° 1ª
08002 Barcelona
Spain
Tel: +34 93 412 15 61
info@textaxis.com
www.textaxis.com

Lazydogs Typefoundry
Büschl, Linke, Strauch GbR
Mauerberg 31
86152 Augsburg
Germany
Tel: +49 821 34 63 614
Fax: +49 821 34 63 615
info@lazydogs.de
www.lazydogs.de

Letterbox
Suite One, 7th Floor, Carlow House, 289
Flinders Lane
3000 Melbourne
Australia
Tel: +613 9650 6433
Fax: +613 9650 5211
info@letterbox.net.au
www.letterbox.net.au

Laura Meseguer
Carders 45, 1° 5ª
08003 Barcelona
Spain
Tel: +34 932 689 499
mail@laurameseguer.com
www.laurameseguer.com

Kenn Munk
Ingerslevs Boulevard 4, 2.tv
DK-8000 Åarhus C
Denmark
Tel: +45 2674 0242
info@kennmunk.com
www.kennmunk.com

Ourtype
Baron De Gieylaan 41
B-9840 De Pinte
Belgium
Tel: +32 9 2202620
Fax: +32 9 2203445
info@ourtype.com
www.ourtype.com

P22 Type Foundry
PO Box 770
Buffalo
NY 14213
United States
Tel: +1 716 885 4990
Fax: +1 716 885 4482
www.p22.com

PampaType Digital Foundry
Alejandro Lo Celso
25 Sur 316
San Cristóbal Tepontla Pedro Cholula
Puebla Mexico 72760
Mexico
Tel: +52 222 2615886
info@pampatype.com
www.pampatype.com

Alejandro Paul + Ángel Koziupa
Sudtipos
Jorge Newbery 3988
C1427EGS Buenos Aires
Argentina
Tel: +54 1145 537 075
sudtipos@sudtipos.com
www.sudtipos.com

José Scaglione
Rodriguez 1339
Suite 7
2000 Rosario
Argentina
Tel: +54 (0341) 426 2534
info@josescaglione.com
www.josescaglione.com

Typodermic Fonts
1115-933 Hornby Street
Vancouver, BC V6Z 3G5
Canada
Tel: +1 778 834 8976
typodermic@gmail.com
www.typodermic.com

Underware
Schouwburgstraat 2
2511 VA The Hague
The Netherlands
Tel: +31 (0) 70 42 78 117
Fax: +31 (0) 70 42 78 116
info@underware.nl
www.underware.nl

Gerard Unger
Parklaan 29A
1405 GN Bussum
The Netherlands
Tel: +31 35 693 66 21
Fax: +31 35 693 91 21
ungerard@wxs.nl
www.gerardunger.com

Malou Verlomme
127 Avenue Jean Jaurès
75019 Paris
France
Tel: +33 6 66 60 99 39
malou@malouverlomme.com
www.malouverlomme.com

Buchgewerbe

Bold

spirován prací českých typografů

Italic

DISCLOSURE

SmallCaps

книгопечатание

Cyrillic Italic

ημιουργός

Greek Bold

LE LOUGHBOROUGH JUNCTION

Regular/Italic SmallCaps

Dynamically

Bold Italic

KING
RULES
FOUNDRY

the word,
and each
of its
stituent

the word,
and each
of its
constituen

Buchgewerbe

Inspirován prací českých typografů

DISCLOSURE

книгопечатание

δημιουργός

N16LE LOUGHBOROUGH JUNCTION

Dynamically

KING
RULES
FOUNDRY

The word,
and each
of its
constituent

the word
and ea
of its
constitue